Drawing is Not Copying!

Drawing is a basic form of art training, where the shapes and the three-dimensionality of objects are represented using a pencil or other drawing implement. You do not draw with the intention of "copying" an exact duplicate of your subject. That's what photos are for! So, why, and how should you draw?

We often hear from students and others that they want to draw the human form, but find it very difficult.

We all come into contact with a lot of people in our daily lives, but when you really look at the human form for the purpose of drawing it, you may be surprised at how little you actually know about it. The realization that you have been "looking without actually seeing" is the beginning of your artistic journey. The true purpose and basis of a drawing is for the artist to communicate the answer to the question, "What have I observed?"

When Drawing, Four Steps Should Continually Cycle Through the Artist's Mind

Observe

There are two types of observation:
1) Observe the whole figure from a distance
2) Observe the parts close up. Here, to "observe" also means to "examine" the subject.

The Four Steps of Drawing

Draw

Use lines and tones to draw the form. Use a variety of dark and light lines and several intermediate tones as needed to depict the subject.

Compare

Compare the subject you are drawing with what is on your paper. Compare and contrast, to see where you have made mistakes.

Correct

Re-draw your subject while making corrections to the form. This "correction" step has great significance in the drawing process.

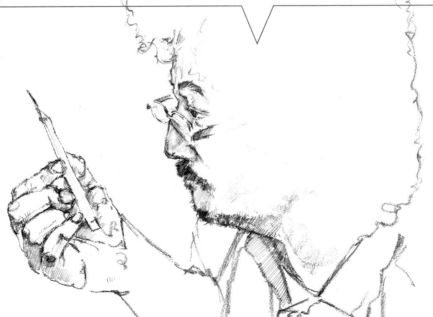

Tone or value: The changes in degrees of lightness and darkness. When drawing with a pencil, this ranges from the white of the paper to the black of the pencil, with different stages of gray in between.

Portrayal: To depict the current state, form and what you felt while observing a subject.

"Croquis" is a Genre of Drawing

When executing a drawing, the four steps depicted on the previous page are repeated over and over, until the artist is satisfied with the results. In *croquis*, where drawings are executed very rapidly within a limited time, even an experienced artist will omit step 3, "Compare" and step 4, "Correct" if the time allocated is less than 5 minutes. Capturing the lively pose of a human figure in a short amount of time is the fun aspect of croquis. The interesting poses you can get down on paper because the posing times are so short is a feature of croquis too. For example, the intense movements of sports, or the elegant steps of a dance scene. If you can capture what you want to depict in an instant, your illustrations and paintings are sure to increase in scope and possibilities.

In this book, we will describe some croquis sketches that have been executed in ever shorter time periods—10 minutes, 5 minutes, 2 minutes and 1 minute. For the 10 and 5 minute drawings, pay attention to how steps 3, "Compare" and 4, "Correct" are executed. We will explain in detail how to observe a subject before you start drawing them. We'll also discuss human bone and muscle structure—information you'll need for the Compare and Correct steps—as well as the basics of capturing a sense of space on your drawing surface. Please refer to this information as you draw.

We will guide you through the wonderful world of croquis

Of the four steps of drawing, the most important of all is number 2, "Draw." We'll introduce you to everything from the basics of holding a pencil to techniques for drawing the human face, body and clothing, as well as how to execute a croquis. If you just try to sketch quickly in a short amount of time without having the desired results in mind, you will lose sight of what you're aiming for. Use the expressive works from three professional artists as your inspiration to take your first steps into croquis.

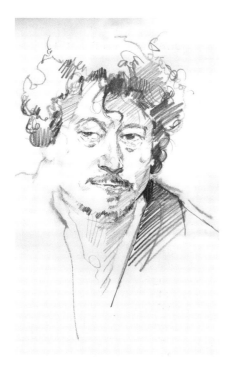

Kozo Ueda

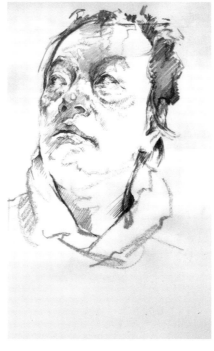

Minoru Hirota

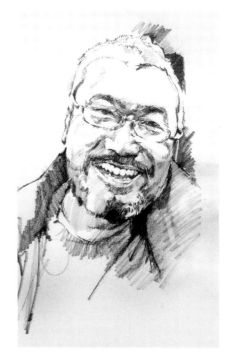

Takahiro Okada

About This Book

Features of This Book

- Most of the croquis examples are carefully selected from the sketches created by three artists specifically for this book, that have never been shown anywhere else.
- Process photos have been selected from a huge archive of photos to highlight key points. All process photos have added explanations.
- We have selected four types of croquis sketches of nudes—executed in 10 minutes, 5 minutes, 2 minutes and 1 minute—for you to practice capturing the structure of the female form.
- We have selected two types of clothing, the "camisole dress" and the "dress," and depicted them in 10-minute, 5-minute, 2-minute and 1-minute croquis sketches.
- It's more important to capture the whole posture and shape of the body rather than focus on details such as the eyes, nose and mouth. To depict faces, refer to the instructions on page 20, as well as the real life examples in Chapter 3, "Three Artists, Three Ways."

About Drawing Times

- Croquis practice is meaningful because it has the restriction of time limits. It's important to patiently and persistently practice drawing croquis over and over to gain experience. It will be tempting to extend the specified time limit when you run out of time before finishing your drawing, but doing so will defeat the purpose of these exercises. Please consider it a challenge and try to keep within the time limits.
- In Chapter 3, "Three Artists, Three Ways," each subject is depicted sequentially in 10-minute, 5-minute, 2-minute and 1-minute versions. The way you practice is entirely up to you. You can, for instance, loosen up by starting with 1-minute croquis, and then gradually increase the time limits.

The Size of the Croquis Sketches in This Book

- All of the croquis in this book were executed on 19 $\frac{2}{3}$ x 12 $\frac{3}{4}$ inch (50 x 32.5 cm) paper. Refer to page 159 for a detailed explanation of the paper size, as well as how to position yourself in relation to the model.

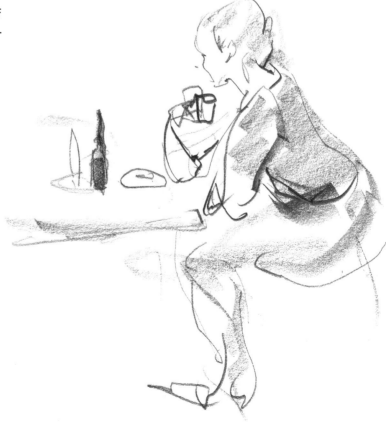

From the editor: Experienced professional artists draw very quickly, so if you are a beginner, we recommend doubling the time allotted. So, if 10 minutes is the time limit, try to do the same in 20 minutes; if 5 minutes, then 10 minutes; if 2 minutes, 4 to 5 minutes, and so on. One-minute croquis may not be possible to complete within 2 or even 3 minutes at first, but give it a try and keep at it.

When we say right, left, front and back in this book, we are referring to the right, left and so on of the model.

Let's Start Croquis Drawing

*The basics of sketching a nude or a clothed figure in
10 minutes, 5 minutes, 2 minutes and 1 minute*

1

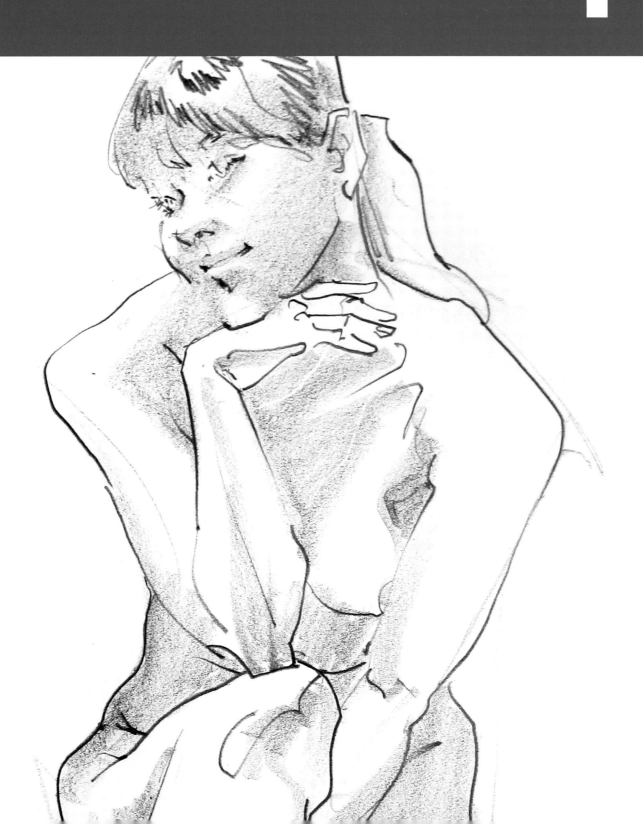

Minoru Hirota: *"In one sentence, croquis is...."*

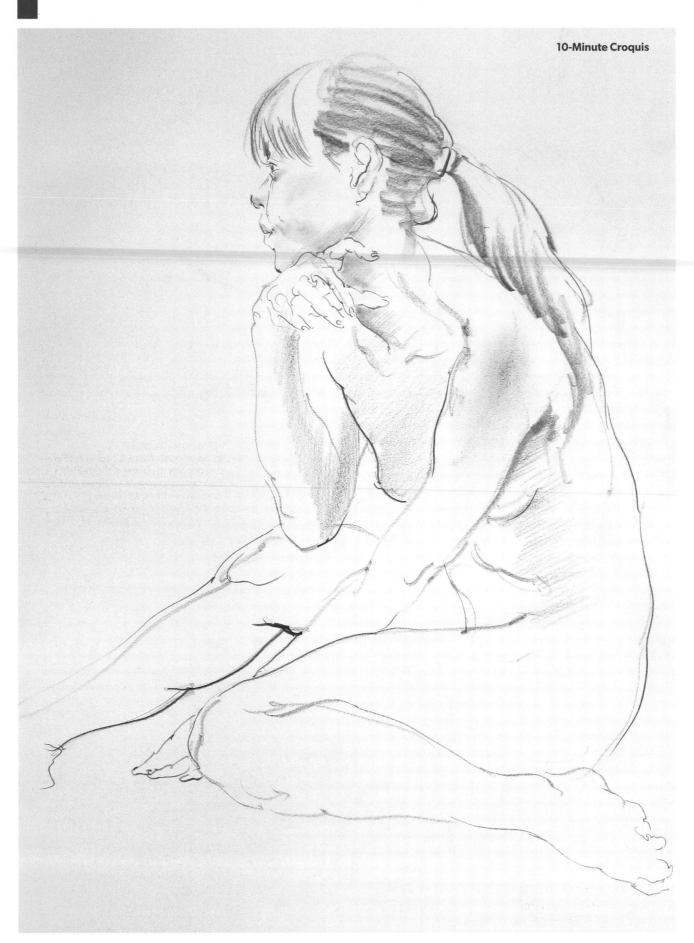

5-Minute Croquis

1-Minute Croquis

2-Minute Croquis

10-Minute Croquis
In this amount of time, it's possible to capture not only the shape of the model, but their facial expressions and hand postures, the texture of their skin and details of what they're wearing*, as well as emphasizing the three-dimensionality of the figure. Not only can you vary the line, you can also indicate tonal changes in a 10-minute sketch.

The clothing a model is wearing is referred to as the "outfit" throughout the book.

5-Minute Croquis
I think this amount of time is the threshold between drawing and croquis. It's possible to express the volume of the model by being aware of the anatomical lines* of the body, with the addition of tonal variations.

Refer to page 14 for more about the lines between planes of an object, or in the case of a human figure, the "anatomical lines."

2-Minute Croquis
I express the form and presence of the model without relying on tonal variations, but rather through the character and rhythm of line, and by varying the pressure of the pencil. With around 2 minutes for a croquis, I feel that the parts that I am not aware of—things in my subconscious— have a profound influence on my work.

1-Minute Croquis
I rapidly put down my impressions of the subject and the rhythm of the form with a continuous line of varying pressure.

This drawing session is very brief, and there's no time for thinking things over, but I feel that you can create some of the most expressive, attractive sketches this way.

"In one sentence, croquis is ... it's difficult to express in words, isn't it? Perhaps it is capturing the vital force or 'chi' of the subject with your body, and transferring that to lines and tones."

Kozo Ueda: *"This is croquis!"*

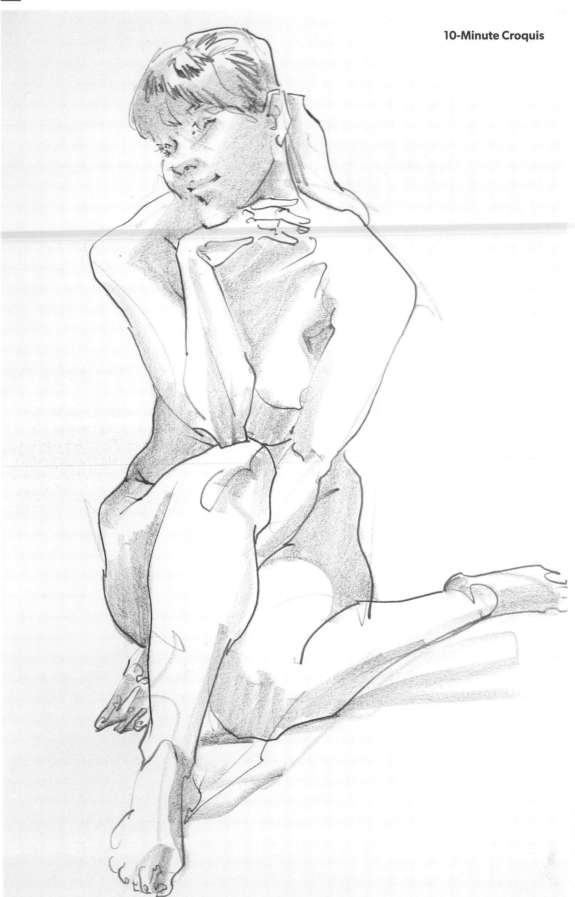

10-Minute Croquis
Make guide lines, check your layout, and express the differences in texture of the skin and hair with lines. Indicate shadows while being aware of the outline curves, to emphasize the space and the volume of the subject.

10

5-Minute Croquis

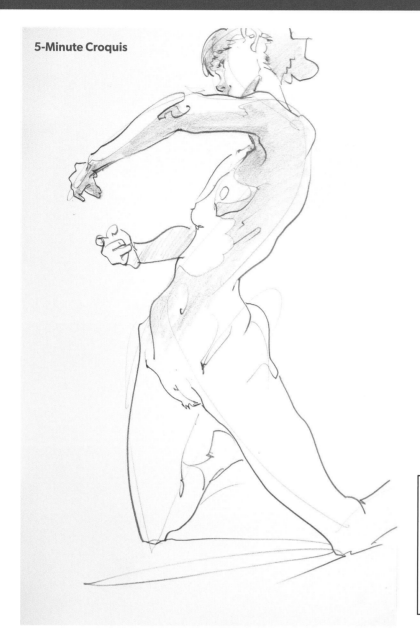

2-Minute Croquis

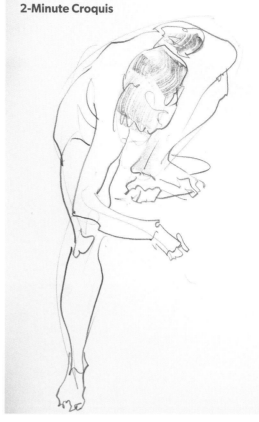

"There are details that reveal themselves the more you observe a subject, but there are also things that you lose sight of in a longer drawing (like the overall flow and undulations). I believe that croquis executed in a short period of time is a way of discovering the shape you initially saw by connecting the movement of the eyes and the hands."

1-Minute Croquis

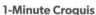

5-Minute Croquis
With a 5-minute time limit, you're faced with the unique challenge of drawing economically. Visualize the next lines you'll make as echoes of the lines and shapes you've already made.

2-Minute Croquis
There's no time to make guide lines, so start drawing the lines of the figure that jump out at you. Complicated parts like the fingers and the face are not eliminated; rather, work on depicting them in simplified ways.

1-Minute Croquis
Find the shape that will be the base of the pose, and draw loosely and continuously. Make bold choices about what to put down and what to leave out. You'll develop an objective eye while you do this kind of work.

Takahiro Okada: *"Briefly, croquis is...."*

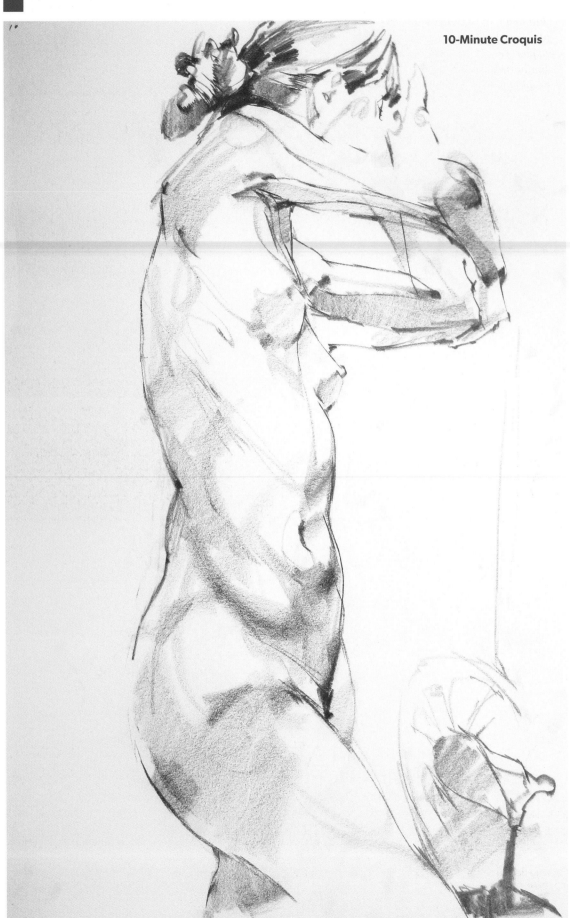

10-Minute Croquis

10-Minute Croquis
For the first 5 minutes, lay a woodless graphite pencil (see page 50) on its side and capture the overall large flow of the human form. The lines of the overall figure while putting down the areas of the large shadows. In the last 5 minutes, switch to the "compare & correct" stages of the work.

Of all the ways of "creating a picture," croquis is the only method where the time allotted for creation is set in advance. Drawing is a process of addition, and the detail in a drawing is reflective of the amount of time spent on it, but as long as one keeps on making new discoveries, there is no "end." In contrast, croquis is a process of subtraction. The true worth of croquis comes from eliminating all unnecessary elements, and capturing the impression of the subject with minimal elements.

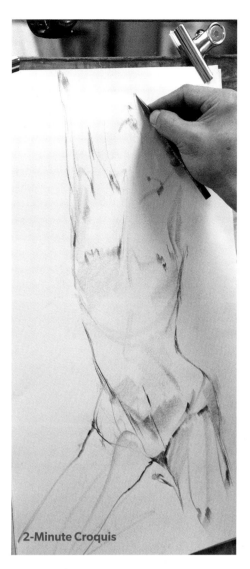

5-Minute Croquis

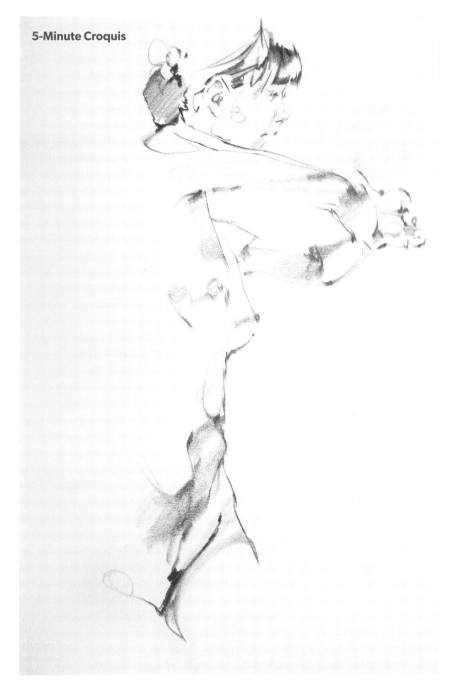

2-Minute Croquis

1-Minute Croquis

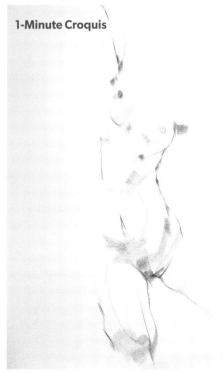

5-Minute Croquis
The decisions made at the beginning of the drawing are strictly temporary, so comparing and observing become important as you refine the drawing. For the "correction" phase, use heavier lines to emphasize the parts that make a deep impression in you.

2-Minute Croquis
Skip making any guide lines and decide on the shape directly by drawing lines. Emphasize essential points as necessary to express your impressions strongly.

1-Minute Croquis
This is the shortest time that I work. Instead of regarding it as serious drawing practice, I try to complete a drawing with just a glimpse of expression.

Three Points to Be Aware of Before You Start to Draw

The model is taking a pose. Where do you look first to start drawing? In any situation, don't be caught up solely with what leaps out at you. You want to start by grasping the overall structure of the pose.

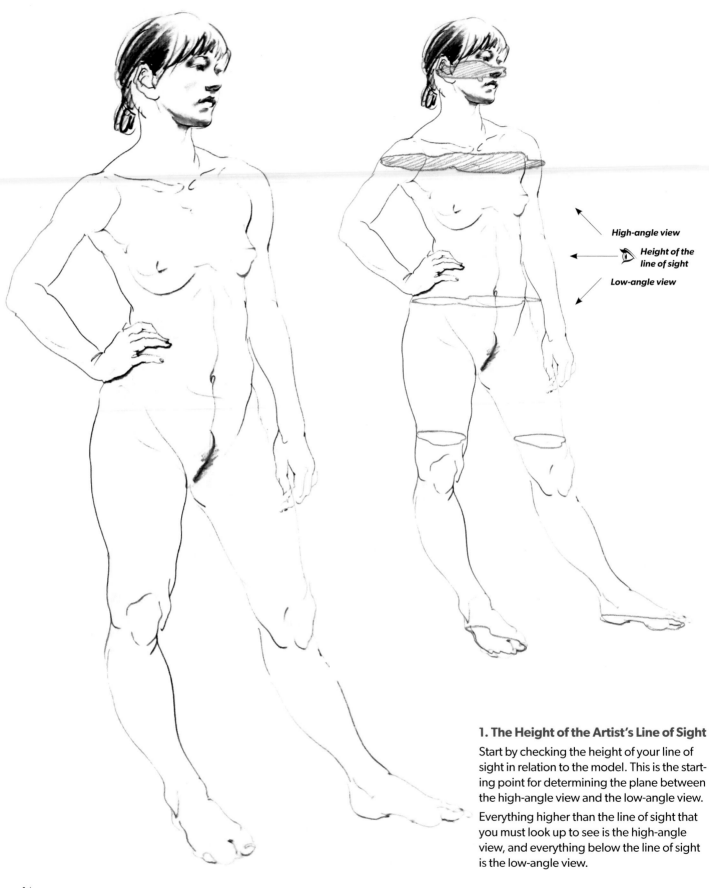

High-angle view

Height of the line of sight

Low-angle view

1. The Height of the Artist's Line of Sight

Start by checking the height of your line of sight in relation to the model. This is the starting point for determining the plane between the high-angle view and the low-angle view.

Everything higher than the line of sight that you must look up to see is the high-angle view, and everything below the line of sight is the low-angle view.

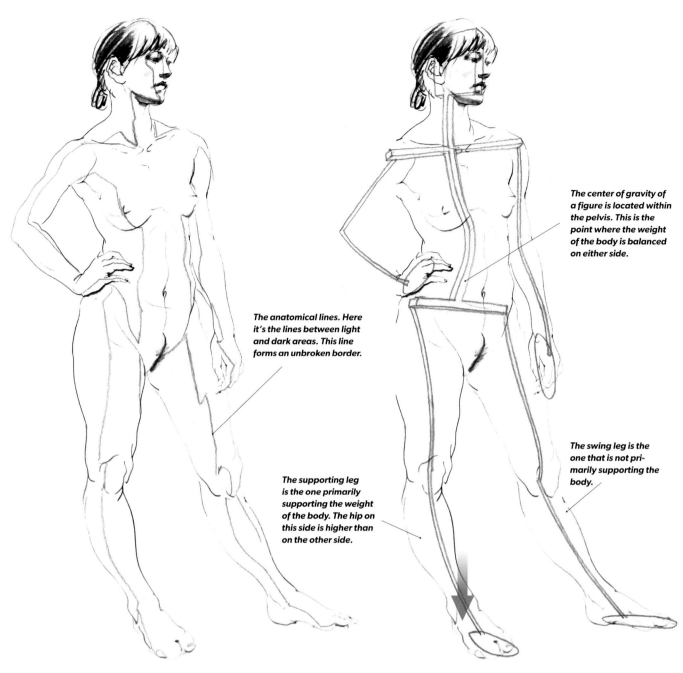

The center of gravity of a figure is located within the pelvis. This is the point where the weight of the body is balanced on either side.

The anatomical lines. Here it's the lines between light and dark areas. This line forms an unbroken border.

The swing leg is the one that is not primarily supporting the body.

The supporting leg is the one primarily supporting the weight of the body. The hip on this side is higher than on the other side.

2. The Direction of the Light

Verify where the light hitting the model originates.

When light hits a form, areas of light and shadow are created. By indicating the border between planes of light and dark and hence the direction of the light, it becomes easier to depict the three-dimensionality of the form.

To understand the way each plane of the body is facing, try envisioning each part of the body as a box.

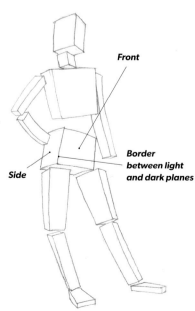

Front

Border between light and dark planes

Side

3. Frame (Structure)

Observe the figure while imagining the overall bone structure and the center of gravity. Establish the backbone and the supporting leg (the leg bearing most of the weight of the body), the angle of the hips and the shoulders, and so on (the posture).

If you connect the left and right sides of each corresponding body part, you can better comprehend the changes in their respective angles.

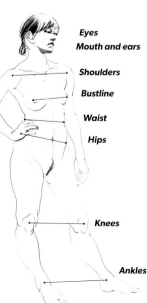

Eyes
Mouth and ears
Shoulders
Bustline
Waist
Hips
Knees
Ankles

How to Hold and Use a Pencil When Drawing

Take a look at how to use a pencil when doing a croquis sketch by following the steps in creating an example sketch. Use an all-graphite pencil (such as Grafstone), a square Grafcube or similar implement, whatever you prefer.

*Mass: The depiction of weight and volume in a drawing or painting that makes it seems as if the subject actually exists in the space.

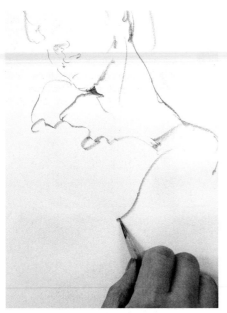

Using a Pencil

1 Hold the pencil at an angle to the plane of the paper when drawing details. Use thin, delicate lines to control the expression.

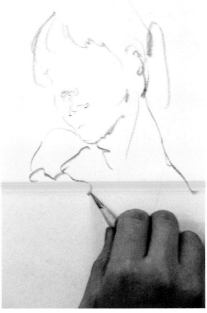

2 When sketching out the overall flow, hold the pencil on its side. A wide, expressive line is created this way.

3 By using the pencil held on its side, you can create line-weight variation to emphasize and de-emphasize different parts of the drawing.

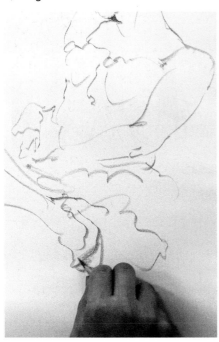

Variable lines shaded on one side

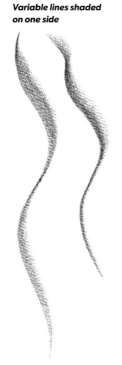

4 Use the side of the graphite tip to rapidly cover large areas of the paper.

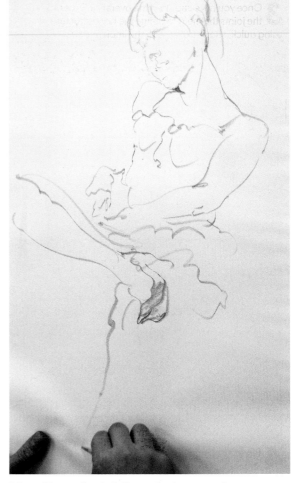

5 By changing the pressure and angle of the pencil, you can suggest the mass* of the figure just with lines.

Minoru Hirota · Camisole Dress · 2-minute croquis

Using an All-graphite Drawing Implement

Drawing implements like the Grafstone pencil are almost entirely made of graphite "lead" with just a thin coating to hold it together. They are called "all-graphite pencils" or "woodless pencils." Refer to page 50 for more about the drawing implements used by the artists in this book.

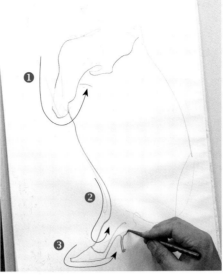

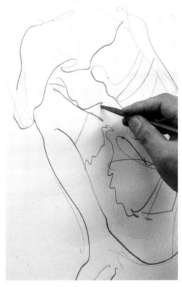

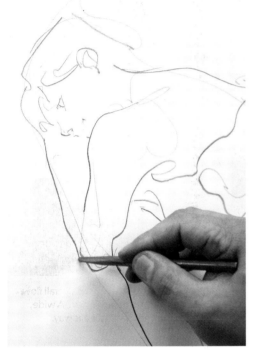

1 Once you have marked down some light guide lines, draw your line in one attempt, with the priority placed on speed. Slide the implement at an angle to the surface of the paper to create a smooth, long curve.

2 By keeping your hand from touching the paper, you can draw a very free, swift, lively line (with no smudging).

Kozo Ueda · Camisole Dress · 2-minute croquis

3 Once you have captured the overall flow, depict the joints that help to define the bone structure using quick, short strokes with the implement.

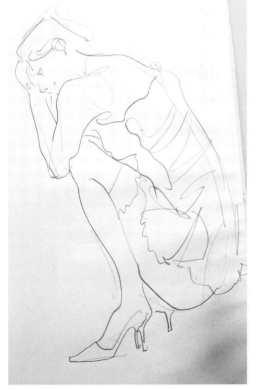

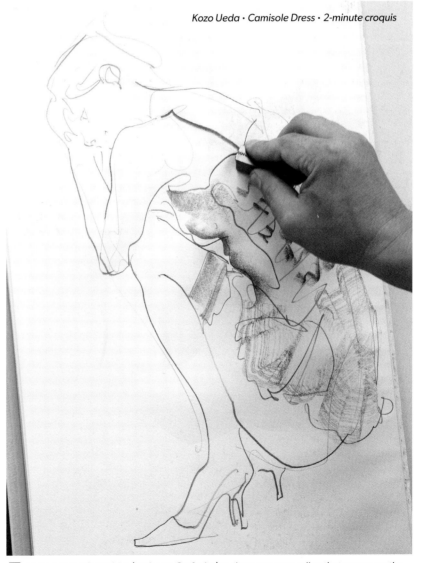

4 Pay attention to the difference between the strong lines used to define the body and the lines used to depict the softness as of the dress. The speed and pencil pressure of each type of line are different.

5 Use a block of graphite (such as a Grafcube) to draw one strong line that expresses the substance of the shoulder strap. The contour of the shoulder is also defined with this stroke. Use the block on its side to softly shade the dress and show its fine texture.

Don't Let the Pencil Leave the Paper While Drawing

Shape

Draw an Abstract Line

When drawing the human form, if you are always conscious of the relationship between paired anatomical structures, you can capture their natural shape. For this, it's important to keep your pencil moving. Here, we show you how to keep the pencil moving by drawing an abstract line, which has separate parts that flow together. When sketching in a short amount of time, try to keep your pencil in contact with the paper as much as possible, and draw the three-dimensional shapes of the body in series.

Visualize drawing a line with two parts that are "separate" but connected by the flow of the line.

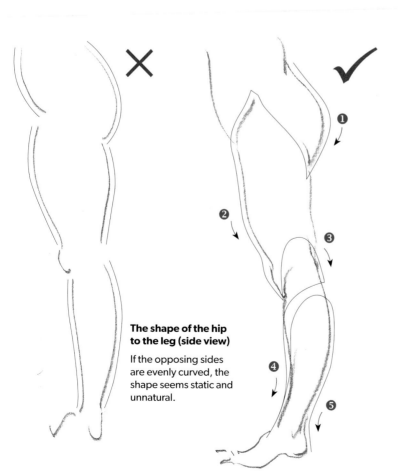

The shape of the hip to the leg (side view)

If the opposing sides are evenly curved, the shape seems static and unnatural.

The lines defining the body are connected in ways that are not visible. By drawing the lines that define the tension of the muscles in sequence from side to side, the form will look natural.

Good Shapes Are Born from Good Lines

Here we show you how croquis sketches with "good shapes" are created with lively pencil movements.

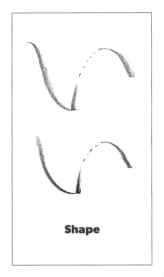

Shape

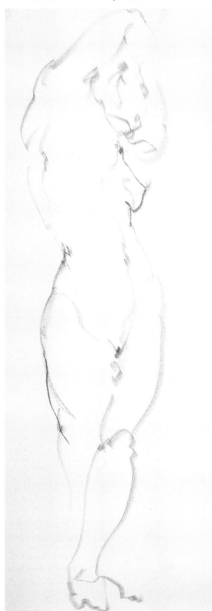

1 Draw the line from the raised right arm to the shoulder.

2 After drawing the line of the back, draw the breast area while visualizing the side of the body that's out of view.

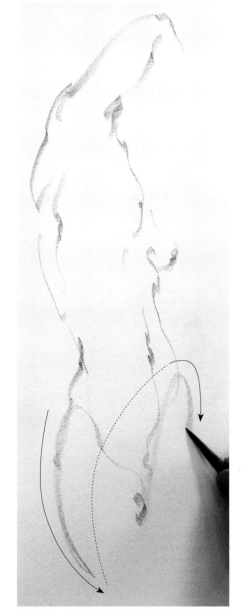

3 Capture the shape of the right thigh, and move the pencil to the left hip.

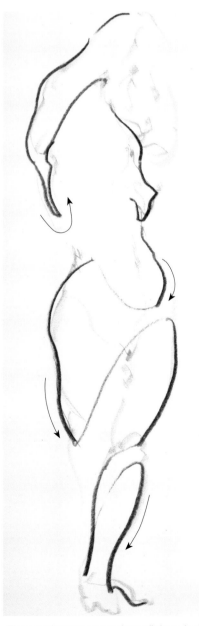

The pencil movement and your "observing" eye movement are connected.

4 Finished croquis.

Refer to page 101 for the complete work process. Minoru Hirota · Nude · 1-minute croquis

19

How to Draw a Face

Drawing a Left-facing Face

Let's look at how a face is drawn in croquis, focusing on an actual example. We'll focus on an example that depicts a common pose, and explain 10-minute and 5-minute croquis sketches.

*Tortillon: A pencil-shaped drawing implement that's typically made of tightly rolled paper. See page 50.

*Reflected light: Light parts created in dark areas. The ambient light is reflected back.

Drawing a Three-quarter Face

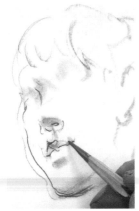

1 At the start of a 10-minute croquis, put down the main guide lines with the pencil laid sideways on the paper.

2 & 3 Rub the underside of the nose, the upper lip, and the indentation in the upper lip with a *tortillon* to create shadows and to define the outlines.

4 Define the nostrils and the shape of the lips with lines.

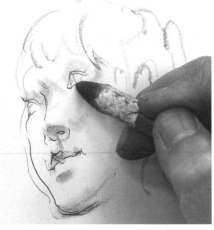
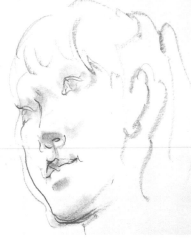
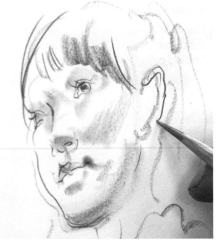

5 Indicate the roundness of the eyeballs as you create tones with a tortillon. Shade the parts of the eyes that aren't visible as well as the parts that are exposed.

6 Tones have been put into the parts that are facing downward, and the face looks three-dimensional.

7 Draw the ears, using the guideline as the starting point.

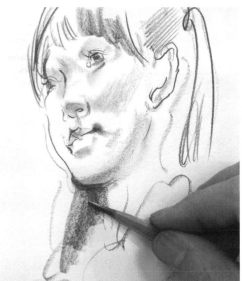
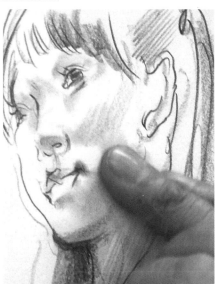
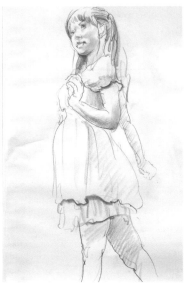

8 Add dark shading to the back parts of the hair to bring out the *reflected light* on the underside of the chin.

9 Smudge the pencil graphite with your fingertips to indicate the roundness of the cheeks.

10 Check the overall balance of the drawing.

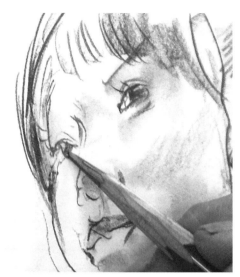

11 Draw in the details of the eyes to give the face expression.

12 Pay attention to the variation in pencil usage.

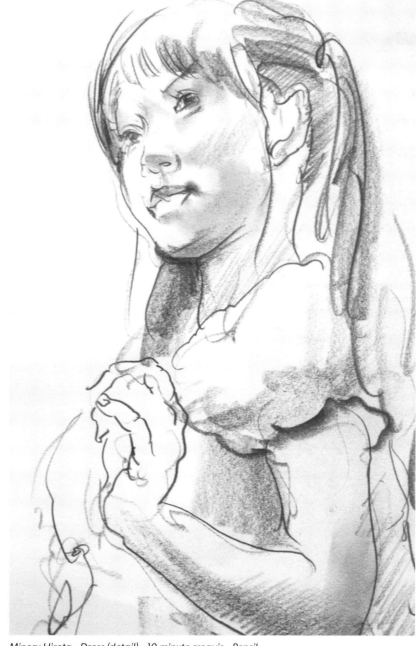

Minoru Hirota · Dress (detail) · 10-minute croquis · Pencil

Drawing a Side-facing Face

Sketch in the eyes and nose, indicating the distance from the cheeks and the protruding parts with varying lines.

1 The outline of the face is defined with curved lines.

2 After drawing the outlines of the face, draw the back of the head.

Minoru Hirota · Nude · 10-minute croquis · (detail of work in progress) · Refer to page 8

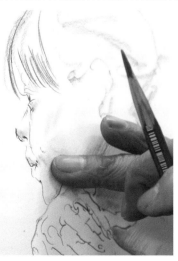

3 Smudge in tones with your fingertips to give volume to the head.

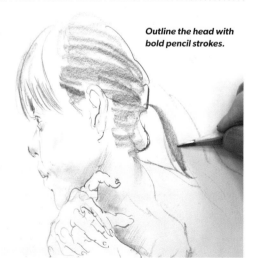

Outline the head with bold pencil strokes.

4 Depict the texture of the hair, following the lay of the hair.

Drawing a
Right-facing Face

Drawing a Face that is Turned Mostly to the Side

Here, we capture a face observed from a position a little higher than the model.

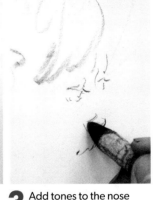

1 For the start of a 10-minute croquis pose, use a pencil held nearly parallel to the paper's surface to roughly define the guide lines.

2 Add the eyes, nose and mouth along the contour of the head.

3 Add tones to the nose with a tortillon, to add three-dimensionality.

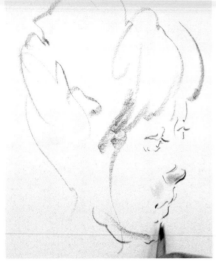
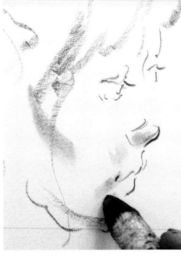
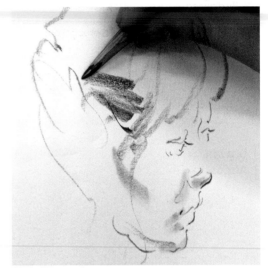

4 Draw in the overlapping parts of the lower lip and chin to depict depth.

5 Add shadows to bring out the three-dimensionality of the side of the mouth.

6 Capture the flow of the hair along the side of the head with strong strokes made with the pencil held nearly parallel to the paper's surface.

7 The twist of the head is depicted by drawing the flow of the ponytail.

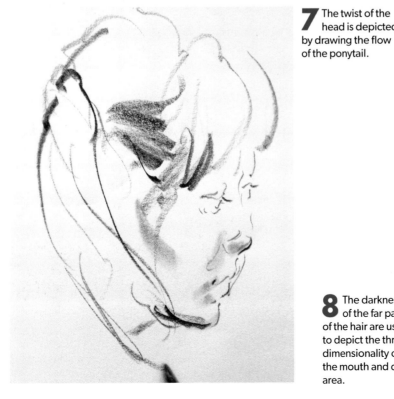
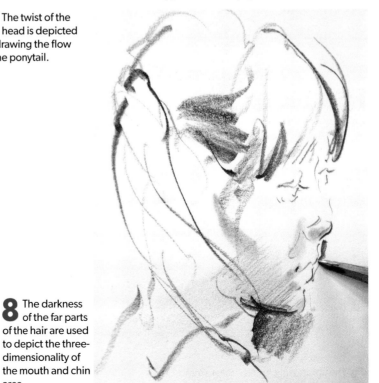

8 The darkness of the far parts of the hair are used to depict the three-dimensionality of the mouth and chin area.

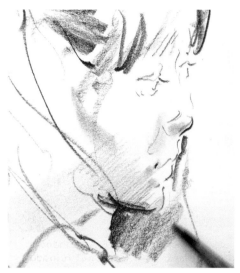

9 By drawing the outline of the neck with strong pressure and gradually making it softer, the volume of the hair in the ponytail is brought out.

10 Add the lines for the bangs to balance the hair on the back of the head.

Drawing a Face that is Almost Facing Front

1 Capture the parts that are facing down such as the chin, nose and upper lip early on.

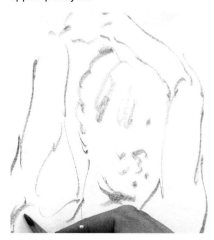

2 The parts facing down indicate that the artist is looking up at the model.

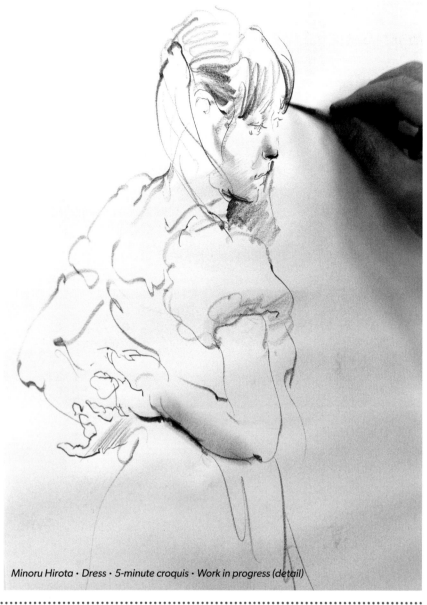

Minoru Hirota · Dress · 5-minute croquis · Work in progress (detail)

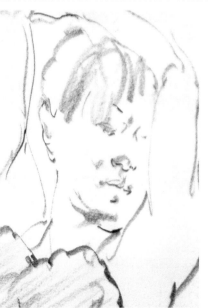

3 Create guide lines with the pencil held nearly parallel to the paper's surface to indicate the position of the eyes.

Minoru Hirota · Camisole Dress · 5-minute croquis · Work in progress (detail)

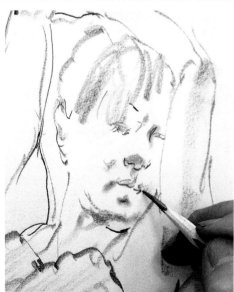

4 Define the nose and mouth with sharp lines.

How to Draw a Nude *Drawing a Standing Pose*

Drawing a Figure Facing the Front

Next, let's look at how to draw the whole body. The following are croquis of nude poses executed in 5 and 10 minutes.

 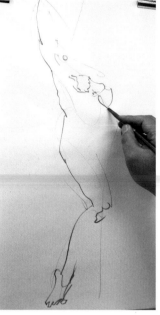 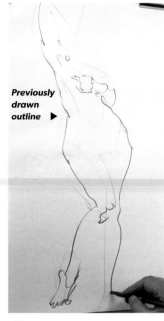

Previously drawn outline ▶

1 Draw guide lines for the whole body, envisioning the final result you are aiming for. Explore the shapes connecting to the side that is hidden from you too.

2 Draw a line in one attempt from the elbow to the toes.

3 Draw the foreshortened span from the hand to the elbow, to express the three-dimensionality of the body.

4 Keep the line you drew in step 2 in mind as you draw the opposing line defining the left side of the body.

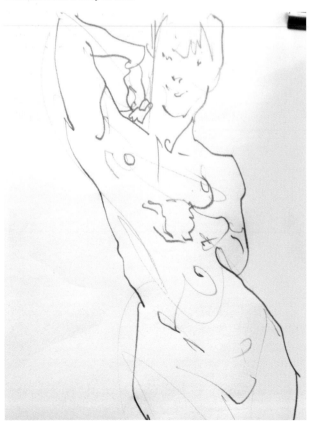 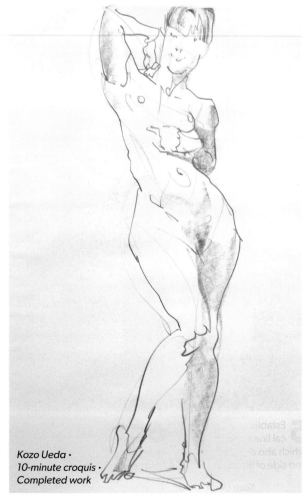

5 Using the guide lines as a reference, continue adding the outlines, always working from one side to the other.

6 Add the minimum amount of tones to depict the three-dimensionality of the figure. A woodless graphite pencil is used here.

Kozo Ueda ·
10-minute croquis ·
Completed work

A Diagonal Pose

 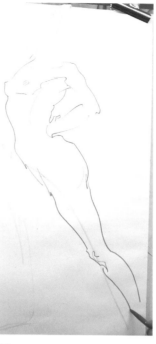 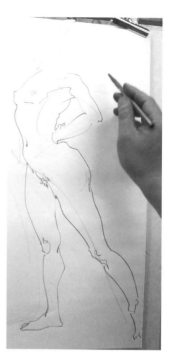

1 After putting down the guide lines, make a smooth, relaxed line along the side of the body that is tensed.

2 Create a strong line to define the elbow, which echoes the shape of the breast, and the space between the arm and the body.

3 Capture the tension of the breast and the bow of the leg, which flow from one to the other.

4 Draw the weight-supporting leg, and explore the shape of the head.

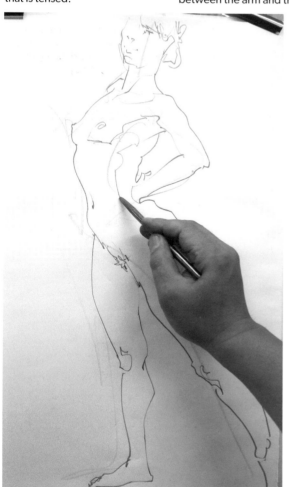 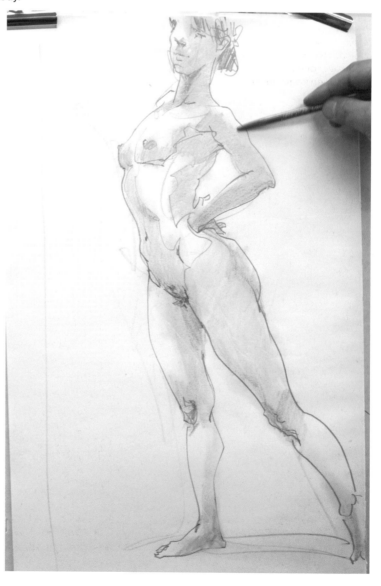

5 Establish the anatomical line along the core, which also divides the front and side of the torso.

6 Tone is added to bring out the volume of the subject by using a woodless graphite pencil held nearly flat against the paper.

Kozo Ueda · Nude · 10-minute croquis · Work in progress

Drawing a Sitting Pose　❚ **Legs Crossed and Arms Folded**

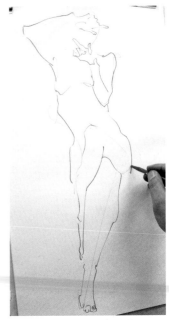

1 Put down guide lines to define the characteristics of the pose.

2 Start drawing the parts showing the most movement, using a rhythmic line.

3 Capture the shape of the leg below the knee.

4 Draw the right side (of the image on paper) to balance and support the left side.

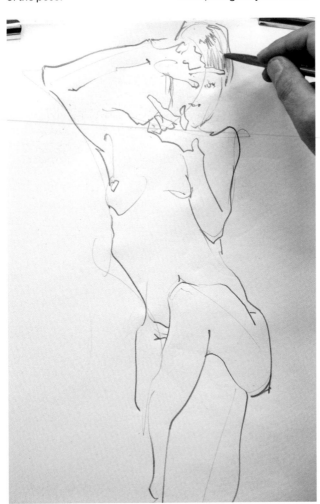

Choose and draw in the shadows required to add three dimensionality.

5 Depict the presence of the head by defining the lines of the hair that hit the fingers.

6 Add shadows to the floor that echo the direction of the right arm, to balance the composition.

Kozo Ueda · 10-minute croquis · Completed work

Another Sitting Pose—Legs Crossed, Arms Down

1 Choose the key points of the twisted pose and put down guide lines.

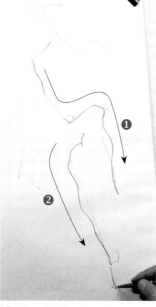

2 Start by drawing the three-dimensional overlap of the elbow and knee.

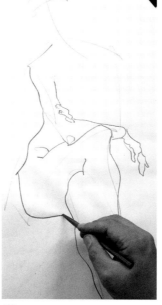

3 Observe the variations in pencil pressure in the line along the shoulder, hip and buttocks.

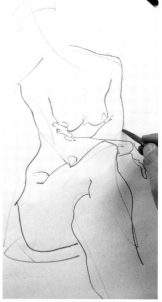

4 Put down a simple line along the left side of the body, in contrast to the dynamic line along the right side.

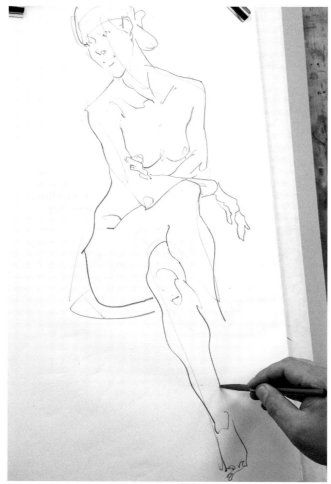

5 At first glance it may look like I'm drawing the left calf…

6 But it was actually the outline of the end of the right foot. The upper body is roughly shaded with broad strokes, in order the make the crossed legs come forward in the composition.

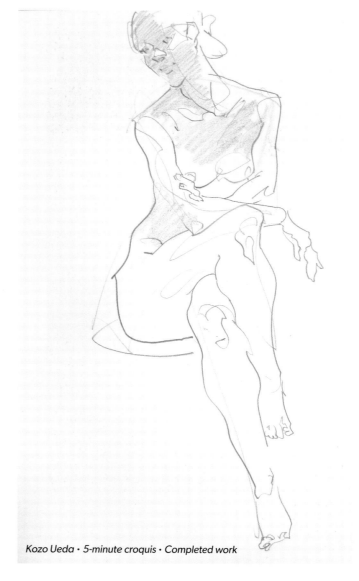

Kozo Ueda · 5-minute croquis · Completed work

How to Draw a Clothed Figure (1) *Drawing a Camisole Dress*

From this point onward, we will focus on 10-minute, 5-minute, 2-minute and 1-minute poses.

1 Vary the lines to reflect the texture and characteristics of the clothing.

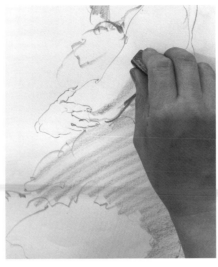

2 Add tone with diagonal lines to the light skirt. Draw a strong line to define the arm and differentiate the difference between and the human body and the outfit.

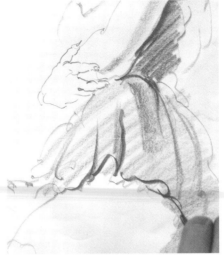

3 Define the shaded part from the upper arm, to the hip, to the hem of the skirt while varying the pencil pressure.

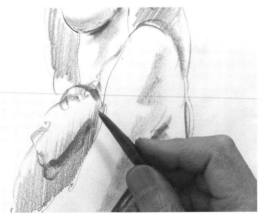

4 The lightness of the arm is emphasized by darkening the clothing on the lower bust.

5 Draw the anatomical line of the bust and the pattern on the dress to emphasize the roundness of the torso.

6 Pay attention to the differences between the lines used to define the body and the lines used for the outfit.

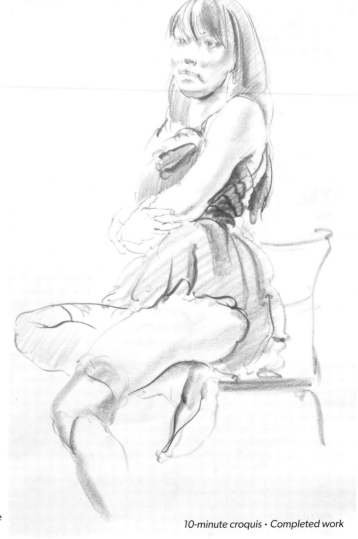

10-minute croquis · Completed work

Minoru Hirota's Croquis Example 2

1 Draw the hem of the skirt with a strong line to represent the shadow created along the leg as well as its three-dimensionality.

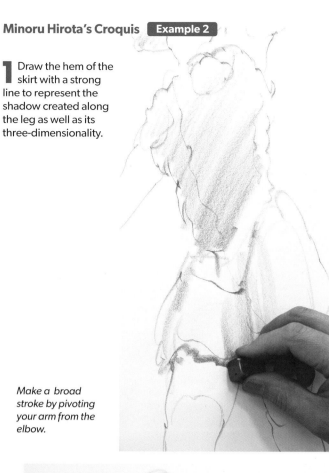

Make a broad stroke by pivoting your arm from the elbow.

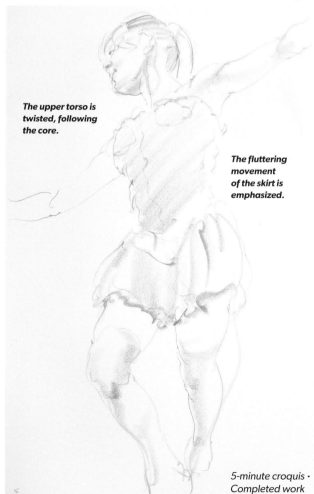

The upper torso is twisted, following the core.

The fluttering movement of the skirt is emphasized.

5-minute croquis · Completed work

2 Use broad strokes that define movement to express the difference between the clothing on the upper and lower body.

Minoru Hirota's Croquis Example 3

1 Define the ruffled line from the bust area to the stomach area by capturing the center line in the front of the outfit.

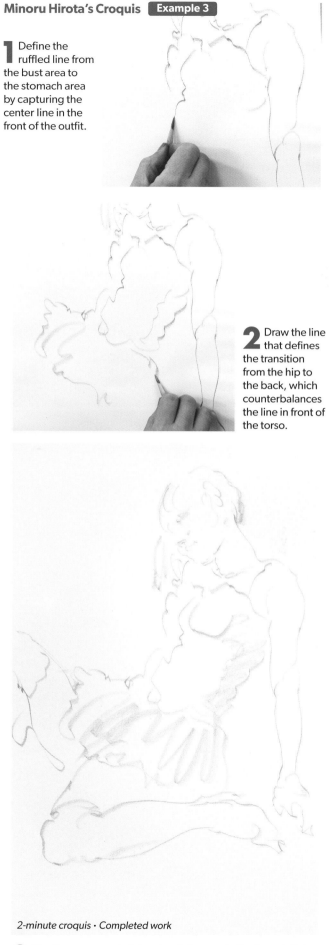

2 Draw the line that defines the transition from the hip to the back, which counterbalances the line in front of the torso.

2-minute croquis · Completed work

3 Use the movement-determined changes in the lines defining the clothing as a guide in your drawing.

1 Select a prominent shape, and put down guide lines that make it possible to visualize the final result.

2 Start by drawing the tensed part of the body where the arms are pulled to the back and the bust is arched, which define this pose.

3 Capture the front-and-back rhythm of the arched position of the body.

4 The position of the legs is defined by the curves of the black garters on the thighs.

5 Make strokes that take the underside of the bust into account.

6 The whole composition has been defined with lines at this point (5 minutes into the drawing.)

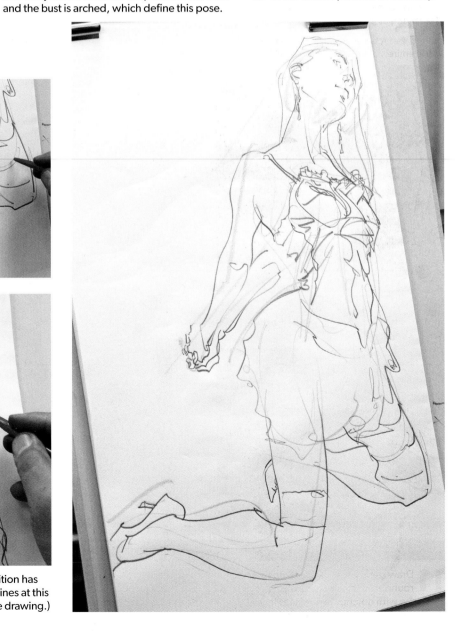

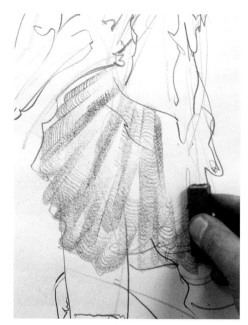

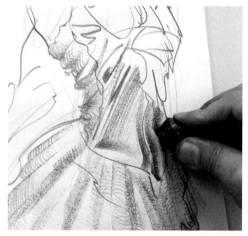

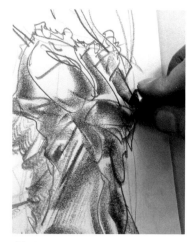

8 Use the same method to depict the tension of the fabric.

9 Emphasize the contrast between light and dark areas to depict the reflectivity of the fabric.

7 Use a Grafcube* with several grooves carved into it with a utility knife, to express the texture and volume of the skirt.

*Grafcube: A block-shaped drawing implement made entirely of graphite. See page 50.

10 Use the narrow edge of the Grafcube to draw the black garters on the thighs in single strokes.

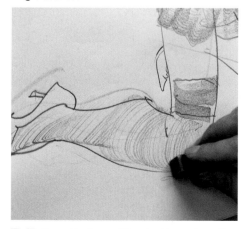

11 Draw the lines of the stockings along the rounded contour of the legs. If you use a Grafcube with notches carved into it, you can easily draw evenly spaced curved lines.

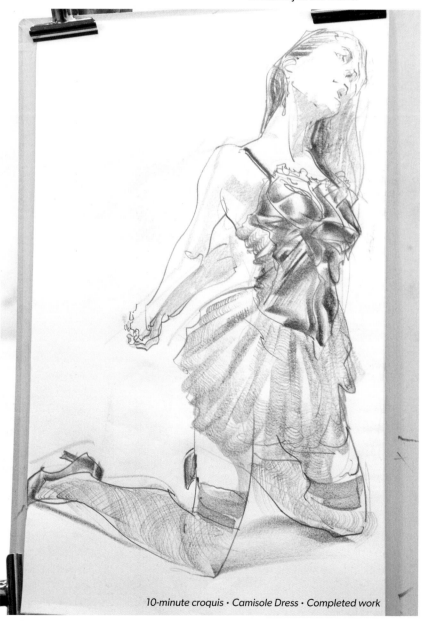

10-minute croquis · Camisole Dress · Completed work

12 By not drawing the space between the left arm and the back, the space behind the back is indicated. I think the Grafcube is well suited to drawing the heavy, high contrast texture of vinyl leather.

Drawing the Texture of Clothing Quickly

Grafcube (see page 50)

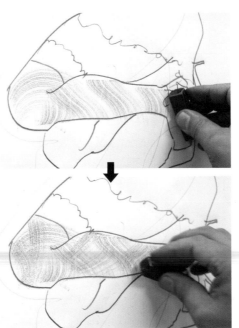

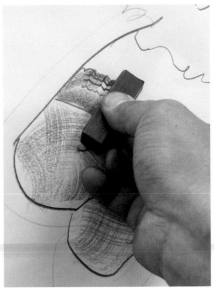

Depict the lace on the garter part of the stockings as a jagged line.

Fishnet stockings: Criss-cross a Grafcube with grooves cut into it along the curves of the legs to depict fishnet stockings.

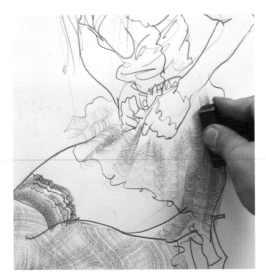

The lace skirt: Draw the light lace skirt using wavy lines.

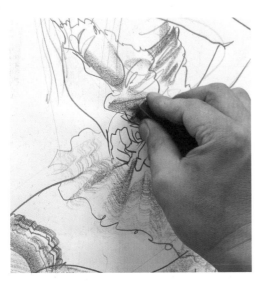

Camisole: To depict the texture of the bodice, increase the contrast between the shaded and unshaded areas.

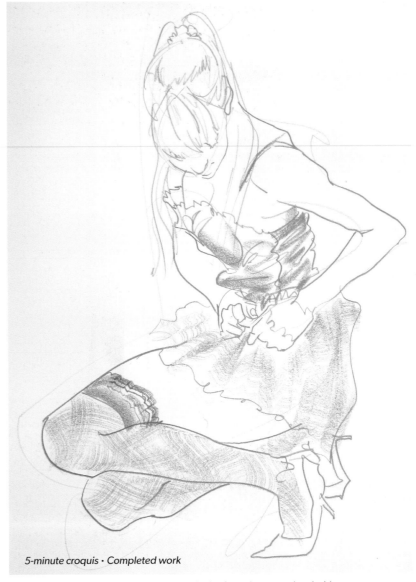

5-minute croquis · Completed work

By not adding significant texture to the hair, the focus is put on the clothing.

1 Capture the snug garment with a continuous spiral.

2 Depict the different orientations of the bust, hips and the arch of the back with curves.

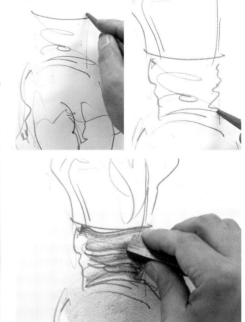

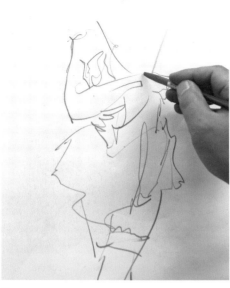

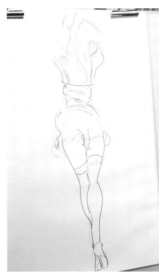

1 For this pose where the elbows are bent, I start by drawing the distinctive shapes, so at this point the head is not depicted. The skirt is simply expressed by drawing the diagonal wrinkles, to emphasize the shape and the left leg that's in front.

3 The lines have been completed at this stage.

4 Add black to the clothing above the waist to emphasize the buttocks. Put in strong, thick sideways lines.

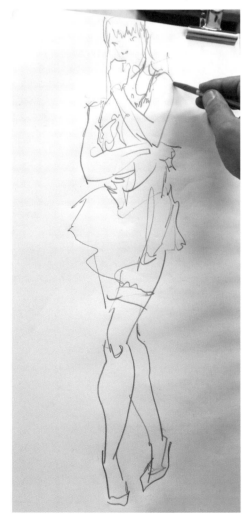

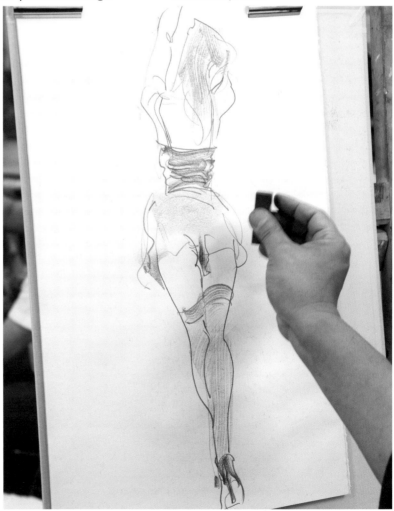

2 A standing pose defined by the zigzag positions of the left and right elbows.

5 Finish by balancing the dark and light parts.

2-minute croquis · Work in progress

Takahiro Okada's Croquis Example 1

One can say that croquis work is the result of a collaboration between the artist and the model. The artist perceives the pose the model has instinctively chosen to take and expresses it on paper. You'll enjoy the process of depicting the model's facial expression and attitude, which changes depending upon the garments selected for the session.

1 Depict the texture of the costume at the same time that you draw the outlines. The right side of the torso has a taut line, while the left side depicts delicate wrinkles.

2 Capture the flow, wrinkles and shadows of the skirt on the right leg in the foreground, and the left leg in the background. Differentiate the leather-like texture of the bodice with the softness of the skirt.

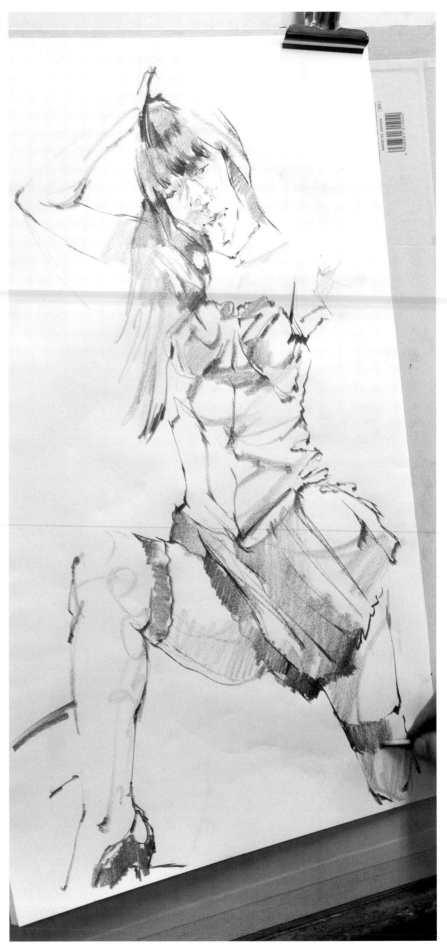

3 Express the different textures of the body, hair and clothing with lines and tones.

10-minute croquis · Work in progress

1 The flow of the side profile and hair, the shoulder straps on the back that lead to the front of the torso and the wrinkles of the clothing are depicted with dark and light lines.

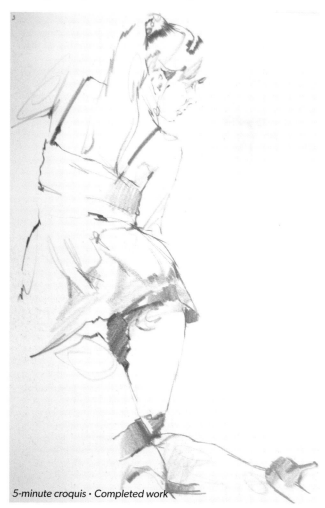

5-minute croquis · Completed work

2 The twist and volume of the body are expressed by adding shade to the underarm area.

1 The bend of the body is expressed by differentiating the line used to draw the arched bust and the line that defines the inward-curved back.

2-minute croquis · Work in progress

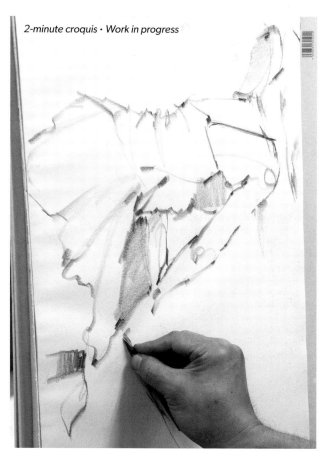

2 In this sketch, details have been simplified as much as possible to put the focus on the curve of the torso.

How to Draw a Clothed Figure (2) *Drawing a Flouncy Dress*

Minoru Hirota's Croquis [Example 1]

Two dresses with different characteristics were made ready for this croquis session. In contrast to the camisole dress on the previous pages with a fitted torso that emphasizes the lines of the body, the white dress on this and the following pages is simply tied at the waist, with the rest of the garment flowing softly around the body, giving the impression that it's wrapped around air. With rounded sleeves and a layered collar, it's a dress with elegance.

1 Lay the pencil nearly flat against the paper, and draw soft, textured lines.

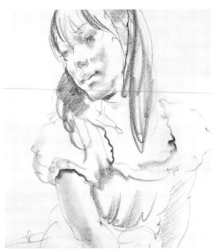

2 Depict the different textures and characteristics of the hair, skin and clothes using a tortillon and pencil.

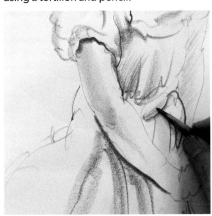

3 By adding soft tones to the dress, the various textures are expressed.

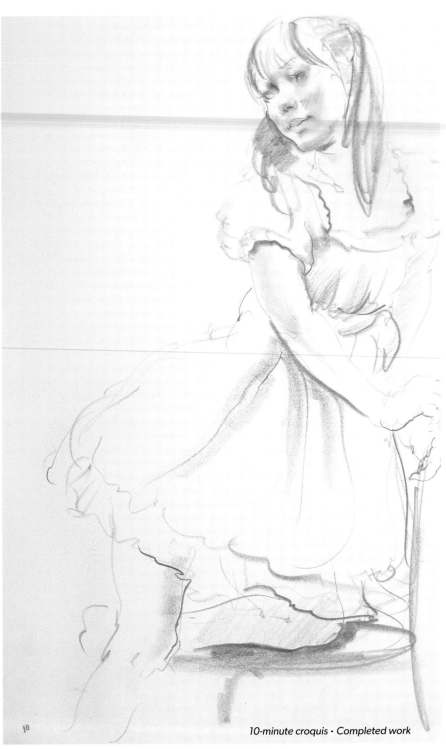

10-minute croquis · Completed work

4 There are many wrinkles and folds all over the dress. If you start by drawing the parts of the clothing that sit close to the body, it becomes easier to capture the relationship between the dress and the model's body.

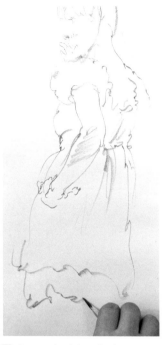
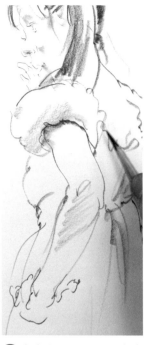

1 By emphasizing the hem, you can better depict the three-dimensionality of the dress.

2 Soft shadows are added to bring out the volume of the sleeve.

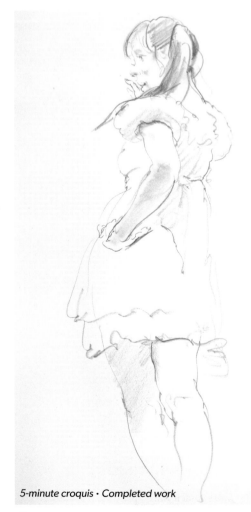

5-minute croquis · Completed work

3 Drawing the taut form of the arm and the jutting elbow emphasizes the light texture of the dress.

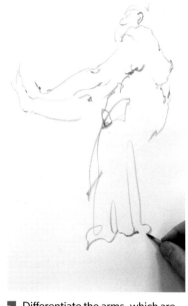

2 Depict the texture of the dress with a light touch.

1 Differentiate the arms, which are held out horizontally, with the folds of the fabric, which are draped.

3 Draw the dress gathered around the back to bring out the volume of the hips.

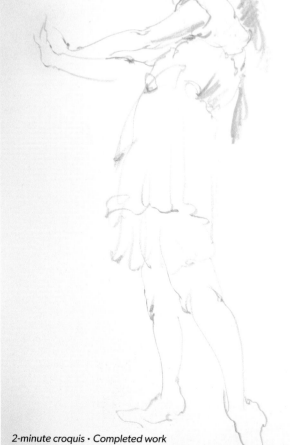

2-minute croquis · Completed work

4 Depict the lightness of the dress by capturing its overall rhythm, rather than trying to draw every wrinkle and fold.

Kozo Ueda's Croquis [Example 1]

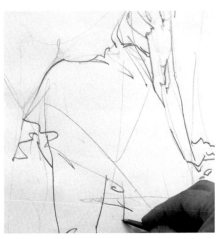
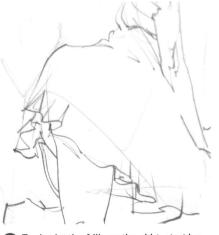
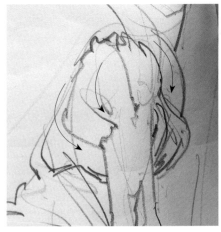

1 Start by drawing the protruding hip, which is the defining feature of this pose, and then proceed to the frill on the dress.

2 To depict the frills on the skirt, start by drawing the line of the hem first, and then add vertical lines.

3 Express the volume of the sleeve with rounded wrinkle lines.

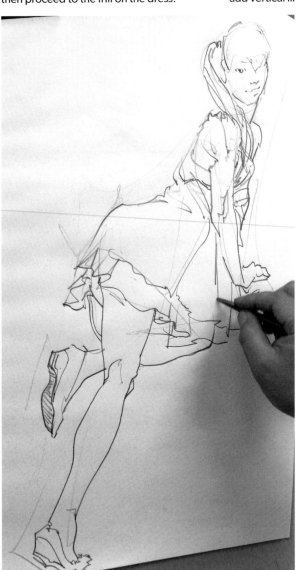
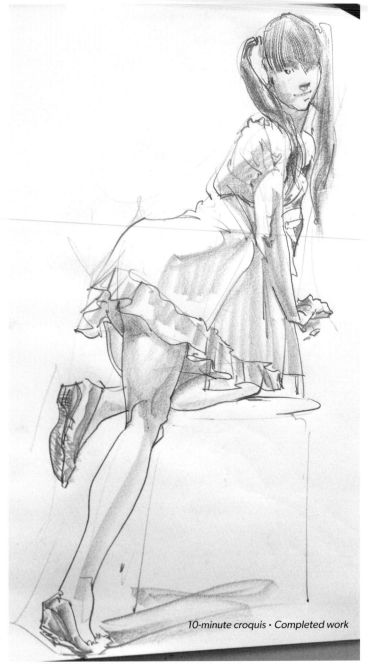

4 Draw the falling folds of the fabric with rapidly executed lines.

5 Depict the hair, which is also hanging straight down like the skirt, with rhythmical lines. Emphasize the shadow revealed along the anatomical lines of the body to emphasize the body's volume.

10-minute croquis · Completed work

Kozo Ueda's Croquis
Example 2

1 By emphasizing the gather lines that are around the anatomical lines of the dress, you can depict its texture at the same time.

2 To contrast the fine lines defining the volume of the bodice, draw the side-seam of the skirt with a rapid straight line.

3 The curved lines of the hem are key to showing the three-dimensionality of the skirt!

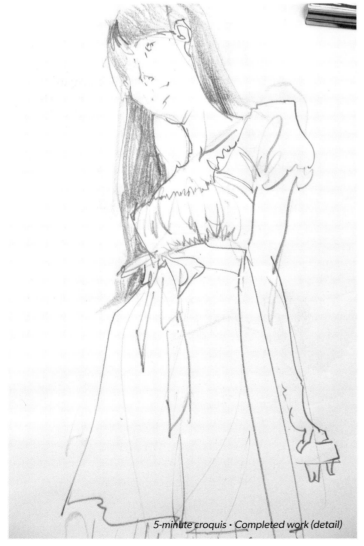

5-minute croquis · Completed work (detail)

4 The brightness of the dress is brought out by darkening the hair.

Kozo Ueda's Croquis **Example 3**

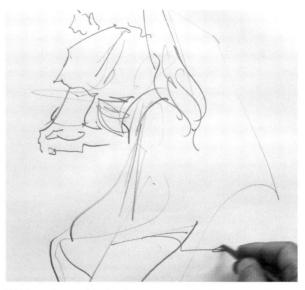

1 The volume of the body is expressed by the curves of the wrinkles on the shoulder, the ribbon under the bust, and the curve of the hem of the skirt.

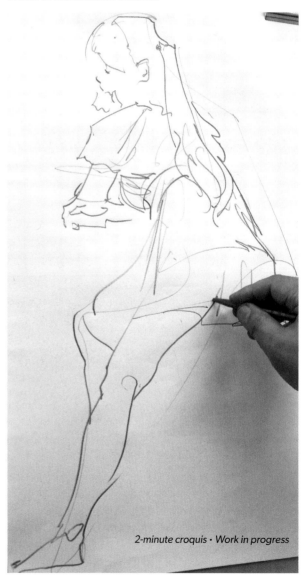

2-minute croquis · Work in progress

2 Observe how the flow of the wrinkles of the dress, the fingers and the backs of the knees are simplified. See page 114 for the completed sketch.

Takahiro Okada's Croquis Example 1

One of the most important elements of croquis drawing is the rhythm of alternating bold and subtle details. By rhythm on the work surface, I mean the contrast between light and dark, the strength and weakness of the lines (the varying pressure applied to the drawing implement), the speed at which you draw the lines, and the contrast between "emphasis" and "simplification." As one way of strengthening the impression of the subject I am drawing, I pay special attention to the contrasts between what I choose to emphasize versus what I choose to simplify.

1 The arrangement of the paired shoulders and breasts help to indicate the vantage point and posture of the model.

2 Indicate the angle of the body by drawing the ribbon around the waist.

3 Capture the shape of the gap between the torso and the arm, while drawing the line of the inner part of the arm.

4 The shape of the belt changes based on the folds of the fabric, which are close to the anatomical line between the side and front planes of the body.

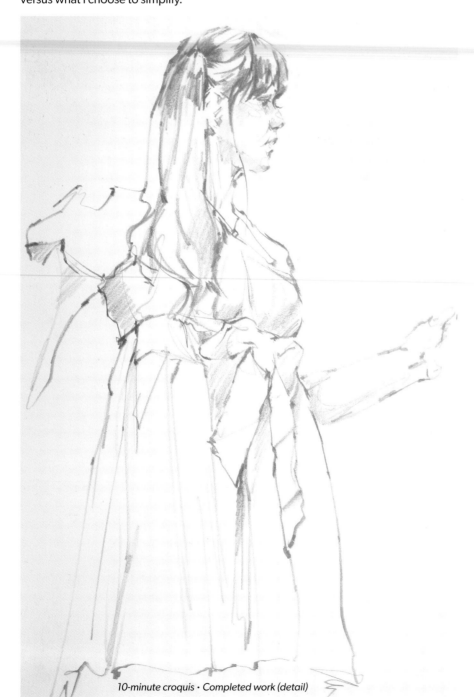

10-minute croquis · Completed work (detail)

5 I have built up my composition around the most striking part of the subject, the shape of the ribbon.

1 The relationship between the overlapping lines expresses the three-dimensional space that's being depicted.

2 The contrasting dark and light lines provide context to the illusion of three-dimensional space.

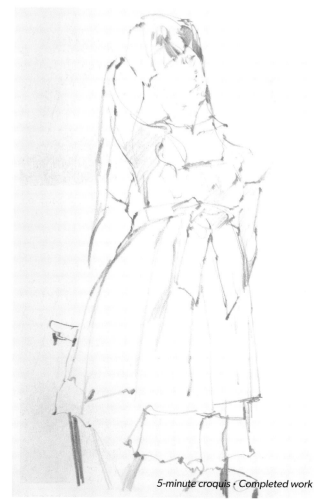

5-minute croquis · Completed work

3 This is the finished sketch exhibiting light and dark lines, and a minimal amount of detail.

1 Capture the changes in the shape of the back of the sleeve, which follows the movement of the arm, with thick and thin lines.

2 See step 3 to understand why the outline along the hip has been broken.

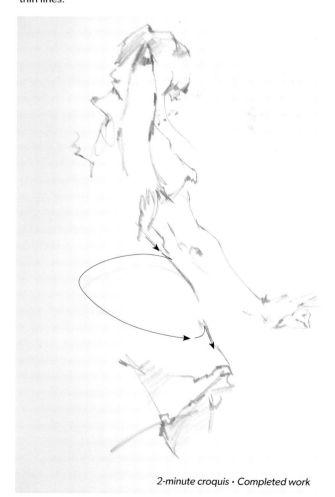

2-minute croquis · Completed work

3 By drawing the outline of just one side of the profile, I've emphasized the bow shape of the pose. The outline of the hips starts at the anatomical line of the buttocks before returning to the outer shape.

The Human Body is Captured by Its Axis and Structure

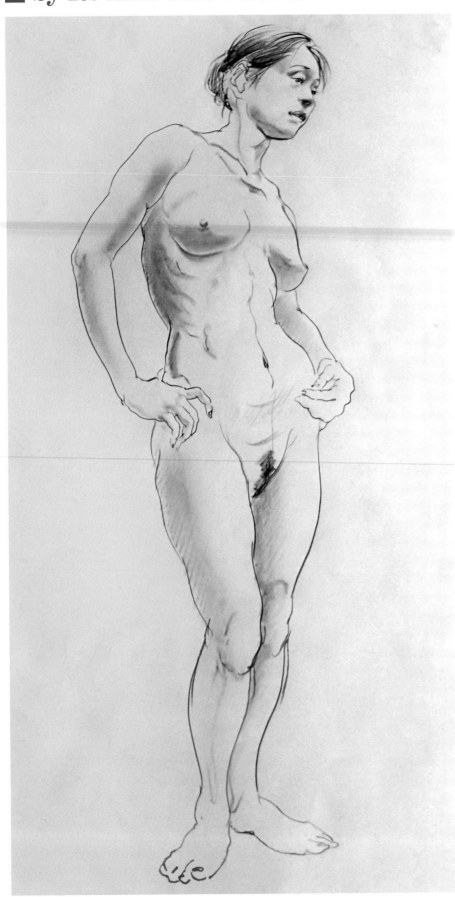

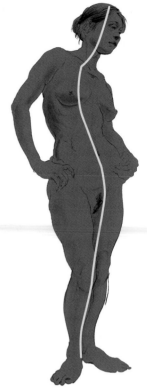

The sketch on the left has been converted to a silhouette above, and the major weight shifts of the body have been expressed with the vertical axis line. This is called the "movement" of the body.

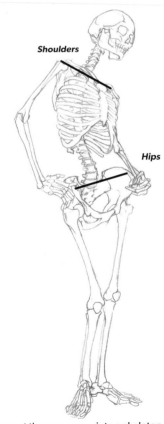

Shoulders

Hips

Convert the same pose into a skeleton, and confirm the sideways angles of the shoulders and hips.

Minoru Hirota · Nude · 20-minute croquis

First, Capture the Overall Bone Structure, the Way the Weight is Supported, and the Twist of the Body

At first glance, a standing model may seem still. However, if you capture the movement of the body, you will understand that the pose is maintained by supporting the weight of the head to the hips with the legs. Let's start by understanding that movement.

In this pose, the weight is on the left leg, therefore the left hip is tilted up. You can then see that the right shoulder is tilted up in order to counterbalance the left hip.

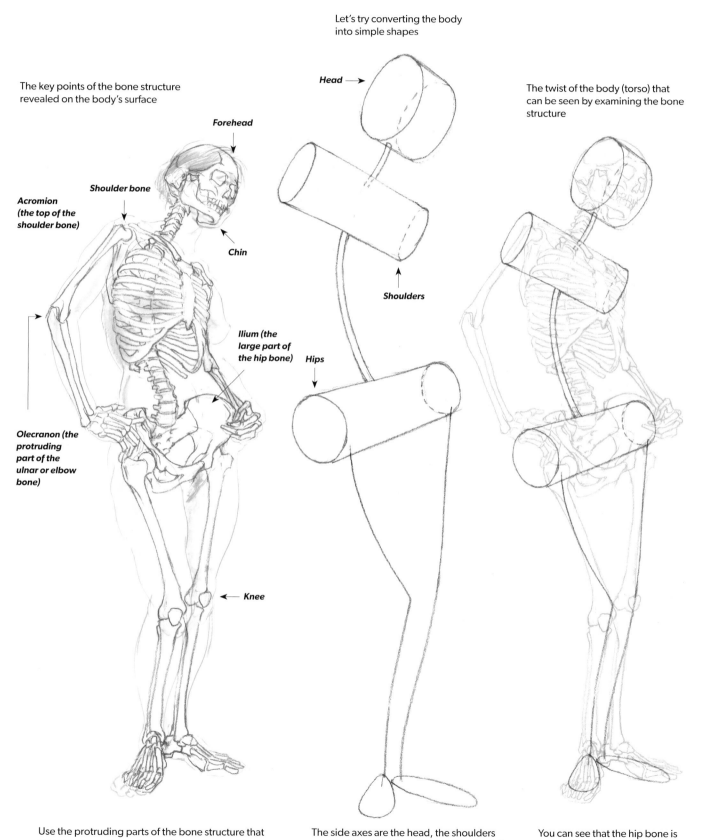

Let's try converting the body into simple shapes

The key points of the bone structure revealed on the body's surface

The twist of the body (torso) that can be seen by examining the bone structure

Forehead

Shoulder bone

Acromion (the top of the shoulder bone)

Chin

Head →

Shoulders

Ilium (the large part of the hip bone)

Hips

Olecranon (the protruding part of the ulnar or elbow bone)

Knee

Use the protruding parts of the bone structure that you can see on the surface of the body as guide points, and confirm their positions.

The side axes are the head, the shoulders and the hips. The tilt and twist of the body is easy to see in this way.

You can see that the hip bone is protruding a bit to the front.

Next, Apply the Small Boxes and the Large Box

Let's try converting the 3 main portions of the human body into discrete rectangular 3-D forms. If you think of the head, chest and hips as box shapes, it becomes easier to get a grip on the way they're facing and their mass. The "big box" is the one surrounding the space that encloses the human form.

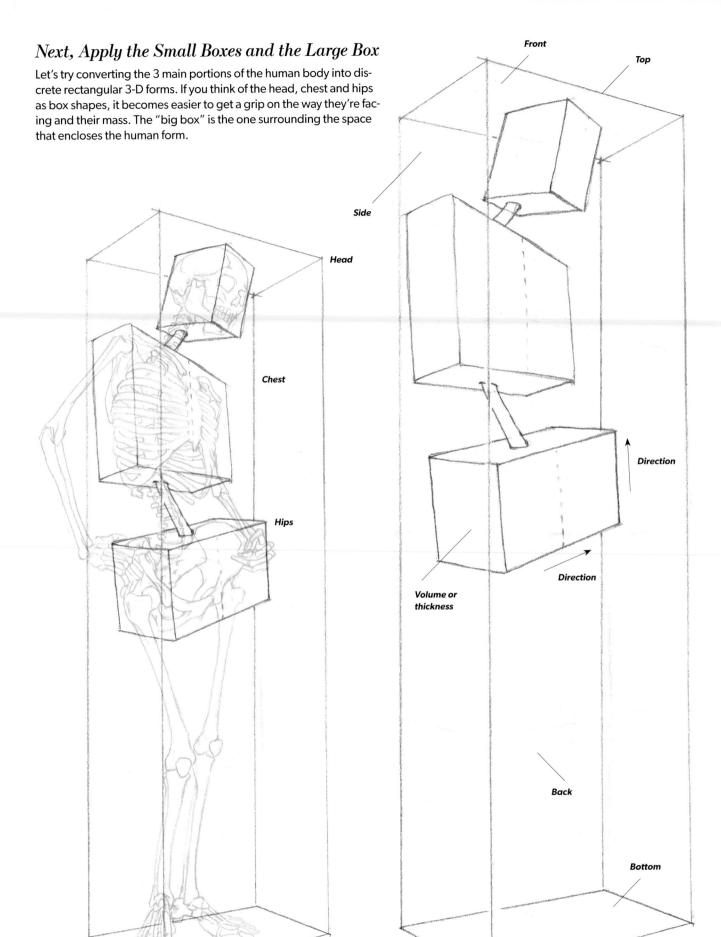

Envision the head, chest and hips as boxes. Overlay the boxes with the bone structure to explore the relationship between the inclination and volume of each part.

The "big box" is the boundary for each of the "small boxes."

Anatomical lines (edges)

Anatomical lines (edges)

Anatomical lines (edges)

Visualize the simple edges or anatomical lines when the body is converted to boxes.

Visualize the Boxes to Find the Anatomical Lines of the Body

The edges of the boxes are the lines between its planes. Here we have added the anatomical line between the front and side planes of the human body. By being aware of these anatomical lines, you can get a better grasp of the three-dimensionality of the human body.

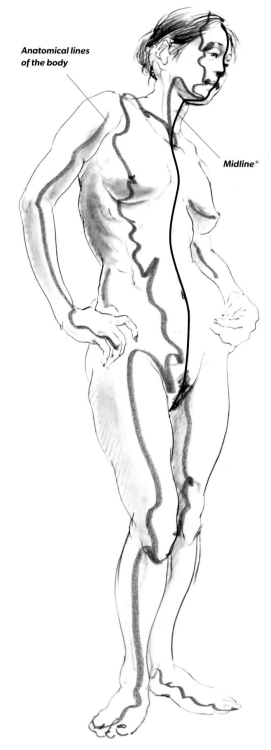

Anatomical lines of the body

Midline*

You can see that the actual anatomical lines of the body are curved and changeable rather than straight. Here, the line is between the front of the body where the light hits, and the side of the body, which is in shadow.

*Midline: The line that divides the planes of the human body into equal left and right halves. It circles the body from the front of the head and torso to the middle of the back in a straight line.

In the Same Way, the Back View Is Also Defined by Its Axis and Structure

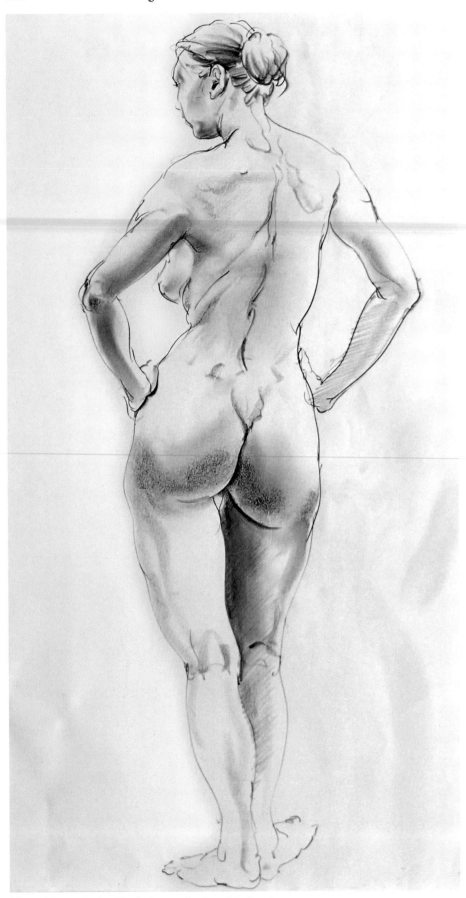

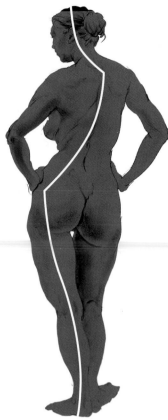

The sketch to the left has been converted to the silhouette above, and the major weight shifts of the body have been expressed with the vertical axis line. This is called the "movement" of the body.

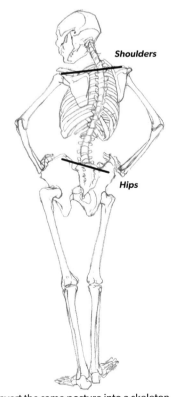

Shoulders

Hips

Convert the same posture into a skeleton, and confirm the sideways angles of the shoulders and hips.

Minoru Hirota · Nude · 20-minute croquis · Completed work

As with the Three-quarter Pose, Start by Understanding the Overall Bone Structure, the Way the Body Weight is Supported, and the Twist of the Body

Substitute the head, shoulders and hips with cylinders, to grasp which way each part is facing. In this example the left hip, which is the side supporting the weight of the body, is protruding to the front. The left side of the shoulder section is facing a little behind the hips, so you can gauge that the shoulder and hip placements are twisted.

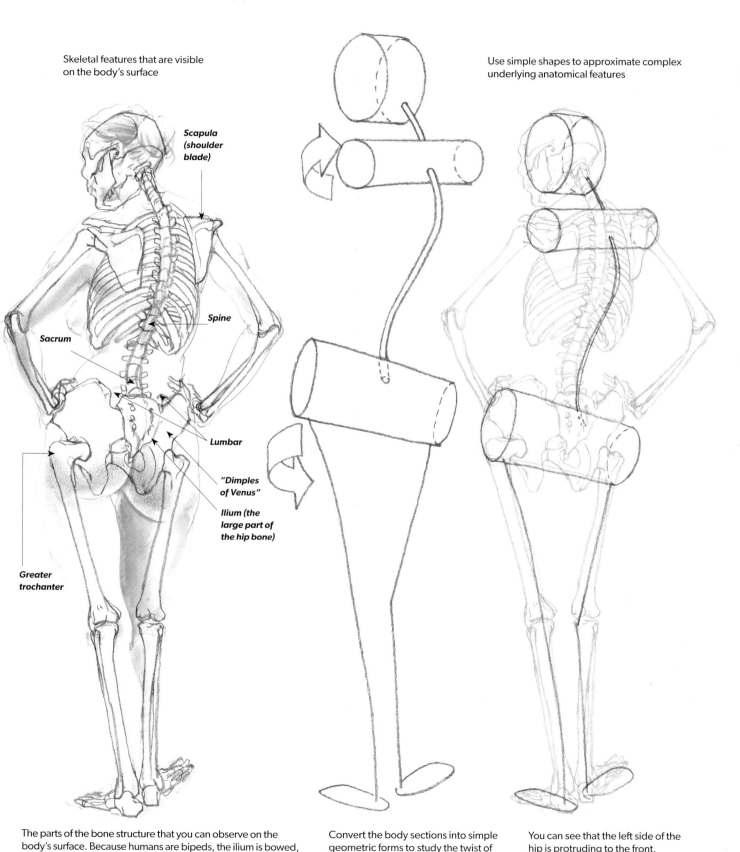

Skeletal features that are visible on the body's surface

Use simple shapes to approximate complex underlying anatomical features

Scapula (shoulder blade)

Spine

Sacrum

Lumbar

"Dimples of Venus"

Ilium (the large part of the hip bone)

Greater trochanter

The parts of the bone structure that you can observe on the body's surface. Because humans are bipeds, the ilium is bowed, and indentations (called Dimples of Venus) form on the sacrum. These characteristics are unique to the human body.

Convert the body sections into simple geometric forms to study the twist of the shoulders and hips.

You can see that the left side of the hip is protruding to the front.

The Pose Seen from the Back Is Also Visualized as Small Boxes in a Large Box

With a back view, the way the "small boxes" of the head, chest and hips are connected to each other can be understood by observing the flow of the spine.

As with the frontal view, visualize the head, chest and hips as box shapes. Juxtapose the boxes on the bone structure to explore the relationship between the orientation and thickness of the parts.

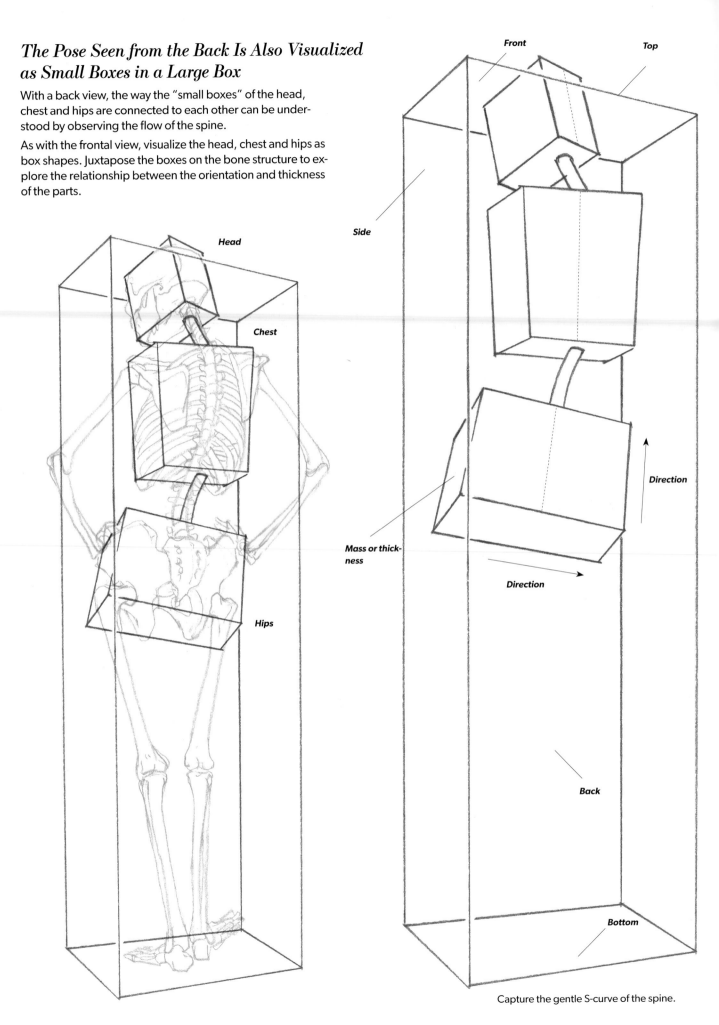

Head

Chest

Hips

Front

Top

Side

Direction

Direction

Mass or thickness

Back

Bottom

Capture the gentle S-curve of the spine.

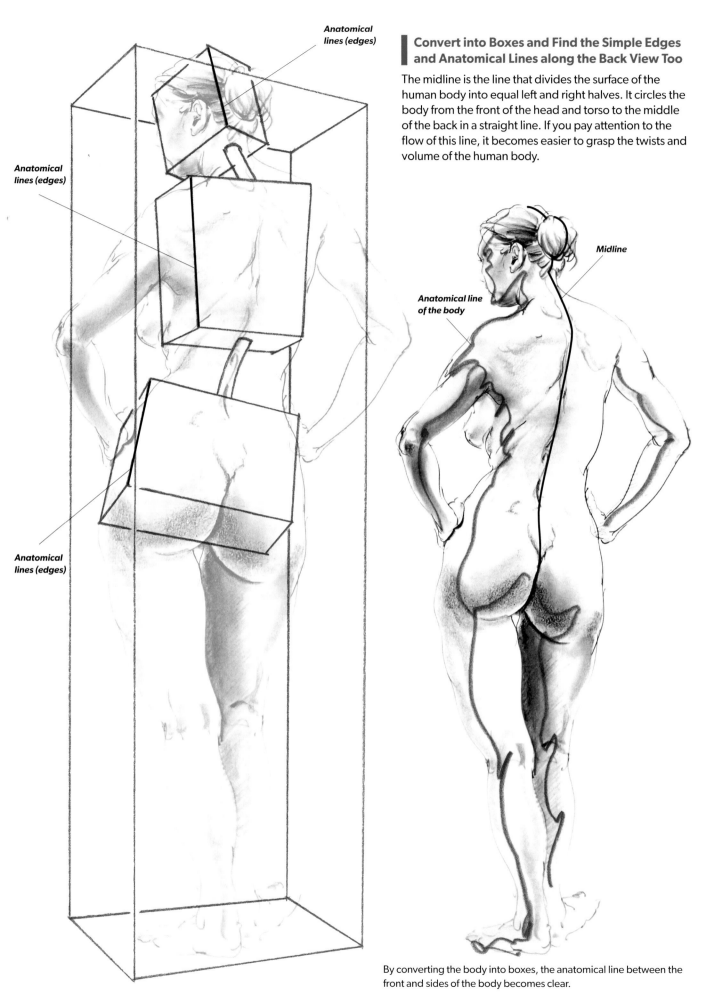

Anatomical lines (edges)

Anatomical lines (edges)

Anatomical lines (edges)

Convert into Boxes and Find the Simple Edges and Anatomical Lines along the Back View Too

The midline is the line that divides the surface of the human body into equal left and right halves. It circles the body from the front of the head and torso to the middle of the back in a straight line. If you pay attention to the flow of this line, it becomes easier to grasp the twists and volume of the human body.

Midline

Anatomical line of the body

By converting the body into boxes, the anatomical line between the front and sides of the body becomes clear.

49

Drawing Tools Used by the Artists

▎Minoru Hirota's Drawing Tools ···

Soft type

Hard type

Tortillons: Pencil shaped drawing tools made of tightly wound paper or similar material. Used by rubbing on drawing surfaces to create tonal variations in shadows. There are hard and soft versions.

Grafwood pencils: Drawing pencils from Caran d'Ache. The drawing feel is very smooth, and it's possible to make beautiful lights and darks with these. From the 15 different hardnesses available, I have selected the 6B, 7B and 8B pencils.

Grafstone

6B

7B

8B

Grafcubes: These have been well used and have gotten rather stubby.

▎Kozo Ueda's Drawing Tools ···

Grafcube graphite sticks: A drawing tool from Caran d'Ache made of graphite and formed into a rectangular stick. You can use it to cover a large area using a flat side, or make fine lines using a corner. It's a very convenient drawing implement.

Grafstone: A pencil made entirely of graphite, also from Caran d'Ache. If you carefully sharpen it to form a long point, you can use it on its side to cover a lot of surface.

6B

15mm

If you carve several grooves into a Graf-cube with a knife, you can draw several lines at once.

Kneaded eraser: The more you knead this type of eraser, the tackier it gets. It also becomes more malleable and easier to shape as you like.

▎Takahiro Okada's Drawing Tools ···

Plastic erasers that have been cut into small pieces with sharp edges. Used to make pinpoint corrections and make thin white lines (to depict highlights in the hair, for example).

Kneaded eraser

Grafwood pencils, Grafstone and Grafcube are all products of Ca-ran d'Ache, a Swiss manufacturer.

Grafstone: 6B is just the right softness for my needs, so I use it the most. There are no rules as to how long the pencil point should be, but when I am drawing fine details I use a long, tapered tip.

Thirteen Key Points for Representing Figures

2

*Eight key points for capturing the human figure +
Five key points for drawing the parts of the body*

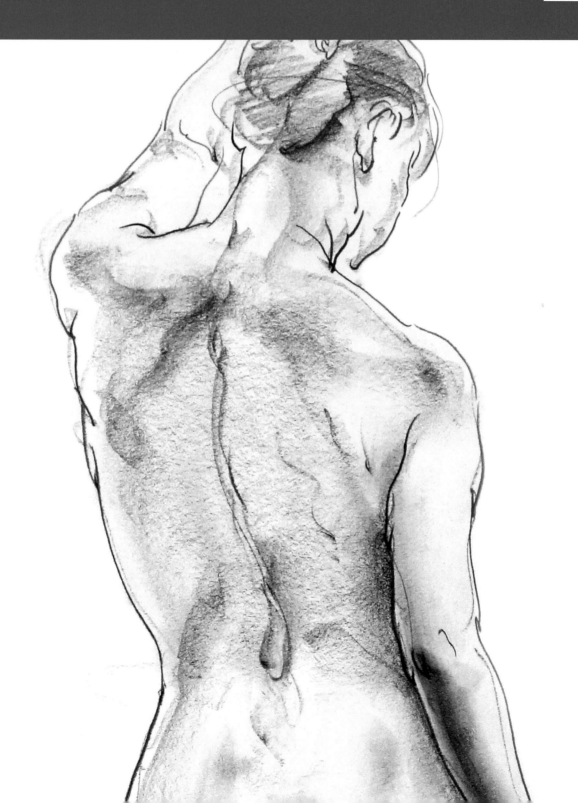

Eight Key Points for Capturing the Human Figure

To review, the "Three Points to Be Aware of Before You Start to Draw" detailed in Chapter 1 are the height of the artist's line of sight, the direction of the light, and the structure of the body. In this chapter, let's go into a little more details, and look at some specific ways of depicting the figure.

1) Represent the Figure Based on Its Axes

Front View

When you view the figure from the front, the vertical axis is the front center line. Use the lines connecting the corresponding left and right parts of the body as a guide for finding the horizontal axes.

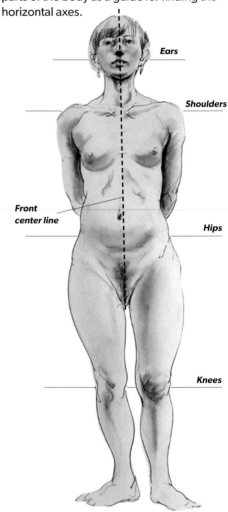

Ears

Shoulders

Front center line

Hips

Knees

If you connect the paired parts on the left and right with lines, those lines will be approximately horizontal. The front midline is approximately vertical.

A pose where the weight is evenly distributed on both legs

When viewing the figure from the front, the angles of the horizontal axes are important references to note. This applies to three-quarter views too.

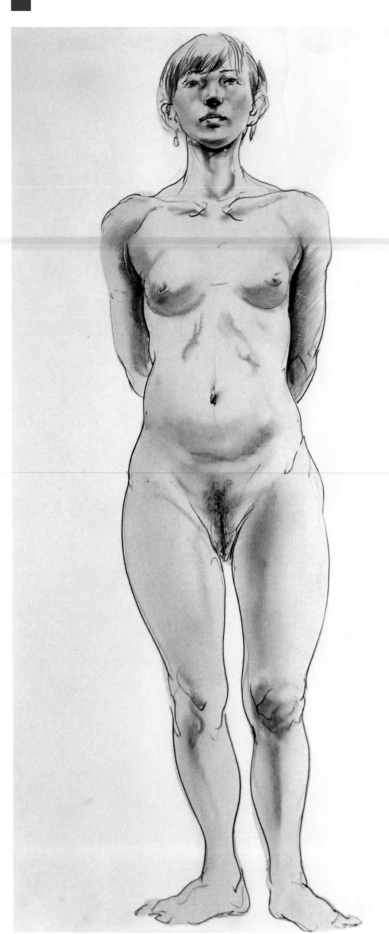

Minoru Hirota · Nude · 20-minute croquis

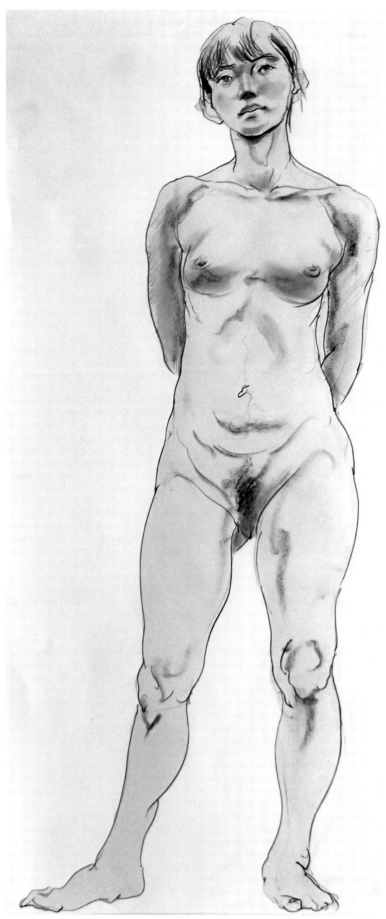

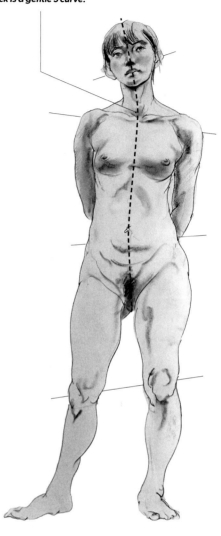

The front midline that runs through the head, neck, the front of the torso and connects to the back is a gentle S curve.

The horizontal axes running through the knees and hips are angled upward toward the left, which is the side of the weight-bearing leg in this instance. To balance this, the left shoulder is lower than the right shoulder.

A pose with weight on the model's left leg

Minoru Hirota · Nude · 20-minute croquis

Side View

Capture the form of the vertical axis. Understand the balanced weight distribution of the body, and aim to draw a croquis that feels kinetic.

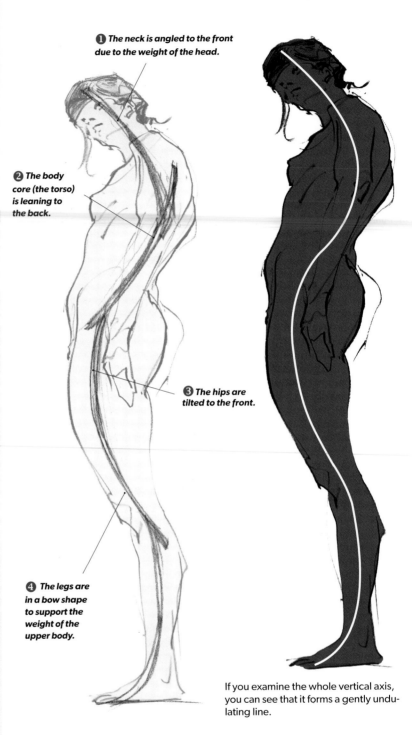

❶ The neck is angled to the front due to the weight of the head.

❷ The body core (the torso) is leaning to the back.

❸ The hips are tilted to the front.

❹ The legs are in a bow shape to support the weight of the upper body.

If you examine the whole vertical axis, you can see that it forms a gently undulating line.

A pose with the weight evenly distributed on both legs

Kozo Ueda · Nude · 5-minute croquis

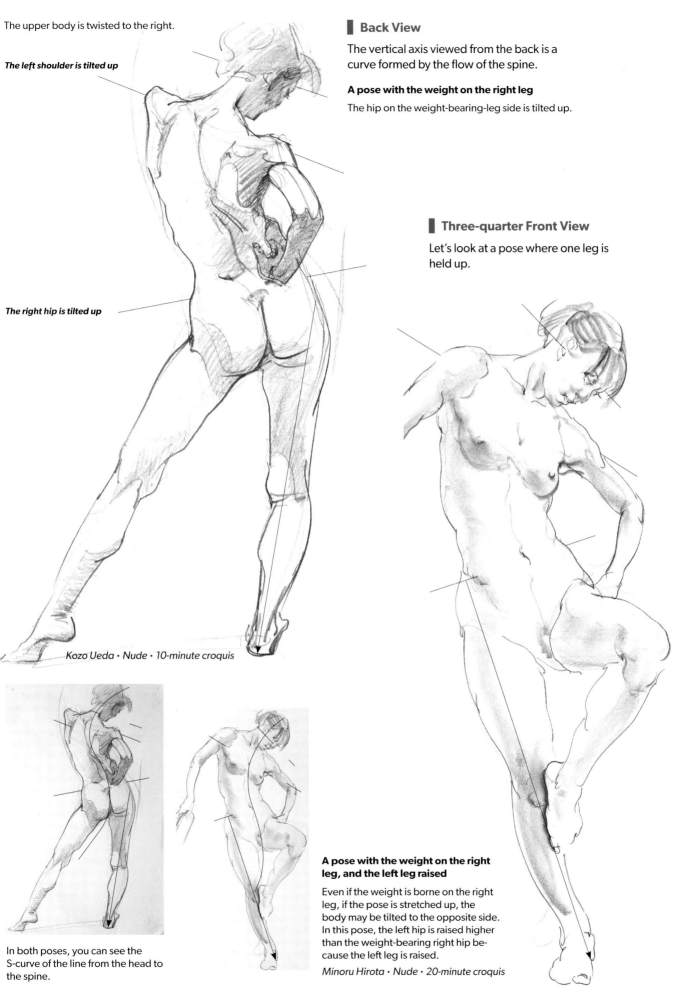

The upper body is twisted to the right.

The left shoulder is tilted up

The right hip is tilted up

Kozo Ueda · Nude · 10-minute croquis

In both poses, you can see the S-curve of the line from the head to the spine.

Back View

The vertical axis viewed from the back is a curve formed by the flow of the spine.

A pose with the weight on the right leg

The hip on the weight-bearing-leg side is tilted up.

Three-quarter Front View

Let's look at a pose where one leg is held up.

A pose with the weight on the right leg, and the left leg raised

Even if the weight is borne on the right leg, if the pose is stretched up, the body may be tilted to the opposite side. In this pose, the left hip is raised higher than the weight-bearing right hip because the left leg is raised.

Minoru Hirota · Nude · 20-minute croquis

2) Represent the Large Parts of the Figure as Blocks

When observing the human figure, train yourself to capture the overall form rather than focusing on the fine details right away.

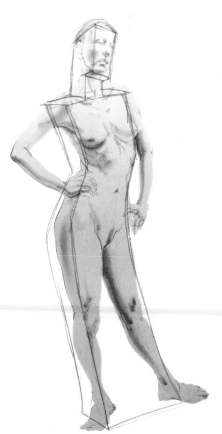

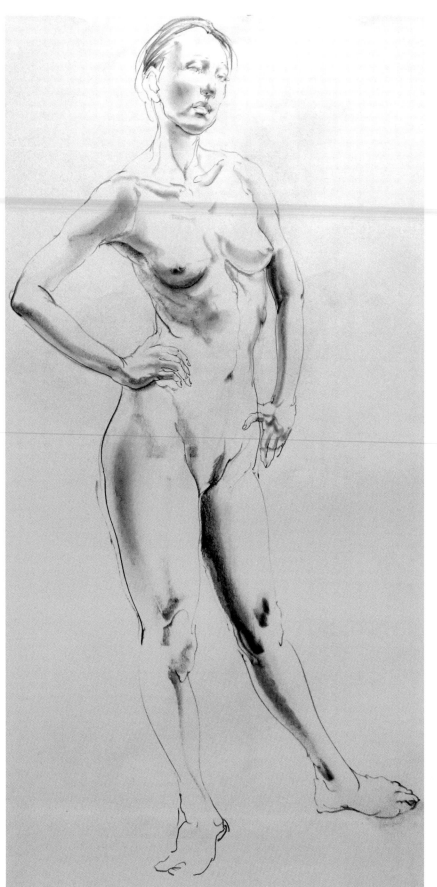

Visualize a roughly defined sculpture, and try capturing the figure as a block; don't get distracted with the details.

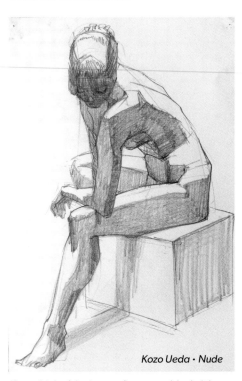

Kozo Ueda · Nude

If you think of the human figure as a block, it becomes easier to understand the different directions it faces depending on the pose. Here all the details have been abbreviated, and the figure has been captured as a block, and the front and side surfaces are differentiated.

A pose with the weight on the right leg

Minoru Hirota · Nude · 20-minute croquis

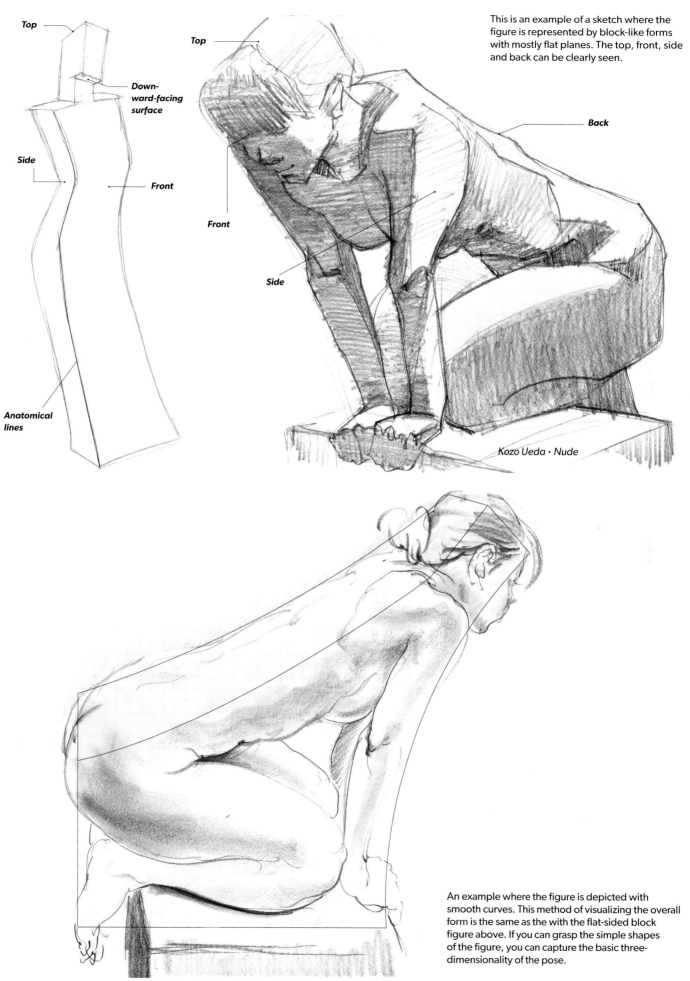

Top

Down-
ward-facing
surface

Side

Front

Anatomical
lines

This is an example of a sketch where the
figure is represented by block-like forms
with mostly flat planes. The top, front, side
and back can be clearly seen.

Top

Back

Front

Side

Kozo Ueda · Nude

An example where the figure is depicted with
smooth curves. This method of visualizing the overall
form is the same as the with the flat-sided block
figure above. If you can grasp the simple shapes
of the figure, you can capture the basic three-
dimensionality of the pose.

Minoru Hirota · Nude · 10-minute croquis

3) Represent the Figure with Light and Dark Tones
Part 1—Five Tonal Variations

In a croquis drawing, volume is expressed through tones. Tones are the light to dark grays created by layering or smudging pencil lines or graphite block marks. Use how the light hits the figure as a guide as you think in terms of high and low brightness. The brightness of an object refers to the degree of lightness it has.

The Basic Set of Three Tonal Values

High brightness (light)　　Medium brightness (middle)　　Low brightness (dark)

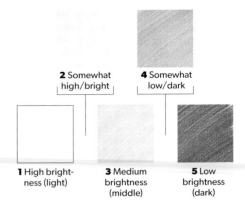

2 Somewhat high/bright　　**4** Somewhat low/dark

1 High brightness (light)　　**3** Medium brightness (middle)　　**5** Low brightness (dark)

Start with the white of the paper, a medium gray, and a dark gray. When you are executing a croquis in a short time period, it's effective to use the white of the paper for the bright planes of the figure, and add the shadows with medium and dark grays. By adding somewhat-bright tones and somewhat-dark tones, you have five tonal values.

Expand to Five Tonal Values

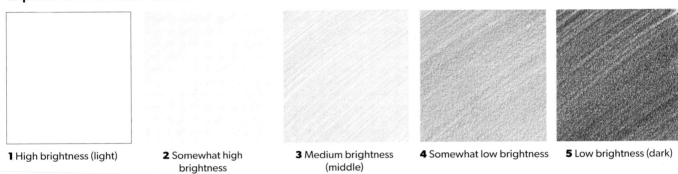

1 High brightness (light)　　**2** Somewhat high brightness　　**3** Medium brightness (middle)　　**4** Somewhat low brightness　　**5** Low brightness (dark)

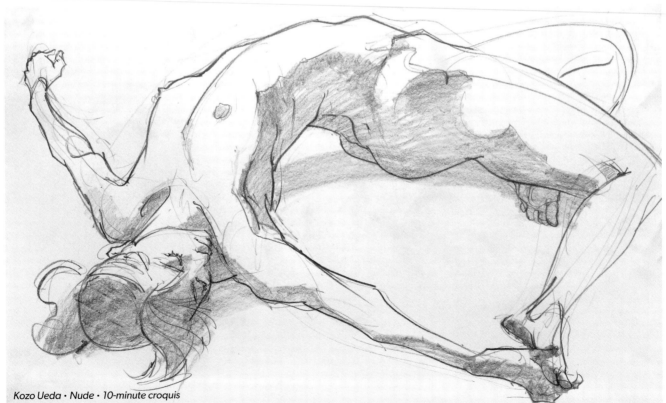

Kozo Ueda · Nude · 10-minute croquis

A sketch executed with three tonal values. Use the white of the paper for the upward-facing parts of the figure, the medium brightness tone for the sides, and add the dark tone for the hair and the deeply shadowed parts to bring out the figure's three-dimensionality.

Using the Direction of the Light Makes it Easier to Express Three-dimensionality

The sides of an object that are facing the light source are brighter, with the sides becoming darker in stages as their direction changes.

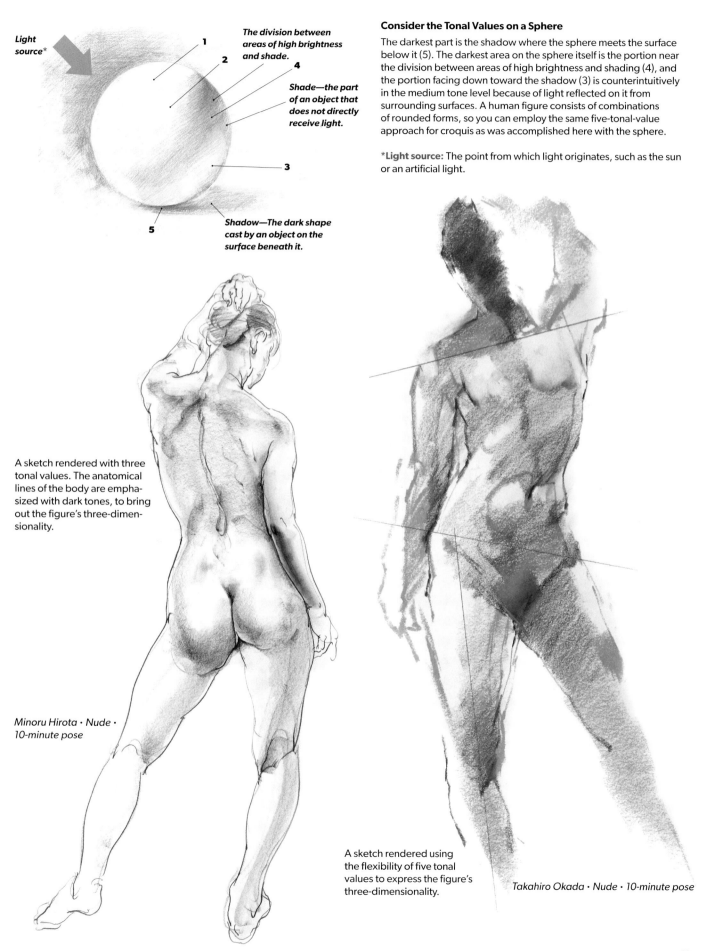

Light source*

The division between areas of high brightness and shade.

1

2

4

Shade—the part of an object that does not directly receive light.

3

5

Shadow—The dark shape cast by an object on the surface beneath it.

Consider the Tonal Values on a Sphere

The darkest part is the shadow where the sphere meets the surface below it (5). The darkest area on the sphere itself is the portion near the division between areas of high brightness and shading (4), and the portion facing down toward the shadow (3) is counterintuitively in the medium tone level because of light reflected on it from surrounding surfaces. A human figure consists of combinations of rounded forms, so you can employ the same five-tonal-value approach for croquis as was accomplished here with the sphere.

*Light source: The point from which light originates, such as the sun or an artificial light.

A sketch rendered with three tonal values. The anatomical lines of the body are emphasized with dark tones, to bring out the figure's three-dimensionality.

Minoru Hirota · Nude · 10-minute pose

A sketch rendered using the flexibility of five tonal values to express the figure's three-dimensionality.

Takahiro Okada · Nude · 10-minute pose

59

4) Represent the Figure with Light and Dark Tones Part 2—Use the Anatomical Lines

Because the human figure is made up of a series of connected curves, think of it in terms of cylinders and spheres. If you establish the lines between the light and dark planes of the object, it will look three-dimensional—even if you just add some simple shadows.

Light

The anatomical lines here at the edge looks like an oval.

The light is hitting the object almost straight from the side, and a line between planes has appeared in the middle.

Division between portions of the form receiving light directly and indirectly.

On a cylinder, the lines between planes on the sides look like straight, belt-like shapes.

Light

Lines between planes.

On a box (cube), the edges are the lines between planes.

Lines between planes

When the light source swings around toward the front side of the cylinder, the shaded lines between planes moves away from it, toward the back.

On a shape with curved planes like a cylinder or sphere, because the planes are connected in succession, a line is drawn between the light and dark sides, using the direction of the light source as the determining factor. When the light source moves, the line on the object moves too.

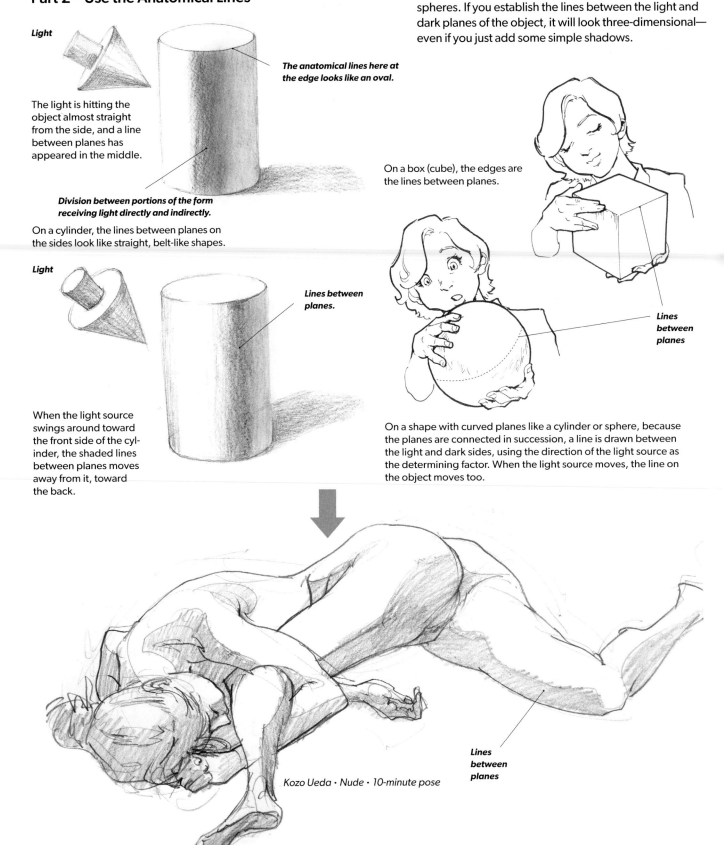

Lines between planes

Kozo Ueda · Nude · 10-minute pose

An Example of a Line Between Planes that Divides the Side and Front Faces of the Figure

The side of the figure facing up is bright because the light source is hitting it, and the anatomical line is revealed between that light side and the shaded side. The lines between light and dark planes clearly show the changing shapes of the arms and legs, which are close to being cylindrical.

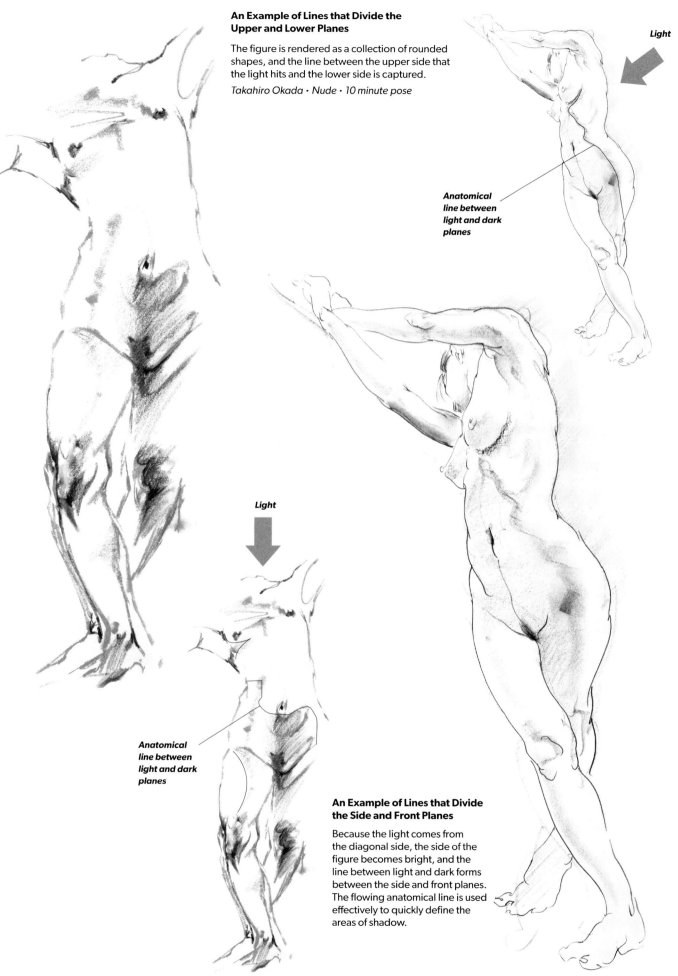

An Example of Lines that Divide the Upper and Lower Planes

The figure is rendered as a collection of rounded shapes, and the line between the upper side that the light hits and the lower side is captured.

Takahiro Okada · Nude · 10 minute pose

Light

Anatomical line between light and dark planes

Light

Anatomical line between light and dark planes

An Example of Lines that Divide the Side and Front Planes

Because the light comes from the diagonal side, the side of the figure becomes bright, and the line between light and dark forms between the side and front planes. The flowing anatomical line is used effectively to quickly define the areas of shadow.

Minoru Hirota · Nude · 10-minute pose

5) Represent the Figure with Light and Dark Tones Part 3—The Figure as a Multi-sided Object

Although the human figure is made up of a series of connected curves, drawing curved forms can be difficult to master. Although many curved lines are used to draw the figure, when observing the overall form, it's more convenient to think of it as an object with multiple sides. In this manner it becomes easier to grasp the way that the light-to-dark tonal values change depending on which way each side is facing.

If you convert a sphere into an object with flat sides…

It becomes easier to understand the tonal value differences of each side.

Light

Think of the leg as an object with large flat surfaces.

If you keep refining, the flat surfaces become smaller and more detailed.

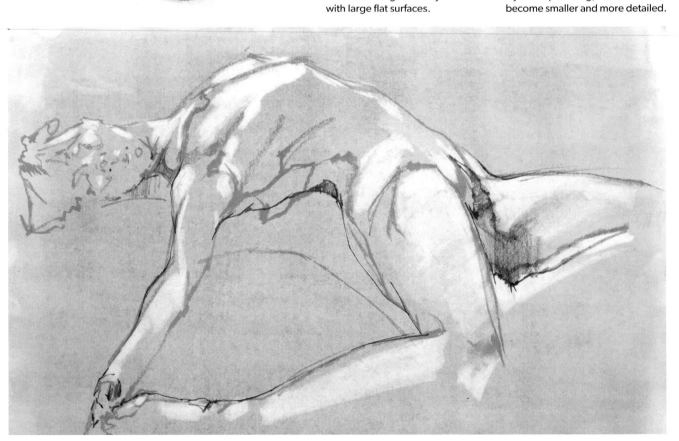

An Example Sketch Where the Medium-tone Sides of the Figure Are Captured

Takahiro Okada · Nude · 10-minute croquis

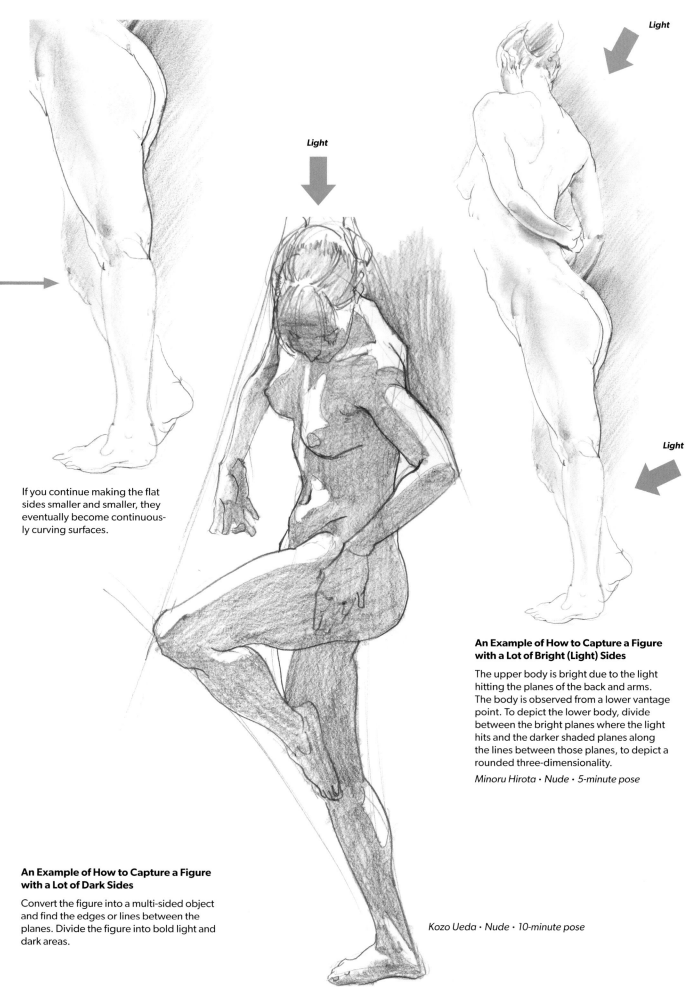

Light

Light

Light

If you continue making the flat sides smaller and smaller, they eventually become continuously curving surfaces.

An Example of How to Capture a Figure with a Lot of Bright (Light) Sides

The upper body is bright due to the light hitting the planes of the back and arms. The body is observed from a lower vantage point. To depict the lower body, divide between the bright planes where the light hits and the darker shaded planes along the lines between those planes, to depict a rounded three-dimensionality.

Minoru Hirota · Nude · 5-minute pose

An Example of How to Capture a Figure with a Lot of Dark Sides

Convert the figure into a multi-sided object and find the edges or lines between the planes. Divide the figure into bold light and dark areas.

Kozo Ueda · Nude · 10-minute pose

6) Represent Movement—Capture the Major Flow of the Gestures of the Figure

With croquis, it's possible to draw tensed poses that are only possible to maintain for short period. One of the goals of the croquis method is to capture the lively movement of a figure. Try to understand the major flow that you perceive from a pose. The arrows in the example sketches show the movement of the pose. "Movement" refers to the large movements of the weight of the body. Capture the flow of weight to depict a shape with movement.

An Example Sketch That Focuses on the Backward Bending Motion of the Upper Body

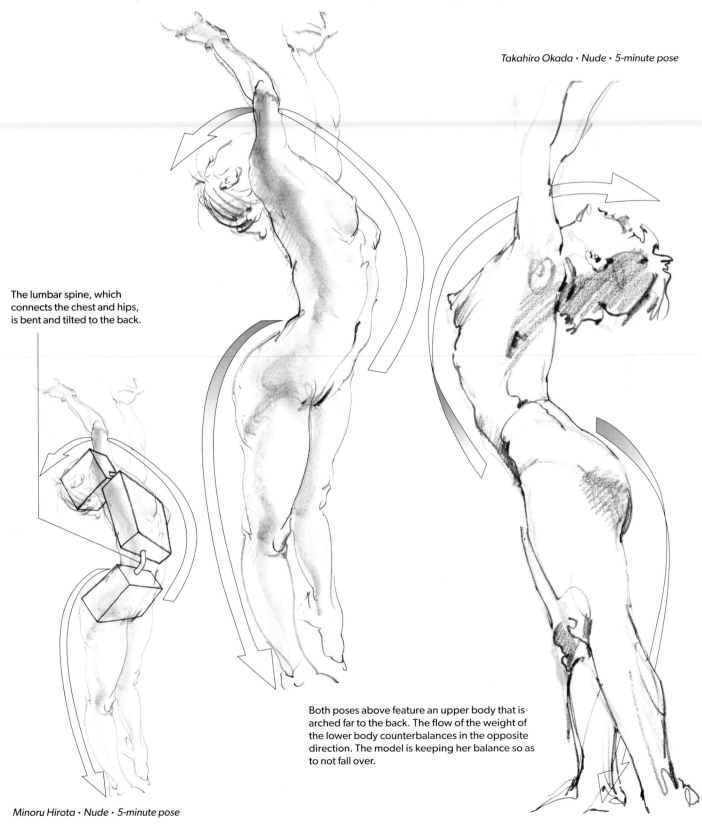

Takahiro Okada · Nude · 5-minute pose

The lumbar spine, which connects the chest and hips, is bent and tilted to the back.

Both poses above feature an upper body that is arched far to the back. The flow of the weight of the lower body counterbalances in the opposite direction. The model is keeping her balance so as to not fall over.

Minoru Hirota · Nude · 5-minute pose

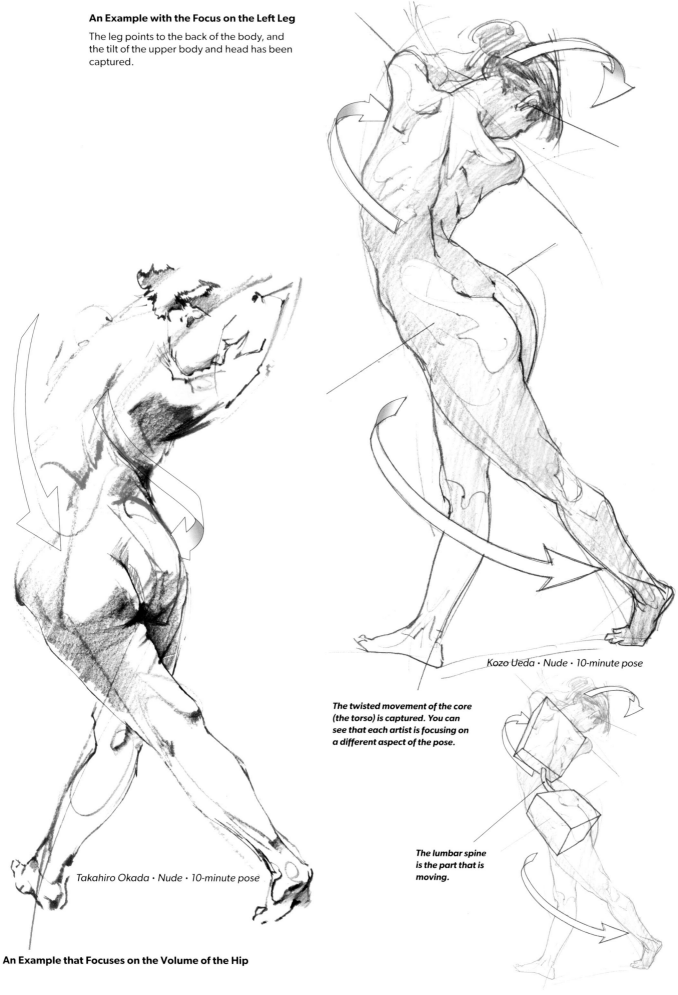

An Example with the Focus on the Left Leg

The leg points to the back of the body, and the tilt of the upper body and head has been captured.

Kozo Ueda · Nude · 10-minute pose

The twisted movement of the core (the torso) is captured. You can see that each artist is focusing on a different aspect of the pose.

The lumbar spine is the part that is moving.

Takahiro Okada · Nude · 10-minute pose

An Example that Focuses on the Volume of the Hip

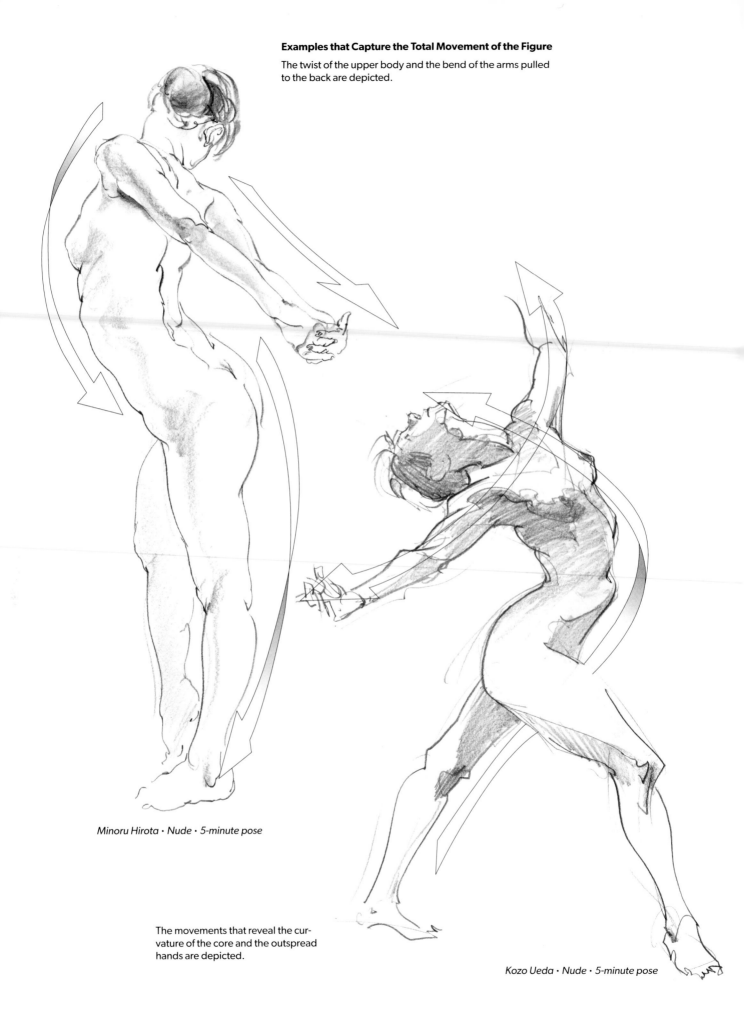

Examples that Capture the Total Movement of the Figure

The twist of the upper body and the bend of the arms pulled to the back are depicted.

Minoru Hirota · Nude · 5-minute pose

The movements that reveal the curvature of the core and the outspread hands are depicted.

Kozo Ueda · Nude · 5-minute pose

7) Represent the Figure Using the Shapes of Its Gaps—Switching Between Negative and Positive

Capturing the gaps that form when a figure takes a pose as shapes is a shortcut to capturing the form in two dimensions.

When drawing, the figure is expressed as being three dimensional, but at the same time, capture it as a beautiful shape by observing the shape of the gaps and using them to your advantage.

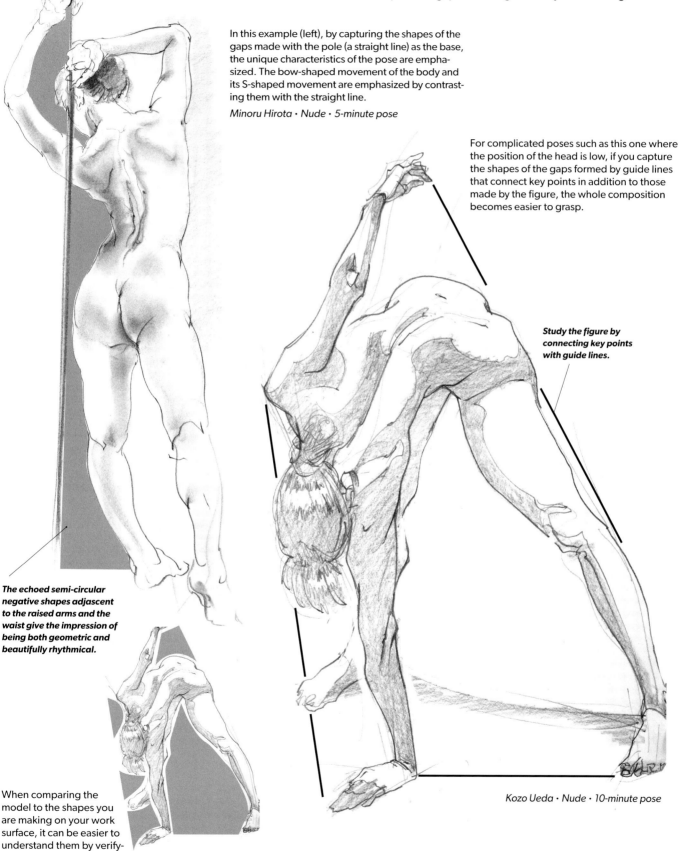

In this example (left), by capturing the shapes of the gaps made with the pole (a straight line) as the base, the unique characteristics of the pose are emphasized. The bow-shaped movement of the body and its S-shaped movement are emphasized by contrasting them with the straight line.

Minoru Hirota · Nude · 5-minute pose

For complicated poses such as this one where the position of the head is low, if you capture the shapes of the gaps formed by guide lines that connect key points in addition to those made by the figure, the whole composition becomes easier to grasp.

Study the figure by connecting key points with guide lines.

The echoed semi-circular negative shapes adjascent to the raised arms and the waist give the impression of being both geometric and beautifully rhythmical.

When comparing the model to the shapes you are making on your work surface, it can be easier to understand them by verifying the shapes of the empty spaces or gaps surrounding the figure.

Kozo Ueda · Nude · 10-minute pose

8) Represent the Figure with Triangles—Place the Figure Well on the Paper

This is an example of a pose that fits within the most basic of geometric shapes, the triangle. The proportions of the triangle reveal the characteristics of the pose. Pay attention to where the lines and the top point of the triangle are placed. This is a very effective way of composing the whole picture.

The top point of the triangle does not always appear within the figure. A triangle forms a composition with stability, but in order to avoid making the sitting pose too small, the left and right sides are clipped, to fill the paper in a satisfying way.

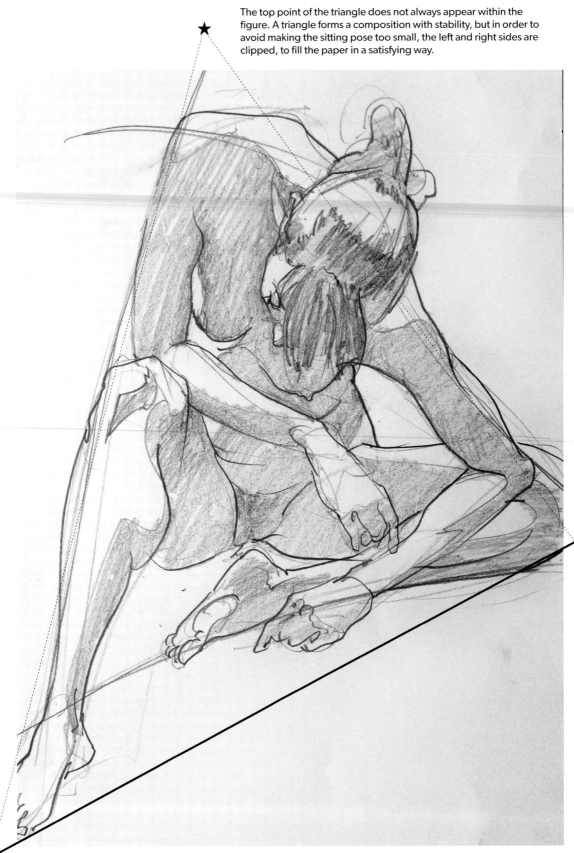

The third side of the triangle, which is the hardest to locate, is shown as a bold line.

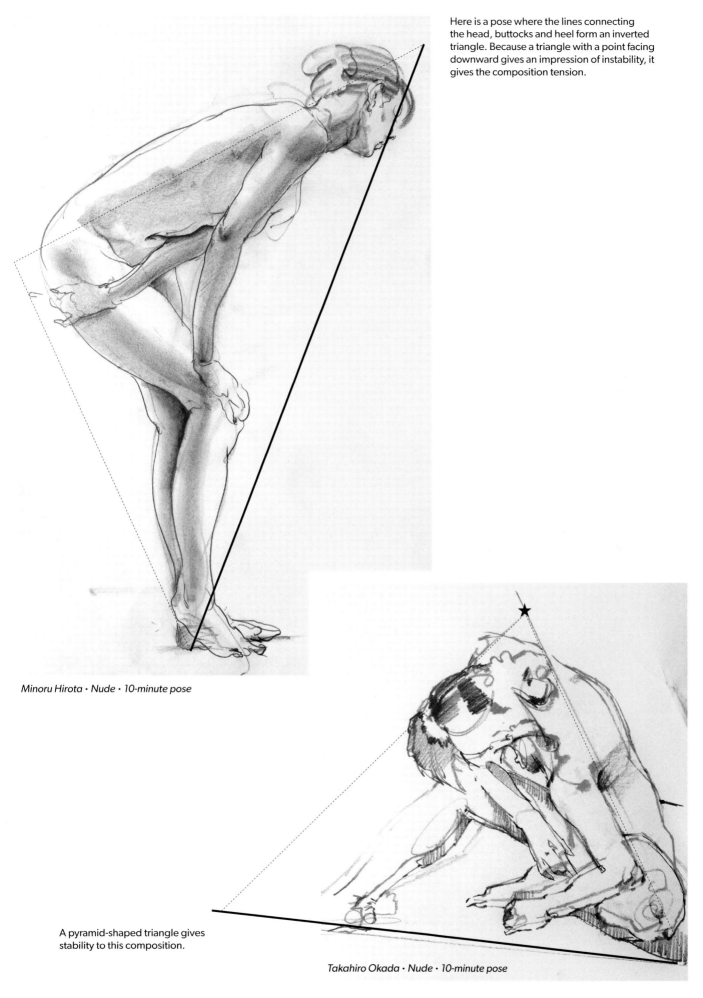

Here is a pose where the lines connecting the head, buttocks and heel form an inverted triangle. Because a triangle with a point facing downward gives an impression of instability, it gives the composition tension.

Minoru Hirota · Nude · 10-minute pose

A pyramid-shaped triangle gives stability to this composition.

Takahiro Okada · Nude · 10-minute pose

Five Key Points for Drawing the Parts of the Body

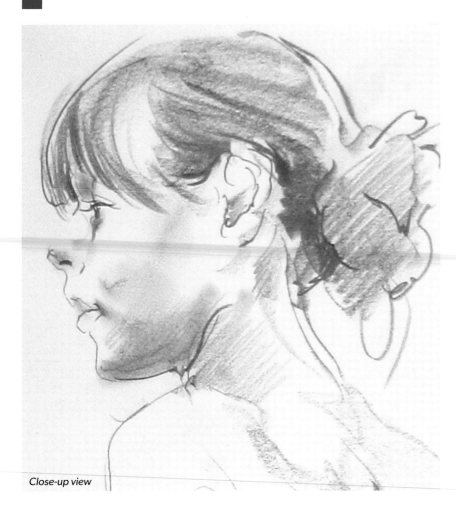

Close-up view

1) Examine the Relationship Between the Chin and Jaw, Neck and Ear

The external auditory meatus (the "ear hole") is located behind the hinge of the jaw. The cervical spine or the neck bone is to the back of the neck, and it connects to the lumbar spine, commonly called the backbone.

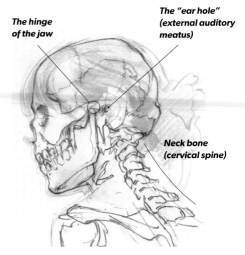

The hinge of the jaw

The "ear hole" (external auditory meatus)

Neck bone (cervical spine)

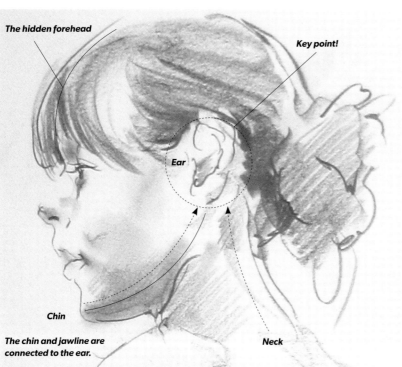

The hidden forehead

Key point!

Ear

Chin

The chin and jawline are connected to the ear.

Neck

By capturing the anatomical line of the underside of the chin, you can express the volume and inclination of the head. And by observing the shapes of the chin and jaw, as well as the forehead which is hidden by hair, you can grasp the shape of the head.

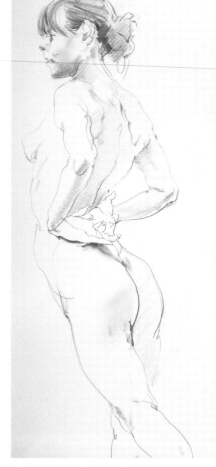

Minoru Hirota · Nude · 10-minute pose
See page 80 for the work process

70

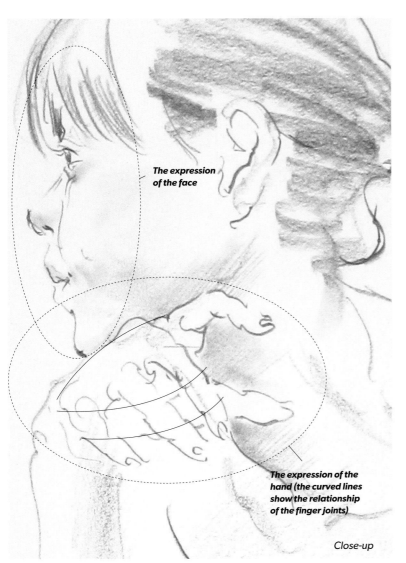

The expression
of the face

The expression of the
hand (the curved lines
show the relationship
of the finger joints)

Close-up

2) Observe the Expressions of the Face and Hands

When drawing the face, if you capture the planes that face downward, you can reveal its three-dimensionality. Look for the downward-facing anatomical features such as the lower eyelid, the underside of the nose, the upper lip and the underside of the chin. In addition, the expression of a face is mainly seen in mouth, so observe it carefully.

The hand becomes three-dimensional when you focus on the alignment of the joints. Capture the thumb separately from the other fingers.

*Minoru Hirota · Camisole Dress · 10-minute croquis
See page 86 for the work process*

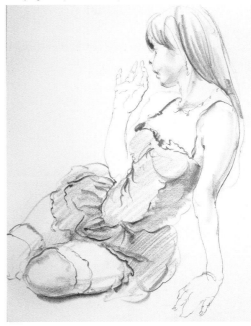

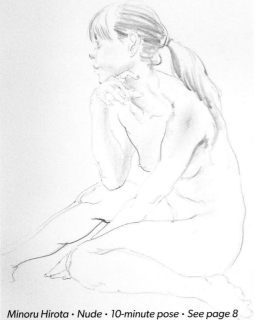

Minoru Hirota · Nude · 10-minute pose · See page 8

The orientation of the fingers become easier to express by drawing the fingernails.

Close-up

When drawing a croquis, you want to avoid taking the pencil off of the surface of the paper as much as possible, as if you're drawing with a single uninterrupted line.

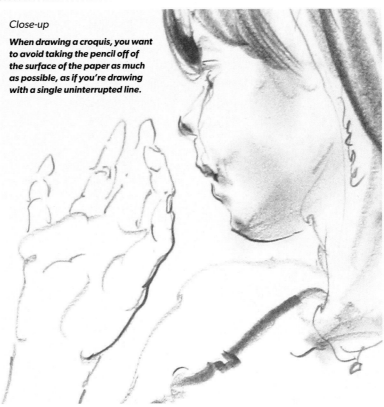

3) See the Relationship Between the Hips and the Supporting Leg

When the model assumes a pose, verify which leg is the weight-bearing one. Because the weight-bearing leg supports the hip, the hip on that side tilts up. To balance the body's weight, the shoulder on the opposite side tilts up.

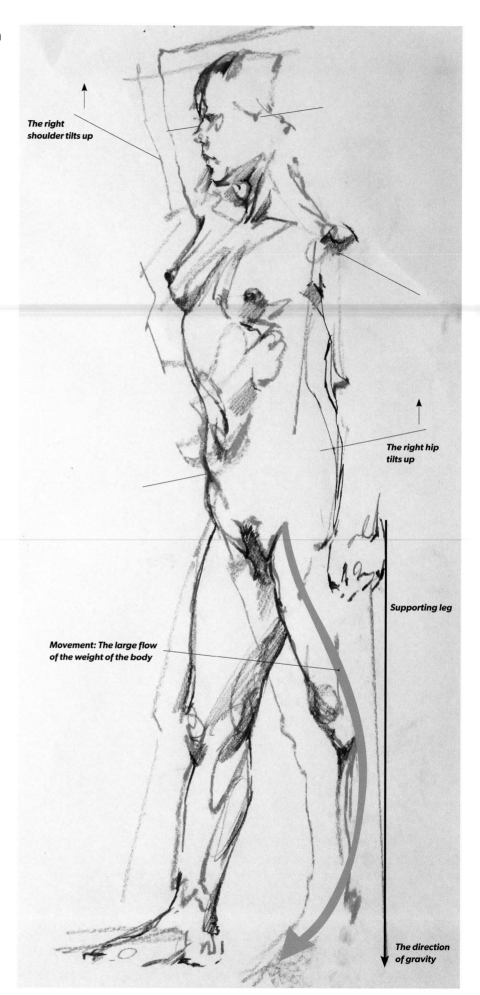

The right shoulder tilts up

The right hip tilts up

Supporting leg

Movement: The large flow of the weight of the body

The direction of gravity

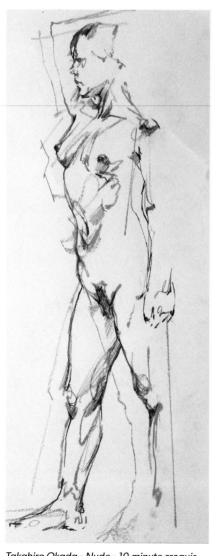

Takahiro Okada · Nude · 10-minute croquis

Biceps

Coracobrachialis
muscle

Triceps

Deltoid

Elongated

Pectoral
muscle

Latissimus

Serratus
anterior
muscle

Oblique
abdominal
muscle

Gluteus maxi-
mus muscle

Rectus
abdominis
muscle

Mid gluteal
muscle

Tensed

Long adduc-
tor muscle

Twisted

Sartorius
muscle

4) See the Shape of the Muscles—The Muscles Stretch, Tense and Twist

Observe the state of the muscles, and practice differentiating the stretched and tensed muscles. Try to express the strength of the muscles by changing the pressure and speed of the pencil. Carefully observe the muscles wrapped around the body that are revealed when a pose is struck to depict them.

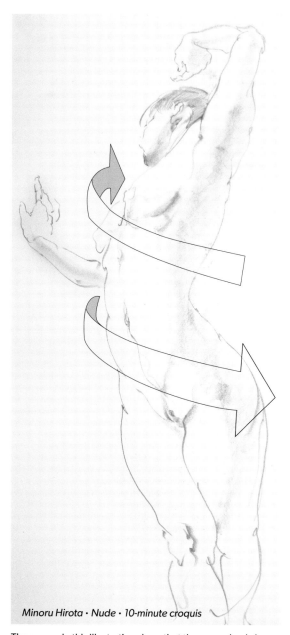

Minoru Hirota · Nude · 10-minute croquis

The arrows in this illustration show that the upper body is twisted backward, and the lower body is twisted forward.

Let's explore the names of the muscles and how they stretch and shrink by examining a croquis drawing. You can see that in this pose, the upper and lower bodies are twisted. It's difficult to remember a lot of muscle names, so it's sufficient to just know about the prominent ones on the surface of the body.

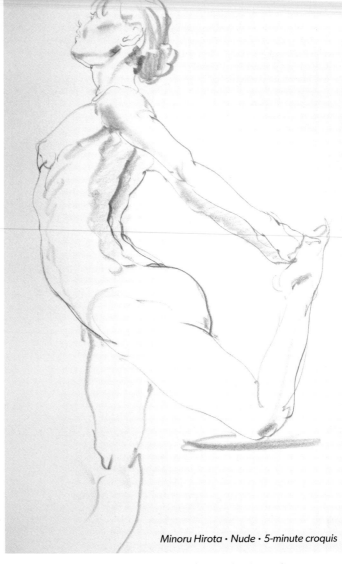

5) See the Muscles and Bones Visible on the Surface of the Body

The shapes that are visible on the surface of the body when a pose is struck are protruding bones, muscles and fat. Roughly memorizing the shapes and positions of the large, prominent muscles of the body is very useful for observing the human figure and depicting it accurately.

Clavicle

Peak of the scapula

Pectoral muscle

Deltoid

Triceps

Serratus anterior muscle

Biceps

Oblique abdominal muscle

Latissmus

Trapezius

A Pose with a Curved Back

The muscles and bones visible on the surface of the body can be clearly seen, because of the tension of this pose.

Minoru Hirota · Nude · 5-minute croquis

Above all else, the clavicle and the bend of the back—due to the presence of the lumbar spine (backbone)—characterize the human torso. In the case of four-legged animals, the scapula is located on the sides of the pectorals. But in a human body, because the shoulder—supported by the clavicle and the scapula—can stand out from the chest, the arm has a lot of freedom of movement. This is why the position of the shoulders can change radically depending on the pose, and the trapezius takes up the largest area of the human body.

An Upright Front-Leaning Pose

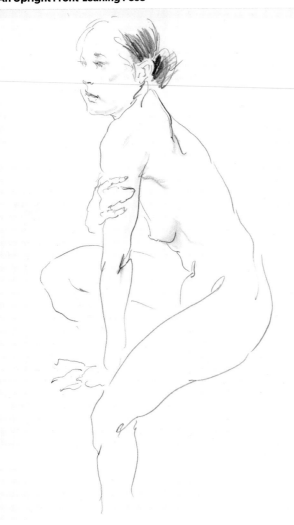

Minoru Hirota · Nude · 5-minute croquis

Summing up Points 1 through 5—the Five Key Points Seen in a Croquis

The five points described in the previous pages are illustrated here.

❶ *Examine the relationship between the chin and jaw, neck and ear.*

❷ *Observe the expressions of the face and hands.*

❸ *See the relationship between the hips and the supporting leg.*

❹ *See the shape of the muscles: The muscles stretch, the muscles are tensed, the muscles twist.*

❺ *See the muscles and bones visible on the surface of the body.*

❷ Facial expressions

In the case of a face in profile, by connecting the line between the forehead and the chin, you can accurately capture the tilt of the face.

❸ The relationship between the hips and the weight supporting leg

Confirm the weight-bearing leg, and the corresponding tilt of the pelvis.

Depending on the pose, when someone is standing on one leg with the other leg raised, the hip on the weight-bearing leg may be raised; or, as in the pose on the right, the hip of the non-weight-bearing leg may be raised.

❷ *Facial expression*

❶ The relationship between the chin and jaw, neck and ear.

When drawing the shape of the neck, be aware of the positions of the chin, jaw and ear.

❷ Expression of the hands

Capture the hands by showing the changes that occur with each joint.

❸ *Relationship between the hips and the weight-bearing leg*

❺ *Muscles and bones visible on the surface of the body*

❹ *Muscle shapes*

Draw the parts of the body with emphasis and simplication

Because a croquis drawing is executed in a limited amount of time, each detail of the figure is rendered with simplified, rapid lines. Let's look at the shapes of parts, using renderings of hands as examples. By simplifying the shapes, you can emphasize the characteristics of each detail, as well as their three-dimensionality.

Capture the joints with simple lines. The four fingers beside the thumbs are rendered as one mass, to depict a clenched hand.

Emphasize the joints of the hands, so that the hands look like "hand shapes" even if they are simplified.

The shapes of the individual fingers express tension.

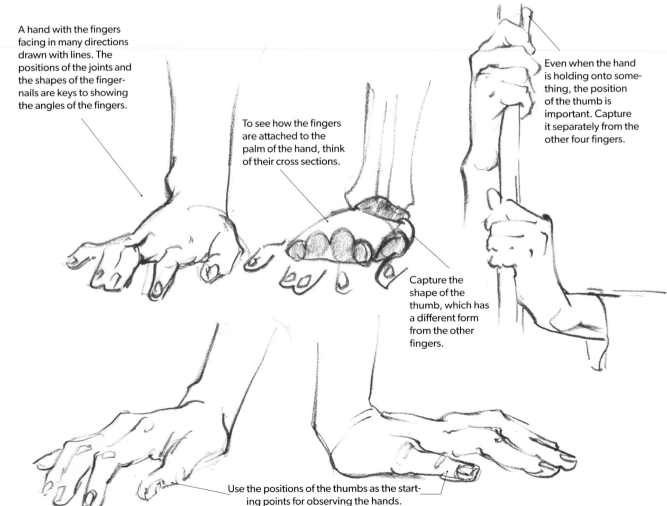

A hand with the fingers facing in many directions drawn with lines. The positions of the joints and the shapes of the fingernails are keys to showing the angles of the fingers.

To see how the fingers are attached to the palm of the hand, think of their cross sections.

Even when the hand is holding onto something, the position of the thumb is important. Capture it separately from the other four fingers.

Capture the shape of the thumb, which has a different form from the other fingers.

Use the positions of the thumbs as the starting points for observing the hands.

Three Artists, Three Ways

3

Lessons from the Croquis Drawing Studio

Minoru Hirota's Croquis Techniques (1)

From here on, we'll be breaking down croquis sketches that have been executed in decreasing amounts of time—10-, 5-, 2- and 1-minute drawings. The density of detail added to a drawing does not necessary reflect the amount of time spent on it, but the way the subject is seen and how the drawing is approached does change, so the image to be rendered becomes increasingly focused.

What is a 10-minute croquis? —according to Minoru Hirota

In a croquis drawing that takes 10 minutes, there is time for contemplating and going back and forth, so there's some leeway to create finer details. After capturing the whole figure, there's some time to have fun adding some artistic flourishes to the sketch. The length of time required for the pose to be held also affects the pose that the model can take. With a 10-minute period, the pose is not too strained, and by necessity is going to be one with stability.

Try assuming various poses yourself, so that you can understand the differences between 10-minute poses and shorter 5- and 2-minute poses and so on, to understand the differences with your own body.

Minoru Hirota · Dress · 10-minute croquis

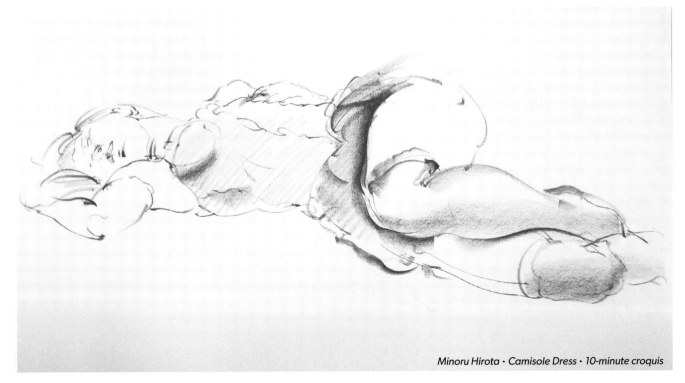

Minoru Hirota · Camisole Dress · 10-minute croquis

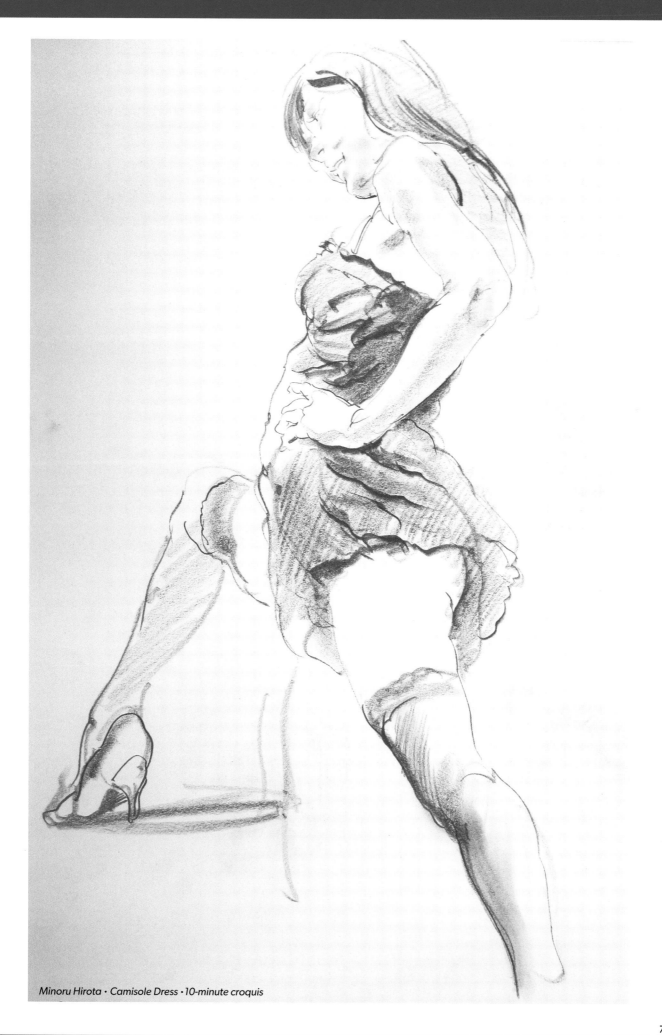

Minoru Hirota · Camisole Dress · 10-minute croquis

1 Start working. Use the side of the pencil for the bangs, and use shaded lined to render the roundness of the head.

2 Render the outline of the face with thin, undulating lines, by holding the pencil upright.

3 The anatomical line of the face and lower chin has been captured.

Roundness

Use lines shaded on one side to depict roundness. Hold the pencil on its side to use the side of the lead. Apply pressure to the tip of the pencil to draw a wide line that's shaded on one side.

● **About 1 minute in**

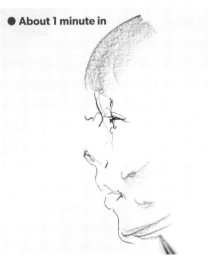

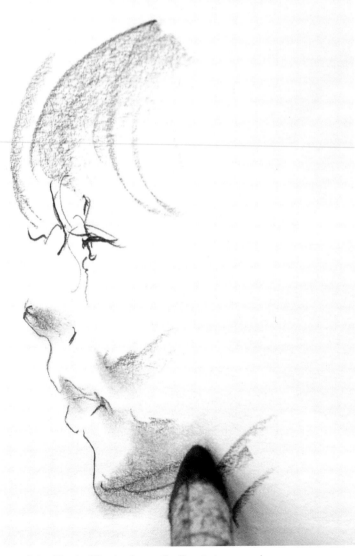

4 Hold the pencil on its side to capture the lower chin/jaw plane.

A pencil held on its side enables you to use the side of the point to mimic brush strokes.

5 From line to tone. Rub with a tortillon to change the lines to tones, and add volume to the nose, cheek and chin/jaw.

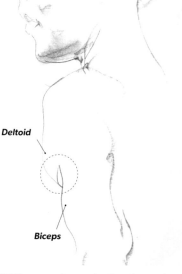

Deltoid

Biceps

If you hold the pencil at an angle, the lines will have variation.

6 Holding the pencil up, draw a sharp outline to define the shoulder, to contrast it with the chin and jaw and to emphasize the volume and position of each part.

7 Pay attention to the line that makes the transition from the shoulder to the arm. The overlap of muscles (the deltoid and the biceps) is expressed.

● About 2 minutes in

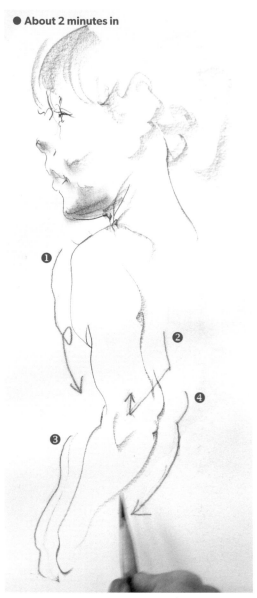

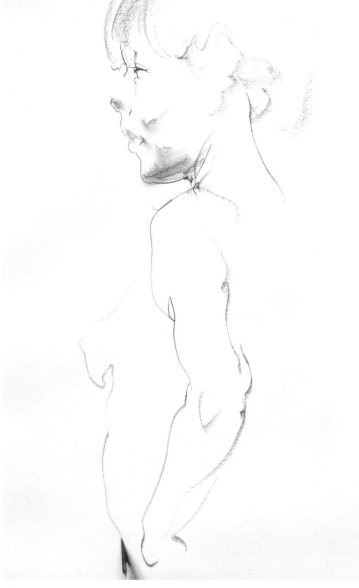

8 The alternately intertwined muscles are rendered with wide lines, by holding the pencil on its side.

9 Focus on the differences between the weights of the lines used for the top and bottom of the bust line. The volume and depth of the breast is rendered in a single undulating line.

● About 3 minutes in

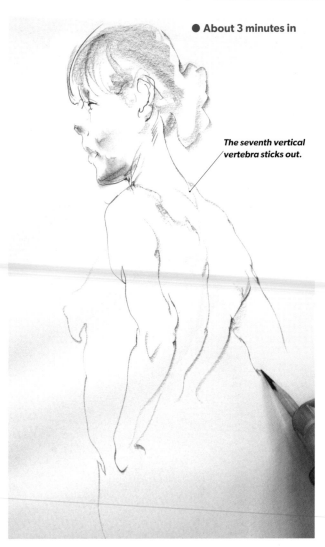

The seventh vertical vertebra sticks out.

● About 4 minutes in

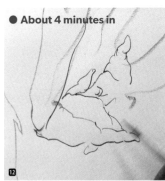

11 & 12 Darken the outline of the left arm, and express the change of direction of the left wrist to the palm and fingers.

● About 5 minutes in

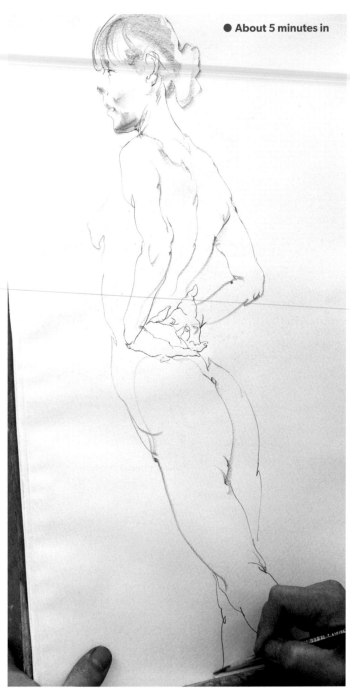

10 Follow the line of the lumbar spine from the seventh vertebra, and continue drawing from the right shoulder to the arm.

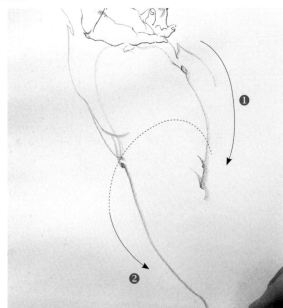

13 After drawing one side of the buttocks, draw the shape of the opposing hip. Use a lyrical abstract line, such as the one shown on page 18. The parts of the body we can't see are connected with lines.

14 Draw the shape of the weight-bearing leg. At this point the overall outline of the figure has been drawn.

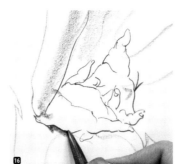

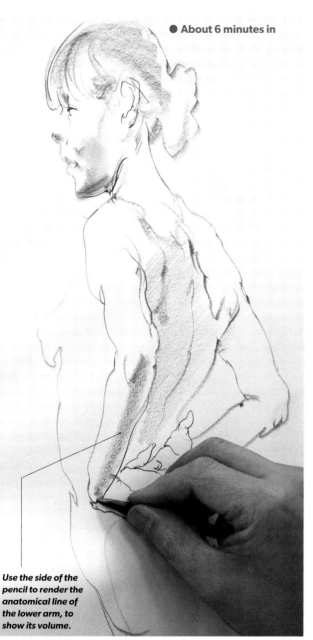

Use the side of the pencil to render the anatomical line of the lower arm, to show its volume.

15 Render the three-dimensionality of the bent shapes of the elbows.

16 & 17 Boldly draw the shadow of the hand where it rests on the left hip, to show its relationship with the hip. The sacrum at the center of the hips is drawn at the same time.

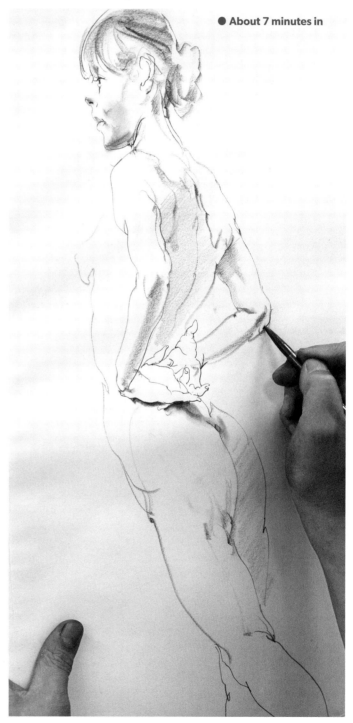

● About 7 minutes in

19 Tones are added to the anatomical line of the right arm, to bring out its three-dimensionality.

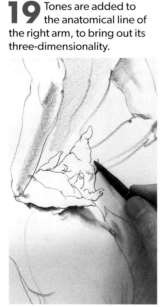

18 Tones are added to the weight-bearing (right) leg, and the left buttock is pushed out to the front.

20 Render the outline of the right elbow to the right wrist with a sharp line. Because this part is supporting the upper back, it is quite bold, with a lot of pressure applied to the pencil.

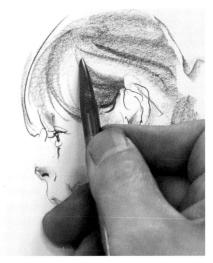

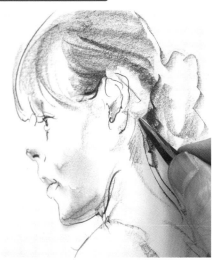

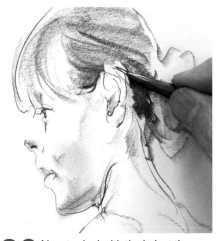

21 Now we're entering the final phase for the head. Add details to the side of the head, centered on the ear.

22 Define the front and sides of the head by adjusting the darkness of the hairline.

23 Now to deal with the hair at the nape of the neck and the back of the ear. Here the darkest tones in the drawing are put down, to make the ear facing the viewer stand out.

● About 8 minutes in

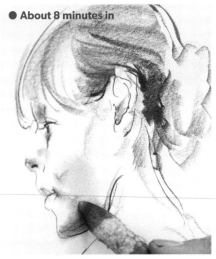

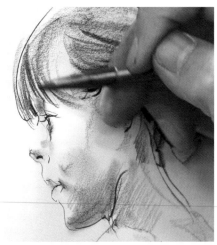

● About 9 minutes in

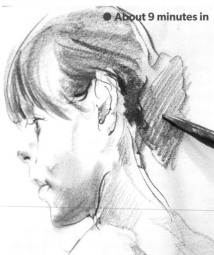

24 To echo the dark shadow of the back of the head, tones are added to the jawline to emphasize its volume.

25 Add details to the center of the bangs, and make the head shape rounded. Add dark shadows to the hair to emphasize the brightness of the skin.

26 The parts of the hair that are separate from the figure are rendered with light diagonal strokes.

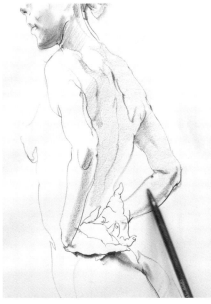

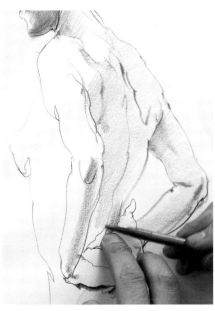

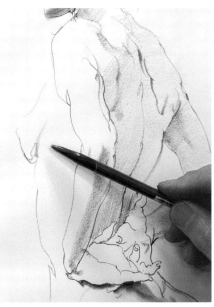

27 Add a light tone to push the right arm to the back.

28 Add vertical tones to the back to bring out and highlight the hands.

29 Capture the position of the serratus anterior muscle, to express the volume of the chest area.

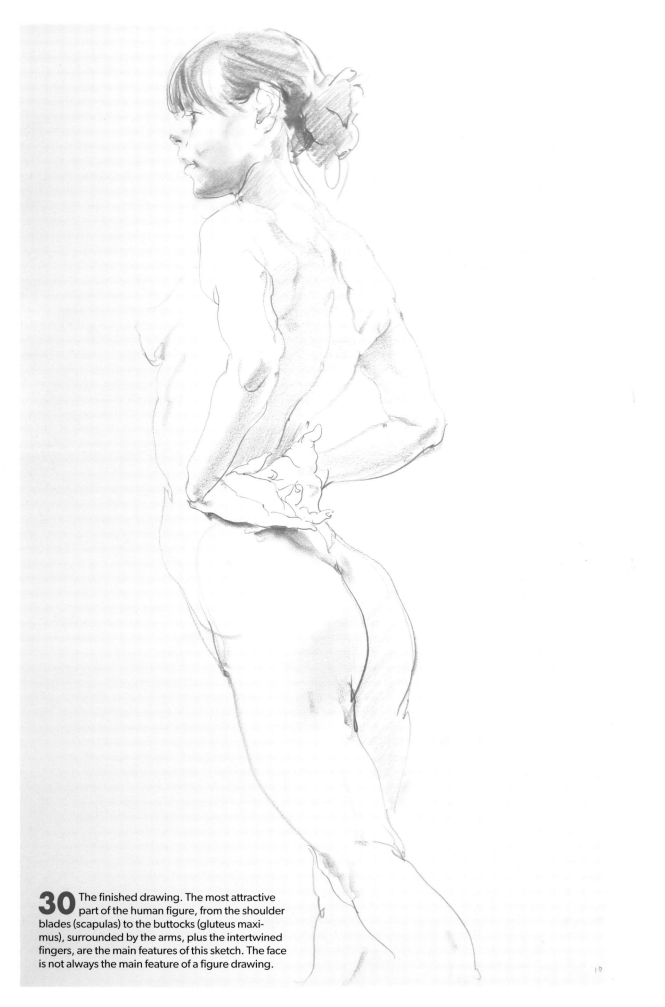

30 The finished drawing. The most attractive part of the human figure, from the shoulder blades (scapulas) to the buttocks (gluteus maximus), surrounded by the arms, plus the intertwined fingers, are the main features of this sketch. The face is not always the main feature of a figure drawing.

● 30 seconds in

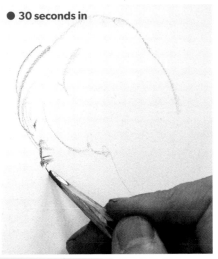

1 The shape of the head is captured with thin and bold lines.

● 1 minute in

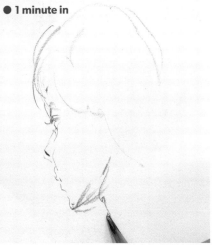

2 Capture the line on the border between the face and the chin/jaw, and the line between the planes of the jaw and the neck, to grasp the shape of the neck.

● 2 minutes in

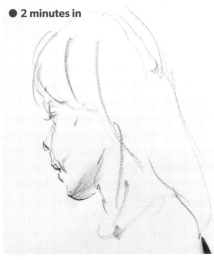

3 Add tones to the underside of the chin/jaw with a tortillon, and add the line from the nape of the neck to the shoulder.

● 3 minutes in

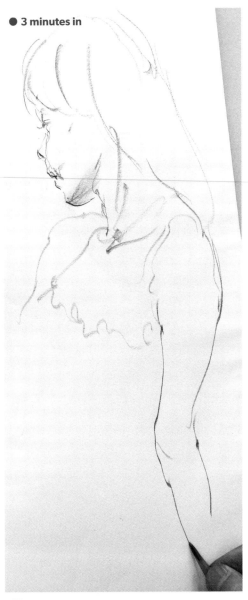

4 The lines of the left arm, which supports the body, are put in first.

● 4 minutes in

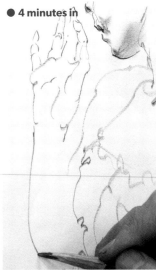

5 Draw the line from joint to joint in one attempt.

● 5 minutes in

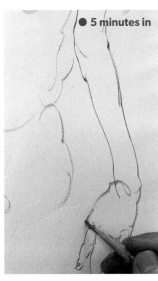

6 Draw the wrinkles of the hand to express its three-dimensionality.

● 6 minutes in

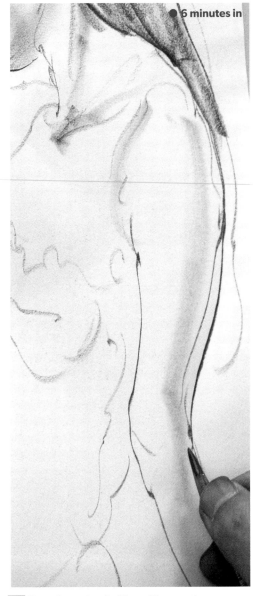

7 Draw the anatomical line of the arm, to express the arm's rounded three-dimensionality.

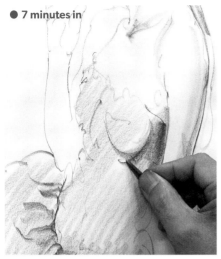

8 Capture the anatomical line between the front and side planes of the torso from the chest area.

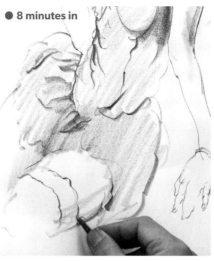

9 Draw the garter belts on the legs to bring out their three-dimensionality.

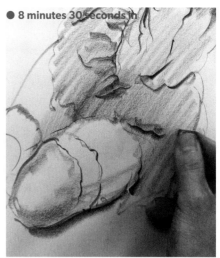

10 Emphasize the folds on the clothing, to make the transition from the surfaces of the torso to the legs clear.

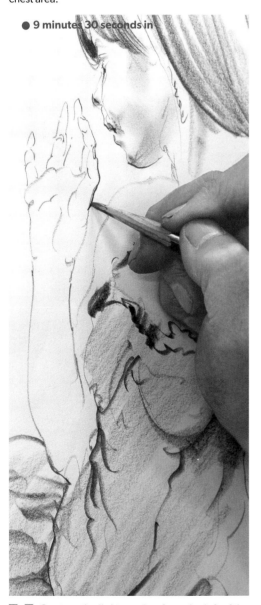

11 Capture the light coming from the left of the image, and emphasize the shaded side of the thumb.

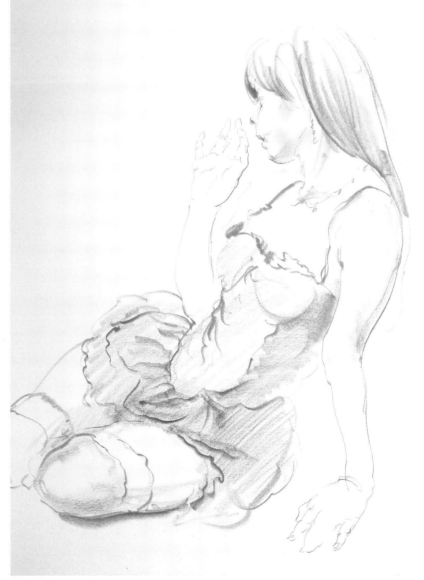

12 Complete. The outward bend of the elbow, which is characteristic of the female body, is the most memorable feature of this pose. The weight of the upper body rests on this arm, and the contrast between the tensed left arm and the suppleness of the right hand are captured.

Minoru Hirota's Croquis Techniques (2)

What is a 5-minute croquis?
—according to Minoru Hirota

In this amount of time, it's possible to objectively analyze the drawing and add some targeted details like the expressions of the face and hands. With practice, you will be able to achieve the croquis you visualize by the end of the 5 minute session.

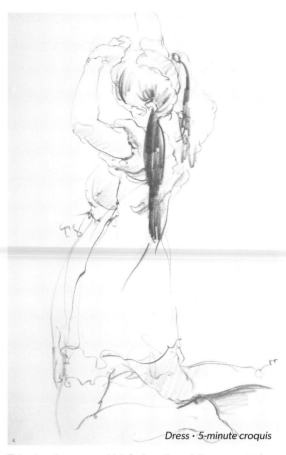

Dress · 5-minute croquis

This attractive pose, which feels as though it represents the everyday life of this woman, seems to tell a story. The large, S-shaped twist of the torso and the straight lines of the ponytails form a contrast.

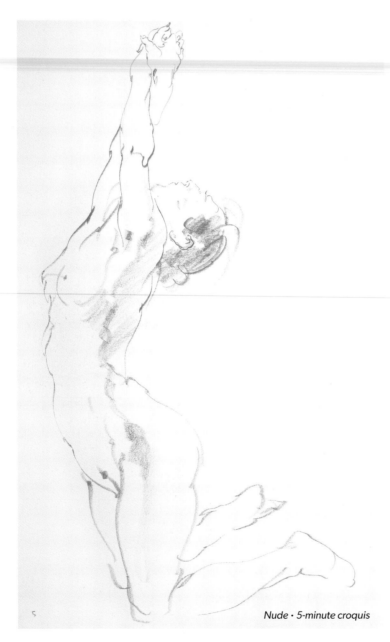

Nude · 5-minute croquis

Capture the large flow of the anatomical lines of the figure from the knees to the fingertips, to express the freedom of this pose.

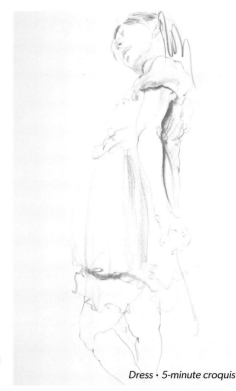

This is a pose where the artist is viewing the model from below. Take a look at the lines of this composition, such as the strong line of the arms held to the back and the soft lines of the clothing. An upward-facing view is effective in depicting a sense of space.

Dress · 5-minute croquis

Minoru Hirota's 5-Minute Croquis

Two croquis drawn at the same time as the one on the left from different viewpoints

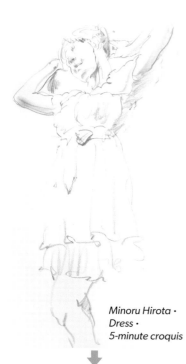

A croquis drawing where the model, who is wearing a soft, light dress, is observed from below. Compare it with the two other drawings to the right where the model is viewed from different viewpoints, you can see that the focus chosen by each artist is somewhat different.

Minoru Hirota ·
Dress ·
5-minute croquis

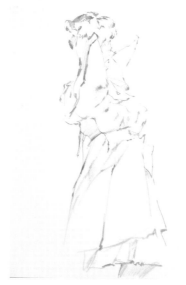

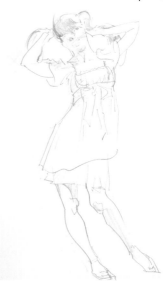

In this drawing, the strength of the shape of the front-facing elbow and the beautiful lines created by the flow of the folds on the dress are the focus.

Takahiro Okada · Dress · 5-minute croquis

Emphasize the S-shaped line formed by the dynamically posed standing figure.

Kozo Ueda · One-piece dress ·
5-minute croquis

1 Start by sketching out the head, starting with the front of the hair. Capture the triangle of the part under the nose that you can see when viewing the model from below.

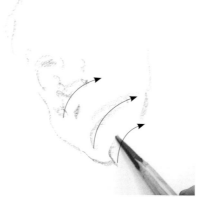

2 Capture the upper lip and the part under the chin, which can also be viewed from below.

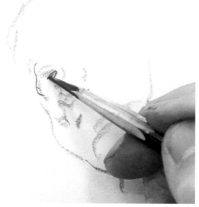

3 Draw the nostrils, to show that the head is being viewed from the left lower point of the composition.

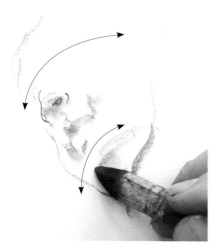

4 The chin and jawline form a gentle curve, so use a tortillon to soften it.

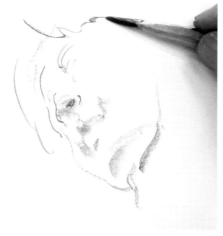

5 Move from the line of the front of the hair to the shape of the cheek. Capture the right front hair and the left front hair as individual shapes, to express the tilt of the head.

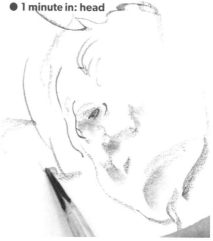

● 1 minute in: head

6 At this stage the undersides of the facial planes have been sketched in. Add the hand and wrist that are on the side of the head.

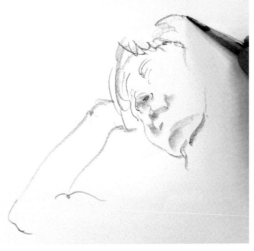

● 2 minutes in

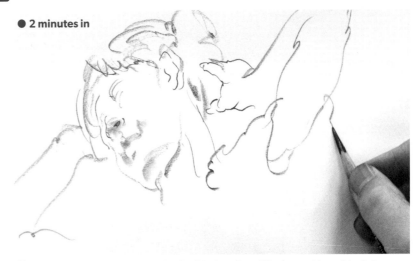

7 Explore the flow of the line connecting the side of the head with the bound hair. This is also the anatomical line of the head.

8 Draw the hand to depict the back of the head, and fix the position of the left arm. By making the left elbow go off the edge of the paper, the arm clarifies the up-ward-facing viewpoint.

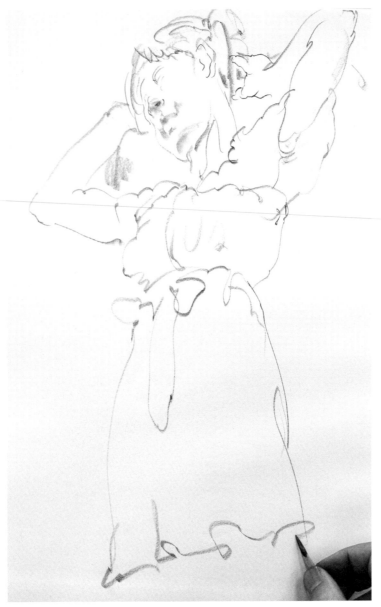

● 3 minutes in

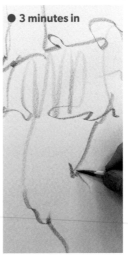

10 Bring out the volume of the leg by varying the pencil pressure.

11 Bring out the three-dimensionality by rubbing the line with a tortillon.

● About 4 minutes in

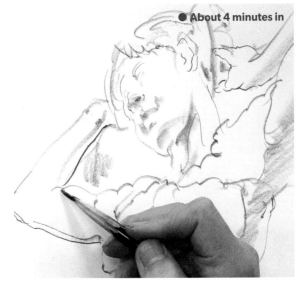

9 Depict the clothing with rhythmic lines that have a different texture from the lines used to depict the body. Although the wrinkles of the dress are what's being drawn here, they also follow the large curves of the torso.

12 Emphasize the outline of the right arm. Add a strong, dark line to outline the left arm and define its contour.

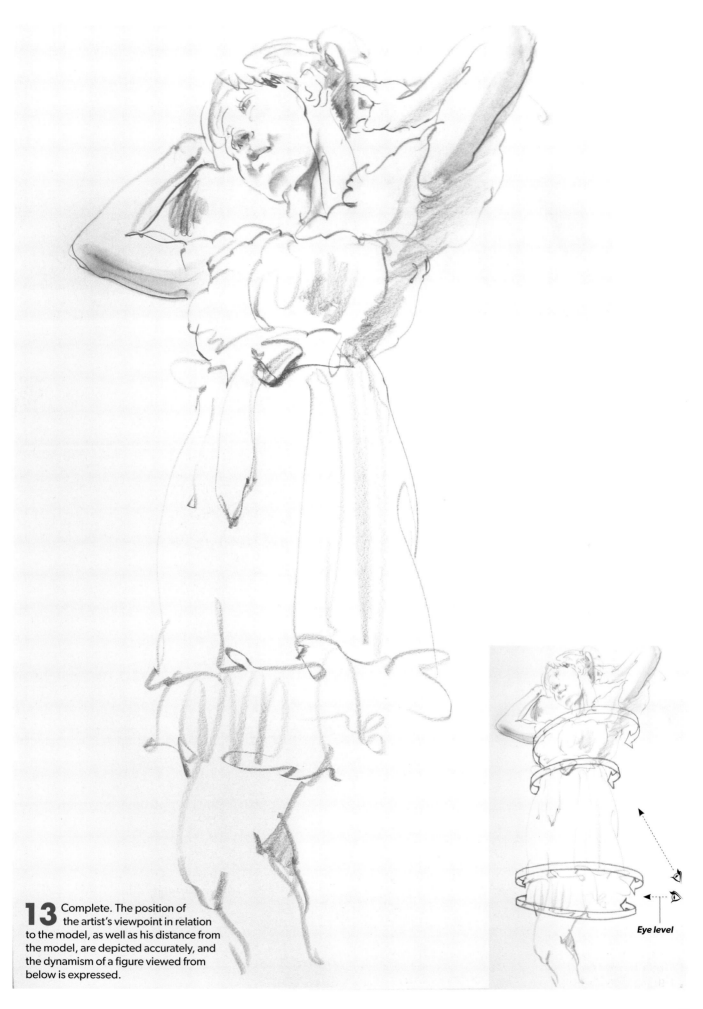

13 Complete. The position of the artist's viewpoint in relation to the model, as well as his distance from the model, are depicted accurately, and the dynamism of a figure viewed from below is expressed.

Eye level

Minoru Hirota's Croquis Techniques (3)

What is a 2-minute croquis? —according to Minoru Hirota

With a 2-minute pose, it's not unreasonable to expect the model to assume a pose with dynamic movement. Two minutes is short, but if you draw smoothly, it's possible to capture the overall bone and muscle structure. If this is thought of in terms of making a clay sculpture, the first half of the time would be used to build up the overall rough figure, and the remaining time would be used to refine the rough shapes. The connections and relationships between the parts of the body can all still be captured without undue haste.

Camisole Dress · 2-minute croquis

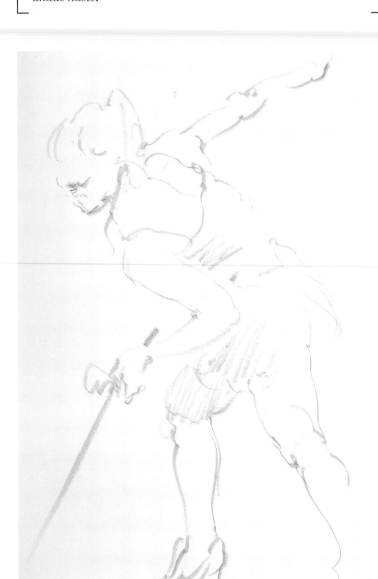

Camisole Dress · 2-minute croquis

If you have the model use a prop such as the dowel depicted above, it's possible to add more variation to the pose. Not only is the overall flow of the pose pursued here, I had the time to capture the attractive details of this composition such as the fingertips and the shoes.

Dress · 2-minute croquis

Camisole Dress • 2-minute croquis

Dress • 2-minute croquis

Here we have selected drawings depicting a model dressed in a form-fitting sporty camisole dress, and a model assuming a cute pose wearing a pretty dress with lots of frills. The camisole dress seems more suited to dynamic poses, so even if the model is lying down, the arm supporting her upper body and her raised legs seem very kinetic. In the drawing depicting the model in the frilly dress, the aim is to contrast the strong arched pose and the softness of the outfit. All of the poses are very feminine and graceful.

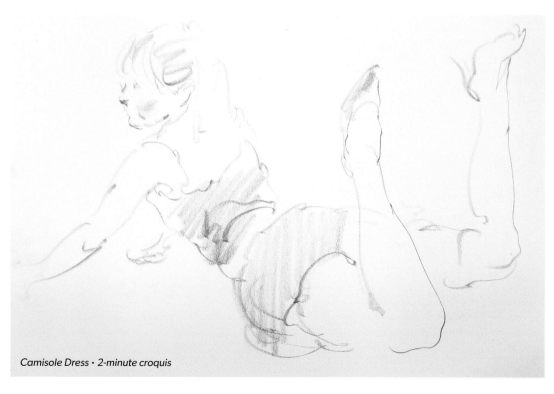

Camisole Dress • 2-minute croquis

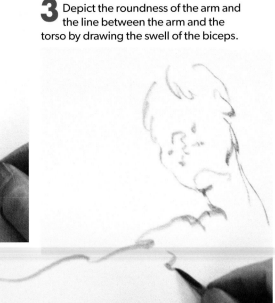

3 Depict the roundness of the arm and the line between the arm and the torso by drawing the swell of the biceps.

1 The face is viewed from below, so the anatomical lines between the jaw and the neck planes are followed here. The underside of the nose is depicted as a triangle.

2 Capture the shape of the back of the head to the shape of the front of the face.

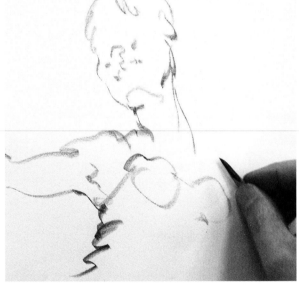

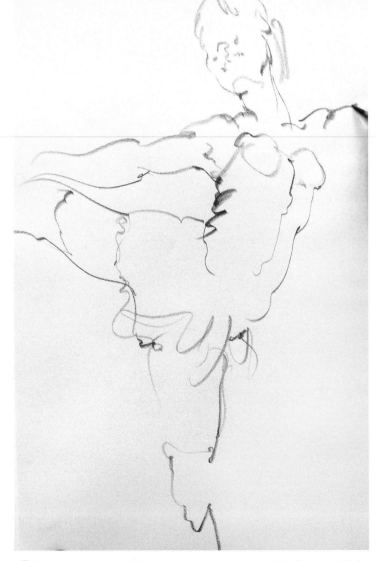

4 Consider the position of the left shoulder in relation to the right shoulder.

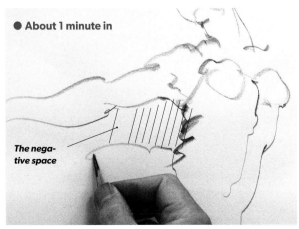

● **About 1 minute in**

The nega-tive space

5 Decide on the line of the hip, as you observe the shape of the negative space between the arm and the raised leg.

6 Express the relationship between the upper arm and the forearm with the twist of the shoulder line.

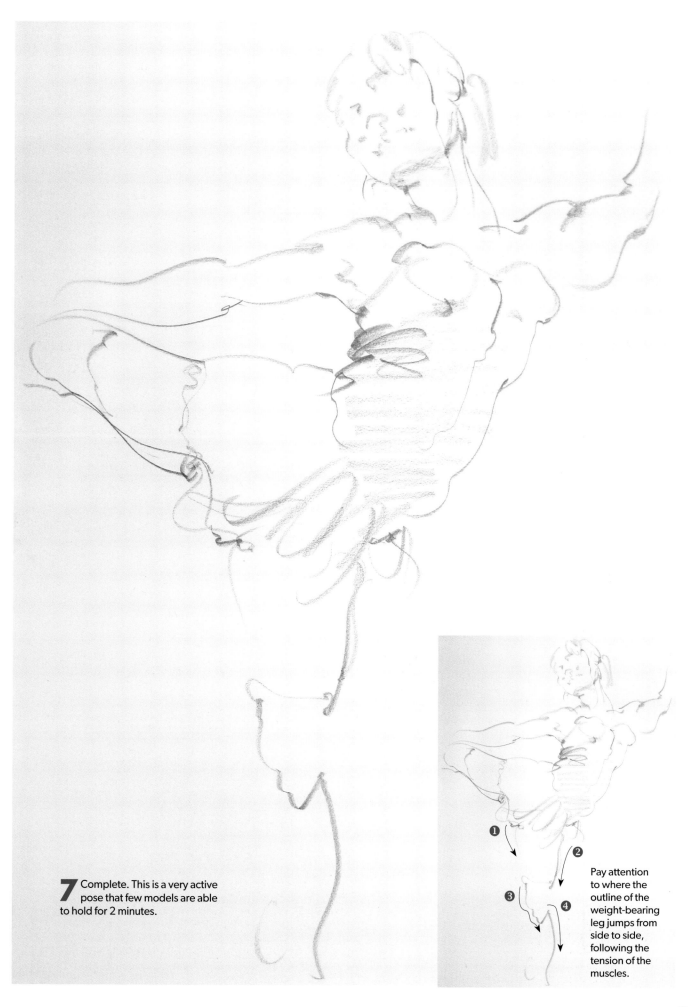

7 Complete. This is a very active pose that few models are able to hold for 2 minutes.

Pay attention to where the outline of the weight-bearing leg jumps from side to side, following the tension of the muscles.

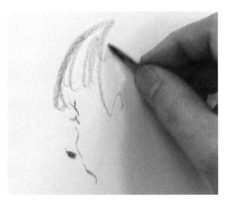

1 Start by drawing the bangs and the profile of the face.

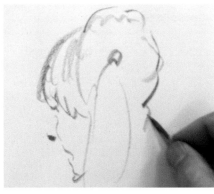

2 Draw the part of the hair on the back of the head, and establish the midline.

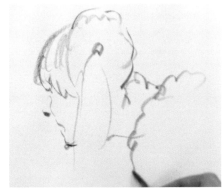

3 Draw the outline of the shoulder (the sleeve) that's slightly left of the back of the head with a bold line.

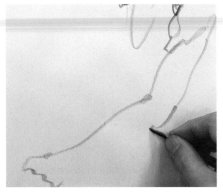

4 Draw the elbow and the outer arm.

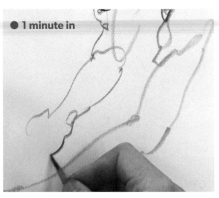

● 1 minute in

5 Depict the weight-supporting right arm with a strong, crisp line.

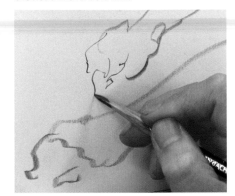

6 Draw the expressive fingers rather than the volume of the hand with thin lines, holding the pencil upright.

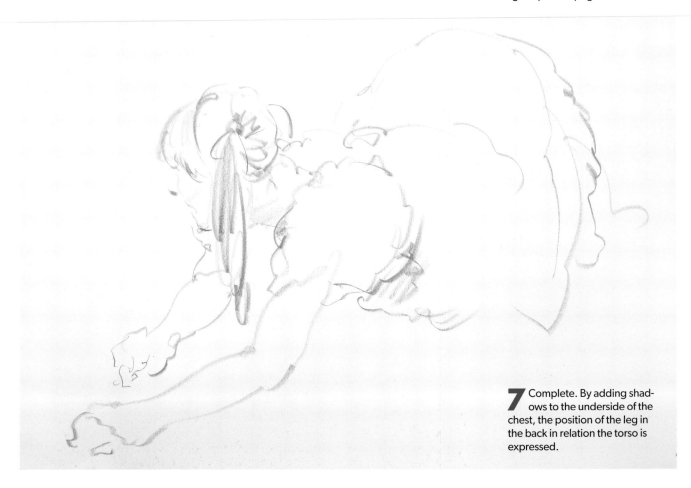

7 Complete. By adding shadows to the underside of the chest, the position of the leg in the back in relation the torso is expressed.

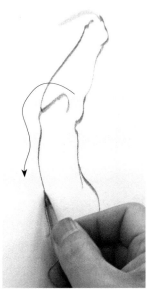

5 Add shadows to the hair to highlight the arms.

1 Use the elbow as the ana-tomical line of the arm, and depict the shape of the arm that's bent to the front, toward the viewer.

2 Draw the arm in the front first, and use that line as the base to capture the head. The further away from the viewer, the weaker the line for the head gets.

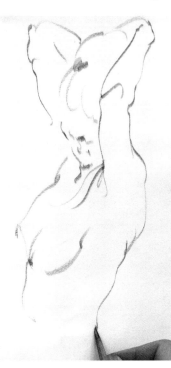

3 Once the arms are depicted, draw the line of the back that extends from them. Because the hips and below are viewed from the back, you can see that the lumbar spine becomes the midline of the figure.

● **1 minute in**

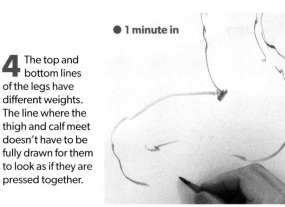

4 The top and bottom lines of the legs have different weights. The line where the thigh and calf meet doesn't have to be fully drawn for them to look as if they are pressed together.

6 Complete. The primary feature of this pose is that the back and front sides of the figure are both visible in turns because the torso is twisted.

Minoru Hirota's Croquis Techniques (4)

What is a 1-minute croquis? —according to Minoru Hirota

It's impossible to draw the fine details within this limited time period, but you can capture the major posture of the figure and depict an impression of it. One benefit of croquis done in only a minute is that its possible to draw strenuous poses that the model can only hold for a short time.

Nude · 1-minute croquis

An attractive pose that can only be assumed for 1 minute. The back is just implied here. Rather than outlining the figure, I have attempted to define the space around the figure.

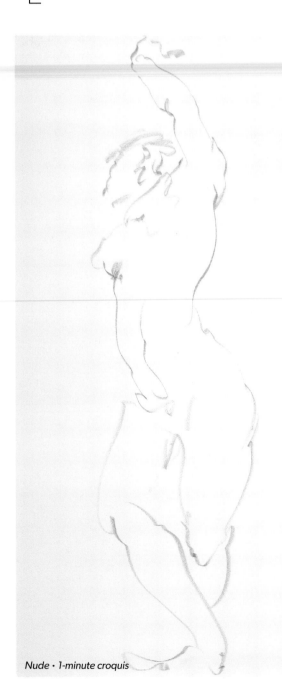

Nude · 1-minute croquis

A dynamic, kinetic standing pose. The zigzag line that is formed by the model keeping her balance is the feature that is highlighted. Pay attention to the changes in pencil pressure!

Key point 1: The key to the hips are the hip bones.

Nude · 1-minute croquis

Key point 2: You can indicate the inclination of the head via the nose and the cheekbone. Don't get caught up in trying to depict the hairstyle.

Minoru Hirota's 1-Minute Croquis Example 1

Draw a figure created by a strenuous pose that can only be held for 1 minute, using a continuous flowing line as described on page 18. Try to capture the shape while keeping the pencil in contact with the paper as much as possible.

1 Capture the line from the fist to the elbow at the top of the sheet.

2 Draw the line from the raised right arm to the weight-supporting left wrist in one attempt. Return to the right elbow.

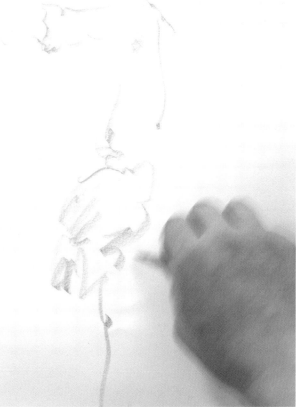

3 Draw the back of the head to the ear.

The flowing abstract line described on page 18.

4 Draw the form of the shoulder, and capture the shape of the trapezius muscle.

5 Complete. The side of the torso to the hip, knee and ankle are captured with one unbroken line. The weight of the body is supported by the left arm and the left leg. The tensed side of the body is depicted with care, but the elongated opposite side of the body is simply implied with the lumbar spine, which forms the midline of the body.

1 Start drawing at the top left part of the working surface. There is no time to draw the individual fingers, so instead visualize the entire figure and start from the wrist.

2 Use the under-bust line as the division between the upper and lower planes of the torso.

3 Establish the positions of the left and right elbows, and be aware of the planes of the body that are labeled A, B, C and D in the illustration at the bottom of this page.

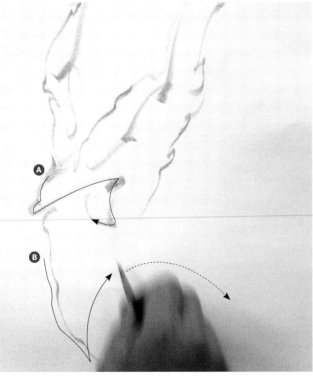

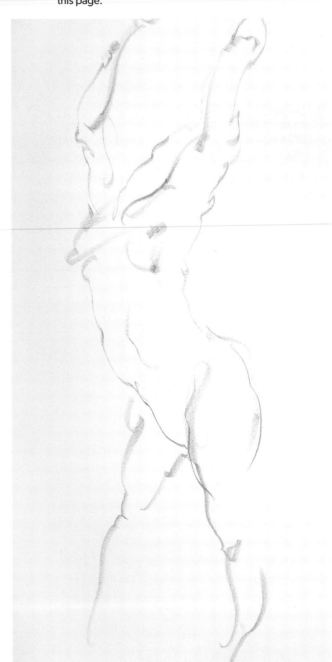

4 After drawing the line from the side of the torso to the bust, draw the areas marked **A** and **B** alternately on the left and right.

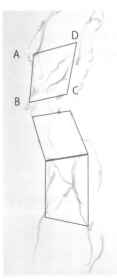

5 Complete. I have tried to depict the zigzag flow of the human figure in this pose.

1 Capture the foreground and background arm shapes quickly, and continue to draw the line from the bust to the hips.

2 Capture the shape of the hips.

3 Complete. This one-legged pose is difficult to maintain even for 1 minute. Instead of the raised leg, I've chosen to draw the weight-bearing leg.

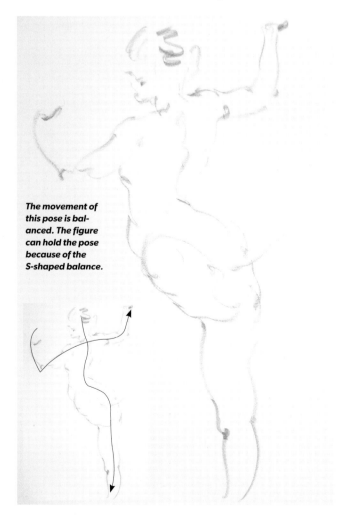

The movement of this pose is balanced. The figure can hold the pose because of the S-shaped balance.

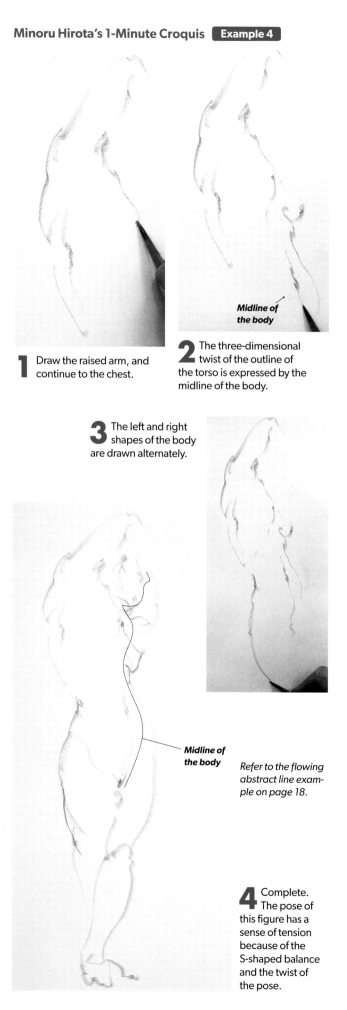

1 Draw the raised arm, and continue to the chest.

2 The three-dimensional twist of the outline of the torso is expressed by the midline of the body.

Midline of the body

3 The left and right shapes of the body are drawn alternately.

Midline of the body

Refer to the flowing abstract line example on page 18.

4 Complete. The pose of this figure has a sense of tension because of the S-shaped balance and the twist of the pose.

101

Kozo Ueda's Croquis Techniques (1)

When executing a lengthy drawing, you need to be a keen observer of the entire figure, right down to the fine details of the subject. In contrast, in a croquis you must capture the general overall shape of the figure, grasp its movement and rhythm, and quickly depict those on your paper.

What is a 10-minute croquis? —according to Kozo Ueda

A croquis is a drawing where the working time is set to a limited period, the time is used very efficiently, and the movements of the eyes and the hands are coordinated. Before starting to draw, lay down the overall composition with guide lines. If you have 10 minutes, it's possible to execute a croquis that's close to a complete drawing in terms of expressing textures and details.

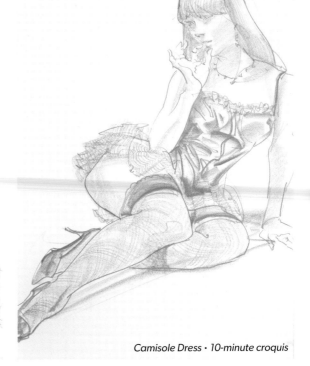

The dynamic zigzag-shaped line of the pose is evident, and I've tried to capture the fine details of the expression shown by fingers of the right hand.

Camisole Dress · 10-minute croquis

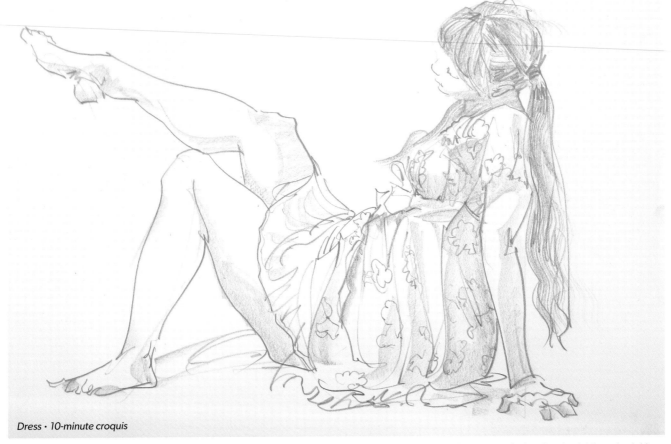

Dress · 10-minute croquis

In this piece I have depicted the soft fabric of the dress, which has a shape that changes along the body, by not only drawing the folds and wrinkles, but by adding the pattern and shadows.

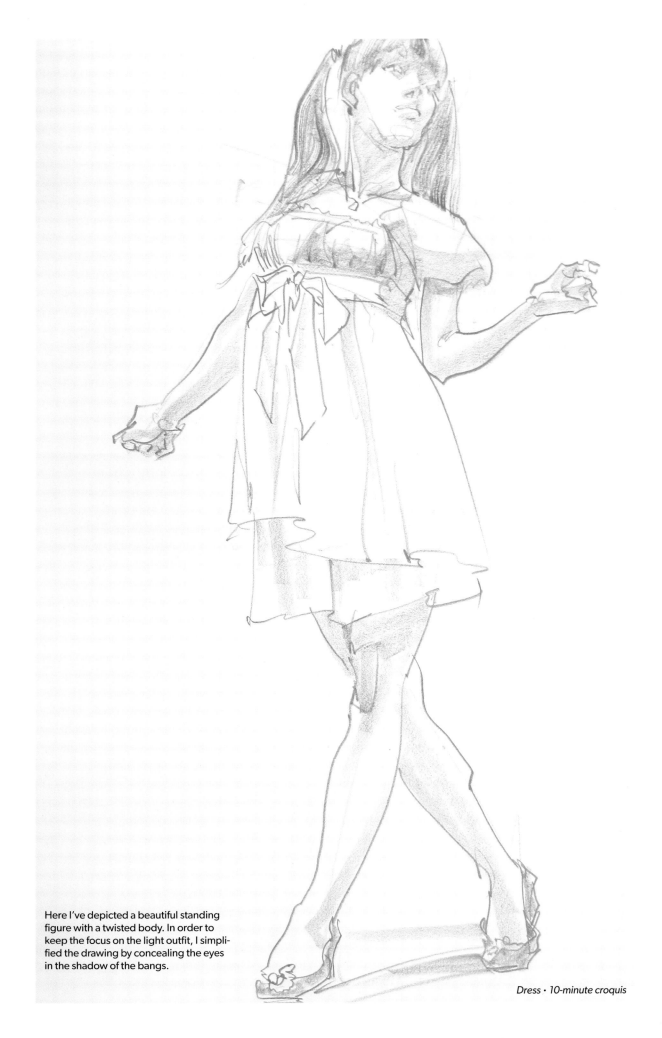

Here I've depicted a beautiful standing figure with a twisted body. In order to keep the focus on the light outfit, I simplified the drawing by concealing the eyes in the shadow of the bangs.

Dress · 10-minute croquis

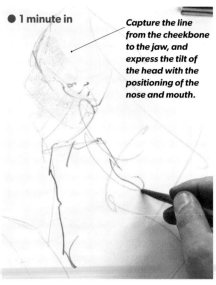

● 1 minute in

Capture the line from the cheekbone to the jaw, and express the tilt of the head with the positioning of the nose and mouth.

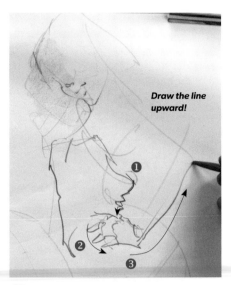

Draw the line upward!

1 Sketch in the general guide lines, and then start with the tones of the front of the face.

2 Establish the midline of the torso and the width of the shoulders, and then proceed to the outlines of the sides of the torso.

3 From the wrinkles on the back, go on to the planes of the hand on the hip. Draw the line from the wrist to the elbow from bottom to top.

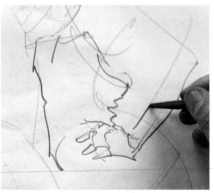

4 Depict the depth of the shape of the arm by alternately drawing the inner and outer lines.

5 Be aware of the muscles from the clavicle, shoulder and inner upper arm, and capture the undulating line.

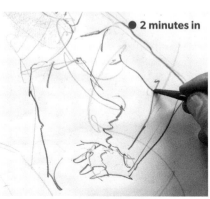

● 2 minutes in

6 Draw the outlines of the space formed by the arm and the back from the front in a three-dimensional way.

7 The seams of the clothing are useful for emphasizing the three-dimensionality of the figure. Capture the seam lines rhythmically, keeping the texture of the fabric in mind.

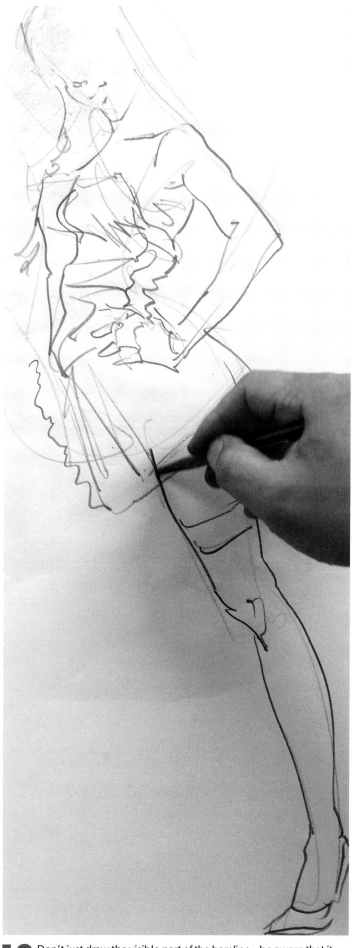

8 Instead of drawing the outline of the leg in one motion, stop and put pressure on the pencil at the knee's patella, and make the line turn back.

9 The line from the shin to the ankle creates a sense of rhythm.

● **3 minutes in**

The back of the leg is captured while considering the knee joint as one mass.

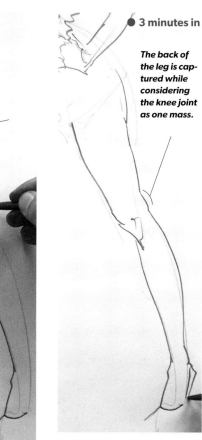

10 The legs start from the front of the buttocks.

11 The gap between the front and back lines adds an attractive sense of rhythm to the leg.

12 Don't just draw the visible part of the hemline—be aware that it overlaps the part of the leg that's hidden by the outfit.

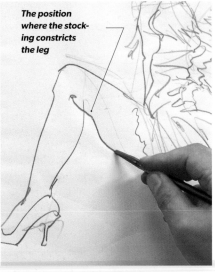

The position where the stocking constricts the leg

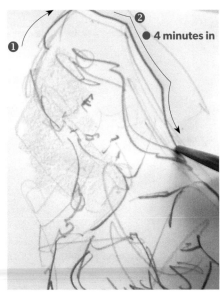

1

2

● 4 minutes in

13 Capture the leg that is raised up. The toe runs past the edge of the paper, but its presence is implied by the heel.

14 Draw the line of the thigh where it's constricted by the stocking, which is not added yet, and the part that is swelling freely.

15 Depict the changing planes of the back of the head with exaggerated concave lines.

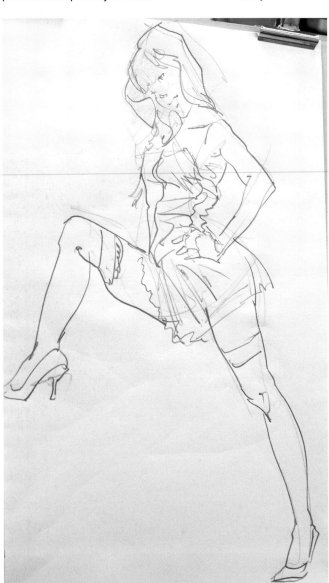

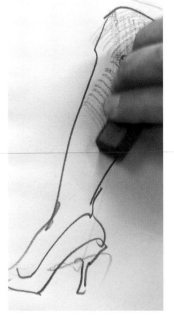

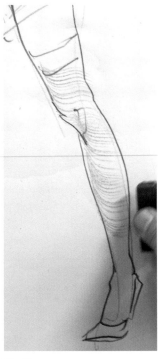

17 Draw the three-dimensionality of the fishnet stockings. This is done with a graphite block with several grooves carved into it (see page 50).

18 You can use the same graphite block to depict the shape of the leg as well.

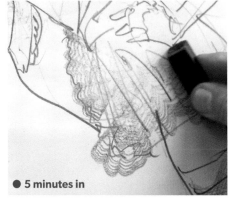

● 5 minutes in

19 By moving the same tool with a rhythmical motion, you can depict the pattern of the lace too.

16 The right arm raised to the side of the head has been drawn in at this stage.

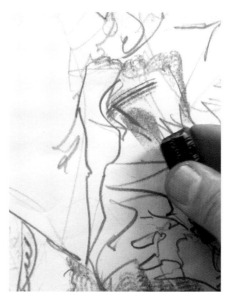

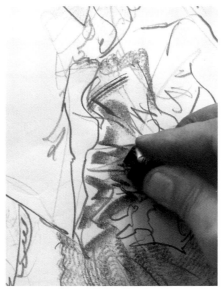

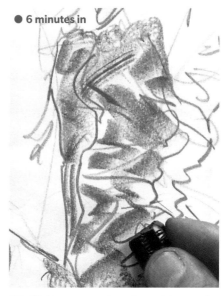

20 Use the flat side of the graphite block to fill in the surface of the bodice.

21 Use strong contrasts to depict the shiny texture of the black vinyl material.

22 You can use the edges of the graphite block for sharp lines.

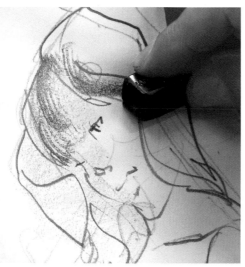

23 Use the graphite block to depict the texture of the hair, and to express its flow and volume.

● 7 minutes in

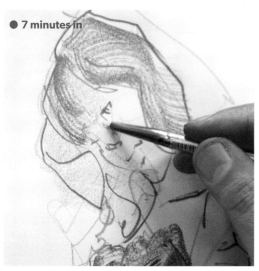

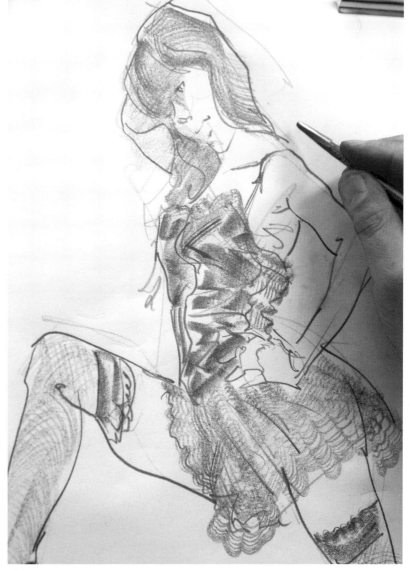

24 Drop in the shadow cast by the bangs, and emphasize the three-dimensionality of the nose.

25 The textures of the clothing and hair have been expressed.

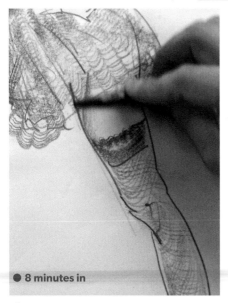

● 8 minutes in

26 Draw the shadow of the skirt that falls on the thighs.

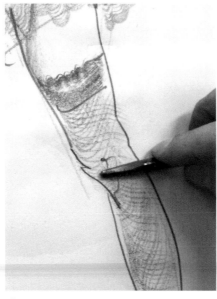

27 Add shadows to express the three-dimensionality of the knee.

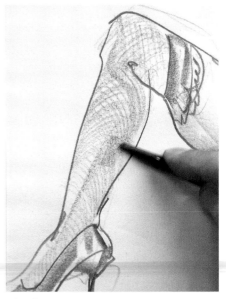

28 Emphasize the anatomical lines of the calf to depict its volume.

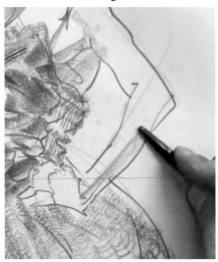

29 Add a line shaded to one side (see page 80) to the anatomical lines of the arm, to depict its three-dimensionality as if it were a box.

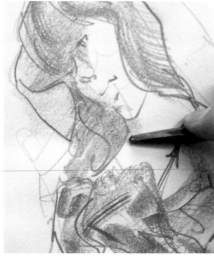

30 Add dark shadows under the chin and jaw to emphasize the shape of the neck.

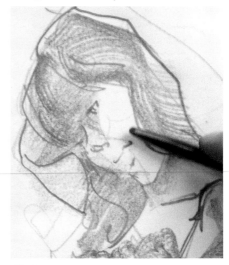

31 Use the side of the pencil to softly depict the roundness of the cheek.

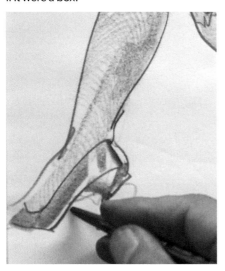

32 Depict the shiny surface of the shoe with highly contrasting black and white areas.

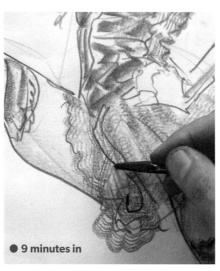

● 9 minutes in

33 Emphasize the contour of the body from the navel to the left leg, and relate it to the tilt of the pelvis and the volume of the buttocks.

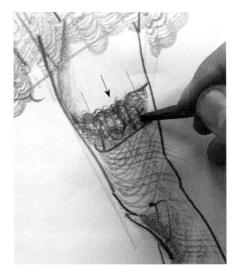

34 The sides of the stocking are emphasized to make the leg more three-dimensional.

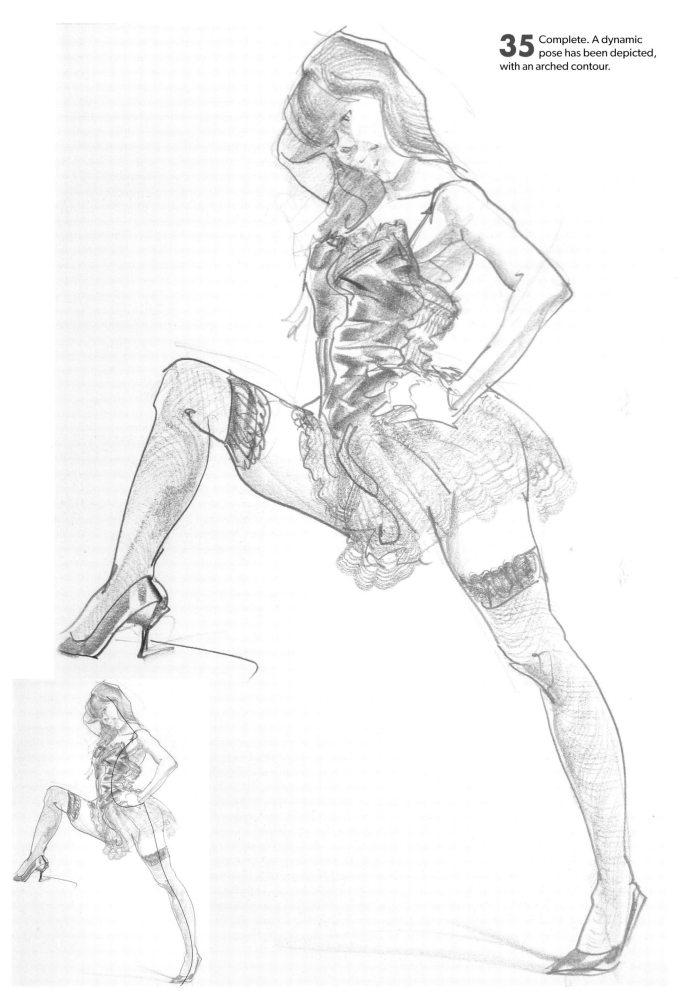

35 Complete. A dynamic pose has been depicted, with an arched contour.

Kozo Ueda's Croquis Techniques (2)

What is a 5-minute croquis? —according to Kozo Ueda

Even though the essentials are captured with lines and tones, with only 5 minutes it's not possible to draw everything. I believe that a 5-minute croquis is best executed by quickly discerning which parts to leave out or simply imply.

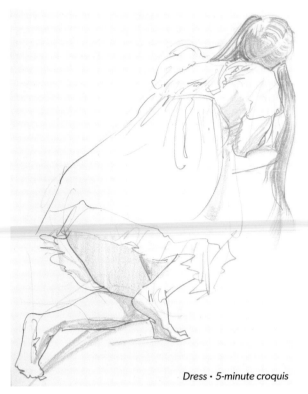

Dress · 5-minute croquis

The large flow of the figure from head to feet is depicted along the diagonal lines connecting the corners of the paper. The planes of the back are used as the base to express the change in direction of the head, and the brightness of the outfit is emphasized by adding shadows to the head and legs.

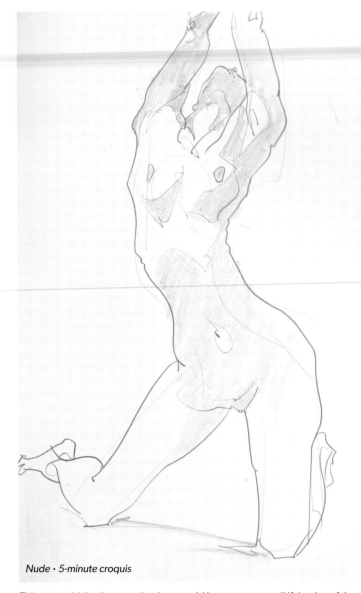

Nude · 5-minute croquis

This pose with both arms raised up would become too small if the tips of the fingers are included in the composition. By running the arms off the edge of the paper at the elbows, the dynamic S-shape of the figure has become visible. When the arms are raised, the breasts rise with them.

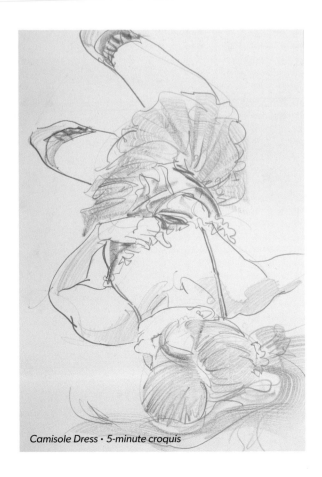

A pose with the head in the foreground may seem difficult at first glance, but the figure is depicted as a foreshortened form to give the viewer cues about its position in space. Drawing unfamiliar forms lends freshness and fun, so I hope you'll give it a try.

Camisole Dress · 5-minute croquis

Kozo Ueda's 5-Minute Croquis

Five-minute croquis drawings of the same pose as the one on the left, viewed from different angles.

Takahiro Okada ·
Nude · 5-minute croquis

Minoru Hirota · Nude ·
5-minute croquis · Refer to page 9

The drawing to the left is viewed from above the model, while the drawing above right shows an almost horizontal vantage point.

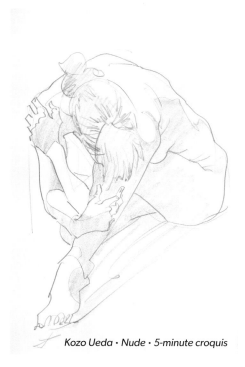

Kozo Ueda · Nude · 5-minute croquis

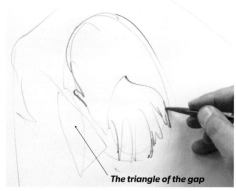

The triangle of the gap

1 Capture the overall silhouette and the triangular shape of the gap between the body and the arms with light guide lines, and then show the inclination of the head from the back of the head.

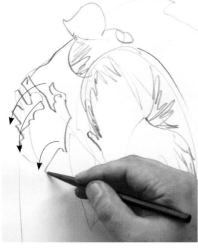

2 Draw the bound hair, which is opposite to the bangs. Move on to the shape of the hand on the shoulder, and then to the anatomical line of the wrist.

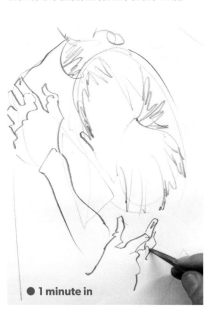

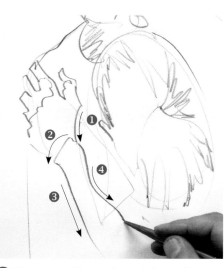

3 The shape of the arm is drawn in one flowing line.

● 1 minute in

5 Pay attention to the way that the shapes of the legs are also captured by moving from one side to the other. Turn back from the shin to the ankle, go over to the big toe that juts out of the front of the foot, draw the other 4 toes and then go back to the heel.

4 Capture the shapes of the fingers of the hand resting on the left elbow with a different rhythm from the lines used for the hair.

Kozo Ueda's 5-Minute Croquis (continued)

● **2 minutes in**

6 The line starting from the cervical spine (the neck bone), which captures the shape of the backbone, continues to the outline of the back and hip.

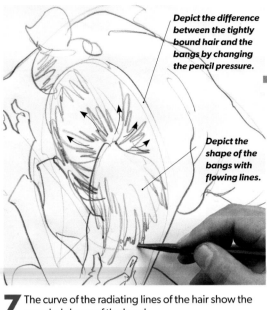

Depict the difference between the tightly bound hair and the bangs by changing the pencil pressure.

Depict the shape of the bangs with flowing lines.

7 The curve of the radiating lines of the hair show the rounded shape of the head.

9 Add the shadow on the back of the hand by using the pencil on its side.

● **3 minutes in**

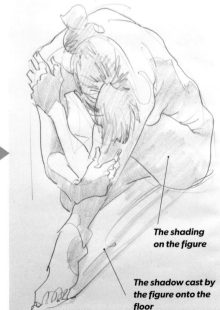

8 The shadows start at the anatomical lines of the body parts. Add the shadows with a light touch.

The work process

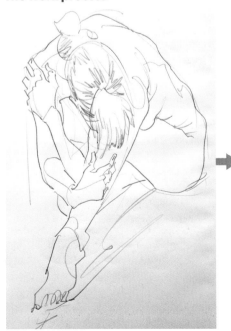

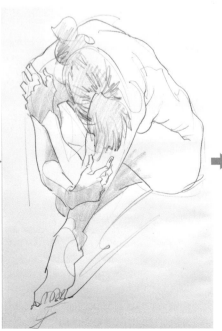

The shading on the figure

The shadow cast by the figure onto the floor

This is at around the 4-minute stage; the shapes of the figure and the shadows have been depicted. This was shown previously in step 8 on page 68, where the figure is captured in a triangle shape.

Fill in the shadows starting with the extremities of the body such as the hands, going towards the larger surfaces.

Shadows have been added to the line drawing to depict the figure's three-dimensionality.

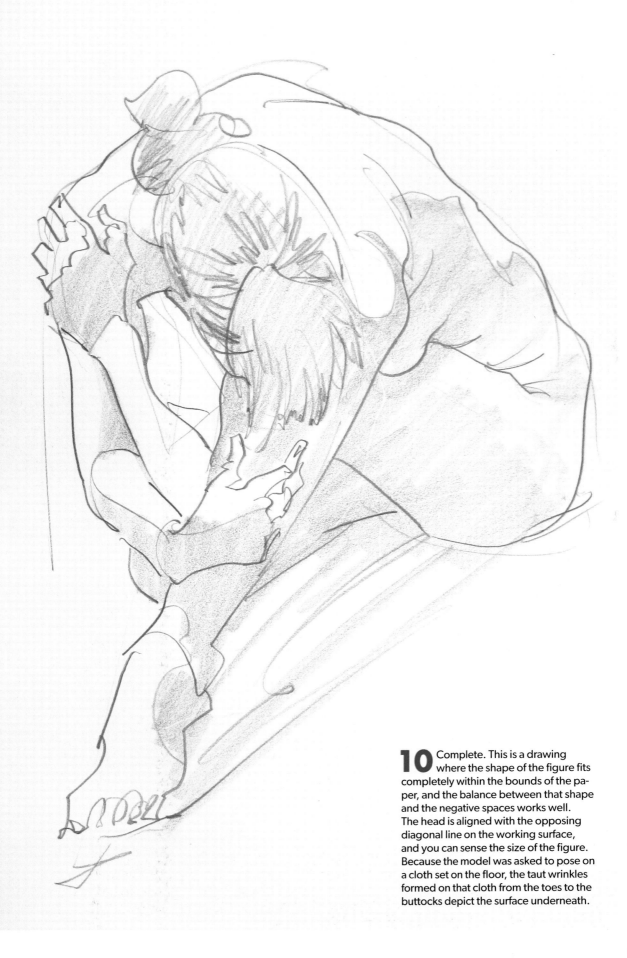

10 Complete. This is a drawing where the shape of the figure fits completely within the bounds of the paper, and the balance between that shape and the negative spaces works well. The head is aligned with the opposing diagonal line on the working surface, and you can sense the size of the figure. Because the model was asked to pose on a cloth set on the floor, the taut wrinkles formed on that cloth from the toes to the buttocks depict the surface underneath.

Kozo Ueda's Croquis Techniques (3)

What is a 2-minute croquis?
—according to Kozo Ueda

It's a short period of time in which to work, but it's still possible to depict the differences between the lines of the bone structure and muscles of the figure. Even when the model is wearing clothes, not only should you depict the texture of the fabric with lines, but you can add light, medium and dark tonal values to turn the drawing into an attractive work of art.

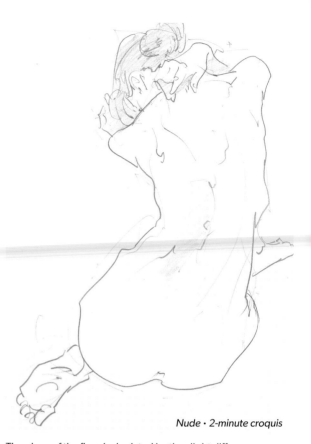

Nude · 2-minute croquis

The plane of the floor is depicted by the slight difference between the left and right bowed lines created by the shape of the back, and the just-visible positions of both feet. A beautiful expression has been added to the right hand too, to emphasize it. Pay attention also to the contrasts between the sole of the foot and the palm of the hand.

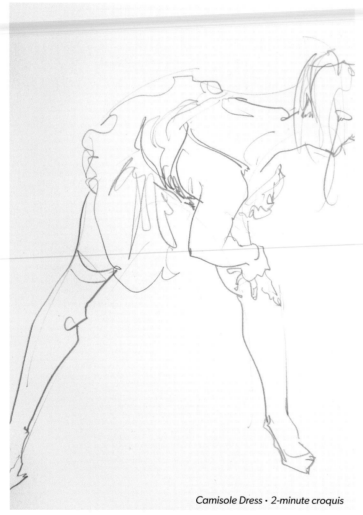

Camisole Dress · 2-minute croquis

Here the focus is on the movement of the figure bending forward. By contrasting the strong lines of the right leg, which goes beyond the edge of the paper, and the weak lines used to depict the left leg, which is drawn to the back, a sense of depth in the space is depicted in this sketch.

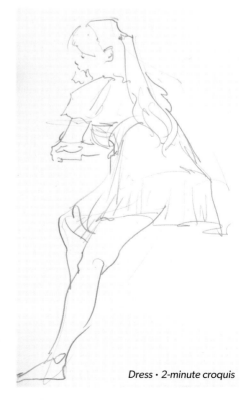

The whole figure is defined by the twisted torso. The straight lines of the outfit contrast with the supple lines of the legs. See page 39.

Dress · 2-minute croquis

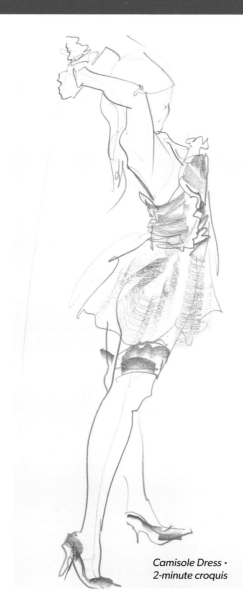

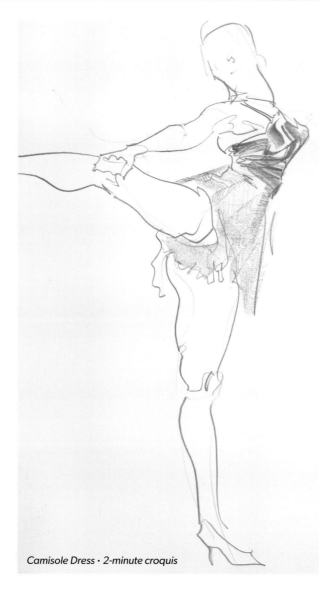

In both drawings to the left, nearly all of figure is depicted within the bounds of the paper, and the supple elongation of the arms and legs are captured. In order to see the difference in textures between the dress and the body at a glance, shadows are added to the former to indicate its color and texture.

Camisole Dress · 2-minute croquis

Camisole Dress · 2-minute croquis

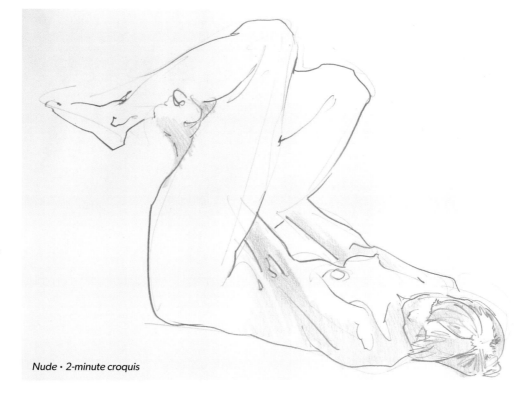

Don't just rush to outline the shape of the subject you are drawing; carefully consider the qualities of the lines you put down to depict the subject. By artfully varying the lines you use within the brief session, an opportunity to make truly expressive work presents itself. This figure is depicted with simple lines and tones.

Nude · 2-minute croquis

1 The tilt of the head seen by looking down on the figure can be depicted by the position of the ear. Be conscious of the relative position of the right ear, which you cannot see.

2 Included among all the shapes formed by the hair hanging down in accordance with gravity are the only parts that are in contact with the body—the ponytails on either side.

3 Because the arm is drawn to the back, the sleeve is drawn at the same time. The tension with which the arm is pulled back is depicted in the folds of the fabric.

4 The intertwined fingers at the back are an attractive focus of the drawing.

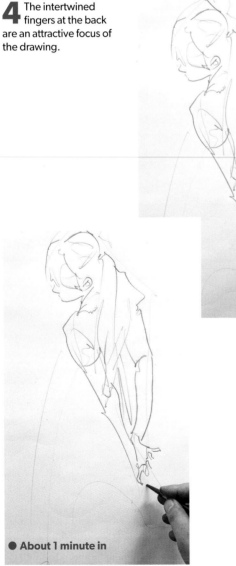

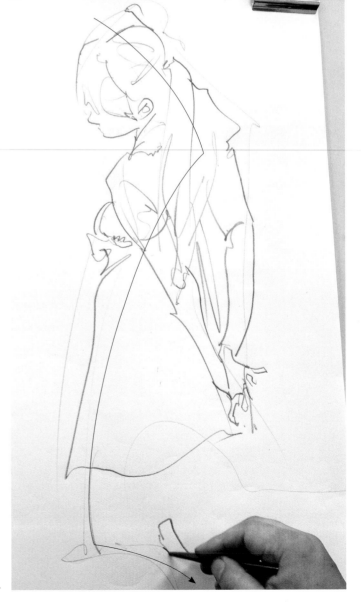

● About 1 minute in

5 Capture the bend of the wrists as part of the palm to form a nice shape.

6 The orientation of the shoe is easier to depict by starting with the sole.

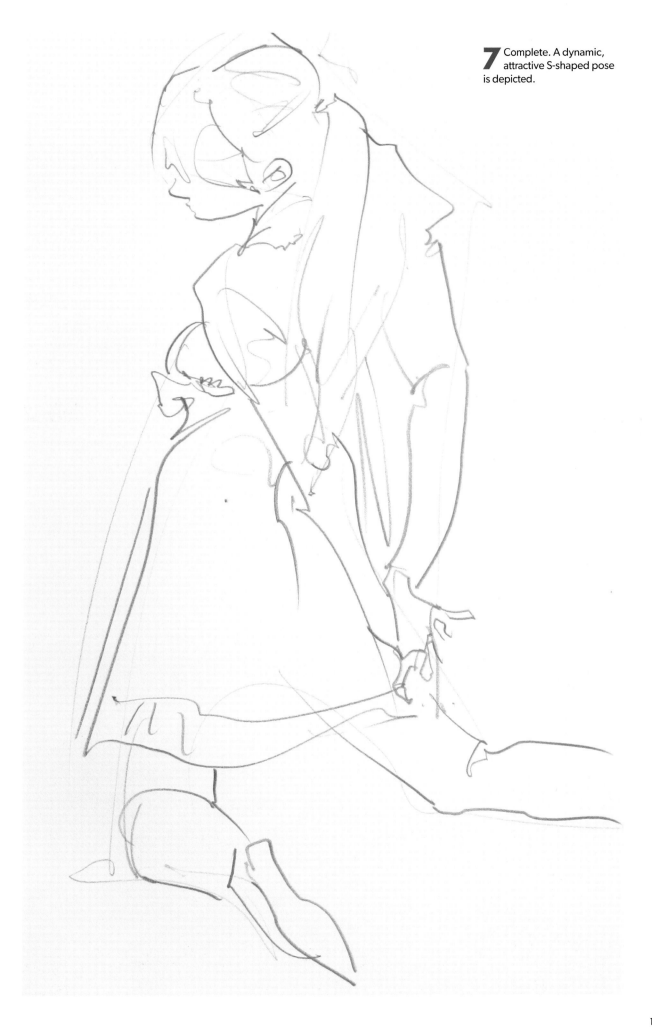

7 Complete. A dynamic, attractive S-shaped pose is depicted.

Kozo Ueda's 2-Minute Croquis [Example 2]

1 Define the bounds of the overall composition with some light guide lines.

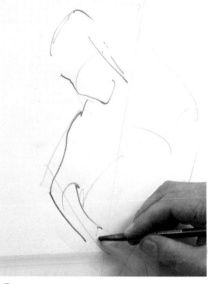

2 Start by drawing the weight-supporting right arm in the foreground.

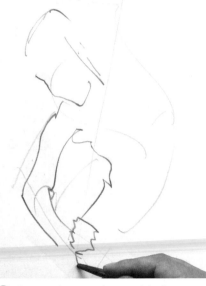

3 Capture the tensed arm and the bent torso, while confirming the shape of the gap between them.

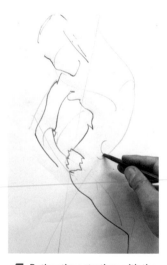

4 Rather than starting with the groin, start drawing from the illium, which is the anatomical root of the leg.

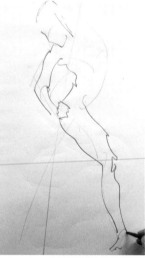

5 Capture the tension of the leg by depicting how it is joined to the ankle.

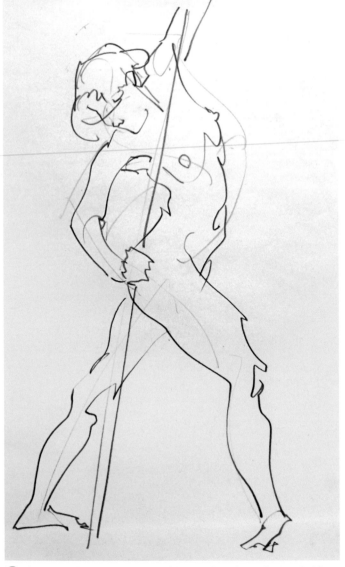

● **About 1 minute in**

6 Depict the twist of the torso by connecting it with the midline leading to the navel.

7 The starting point of the leg has been captured here, in order to express the hidden side of the hip.

8 Complete. The strong shapes of the legs have been depicted with a lyrical line that artfully indicates the knee joints.

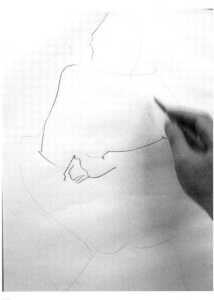

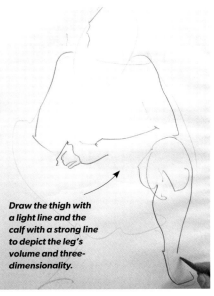

Draw the thigh with a light line and the calf with a strong line to depict the leg's volume and three-dimensionality.

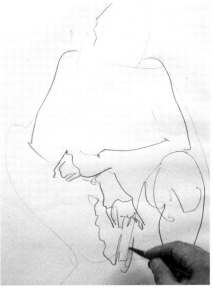

1 Draw the line of the arm that is in the foreground in relation to the shoulder of the other arm.

2 Draw the left shoulder and then the left leg.

3 Contrast the lines of the fabric of the dress with the lines depicting the figure.

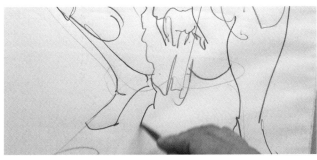

4 Draw the slender line of the heel of the shoe, which is bearing most of the weight of the body.

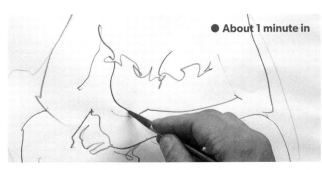

● **About 1 minute in**

5 Contrast the swell of the bust with the rhythmic wavy lines of the gathers of the fabric.

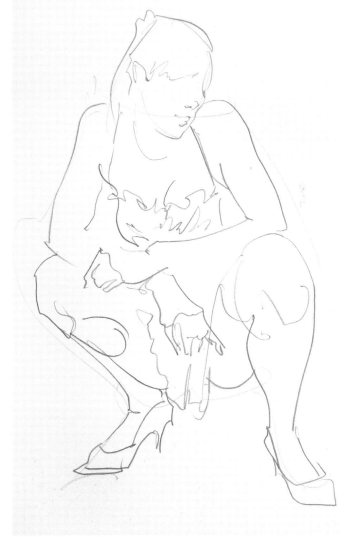

6 Draw the underside of the nose, and depict the tilt of the head and its volume with minimal detail.

7 Complete. I think that I was able to depict the sense of volume and weight of the figure with relatively few lines.

Kozo Ueda's Croquis Techniques (4)

What is a 1-minute croquis? —according to Kozo Ueda

Within only 1 minute, it is still possible to discover the essence of the shape that defines the whole figure. It's important to record the pose before it's lost. You could say that it's a rather experimental way of drawing. There is no time to compare what you are drawing with the subject, so all planning efforts (such as figuring out the composition on the paper beforehand) are eliminated.

Imagine the changes in speed of the lines as they were drawn. With a drawing this brief, you can capture the satisfying undulation of a strenuous pose that can only be held for a few moments.

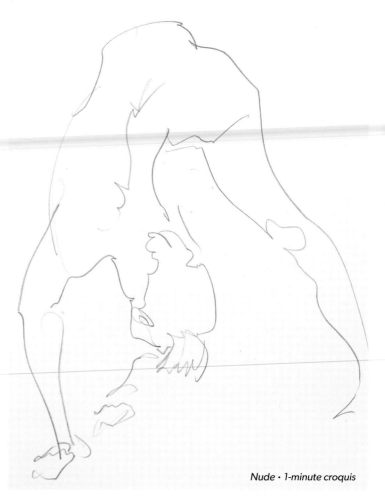

Nude · 1-minute croquis

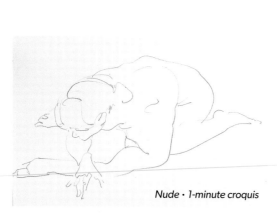

Nude · 1-minute croquis

The shape that depicts the sense of volume is drawn differently than the finer shapes. The soft curves formed by the muscles and fat, and the angular parts where the bone structure can be seen are depicted by lines with contrasting tones.

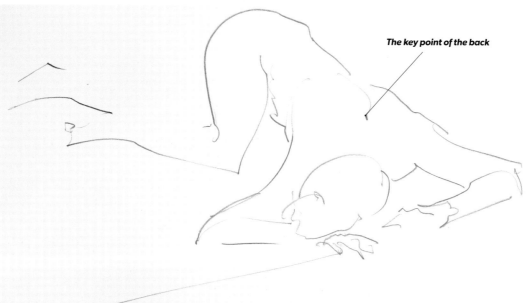

The key point of the back

The twist of the torso is depicted in an interesting way. The presence of the floor is hinted at by the diagonal line.

Nude · 1-minute croquis

This way of drawing captures the pose of the figure and isn't concerned about the details. The elongated and contracted parts of the figure are depicted by varying the strength of the line. Because there is no time to detail the face or the hands, the drawing is limited to indicating the direction the head and wrists face. By concentrating on drawing a single continuous line to outline the shape of the bone structure and muscles, I have expressed the gracefulness of the body.

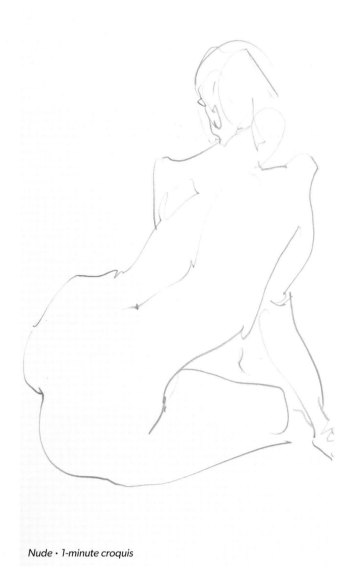

Nude · 1-minute croquis

Nude · 1-minute croquis

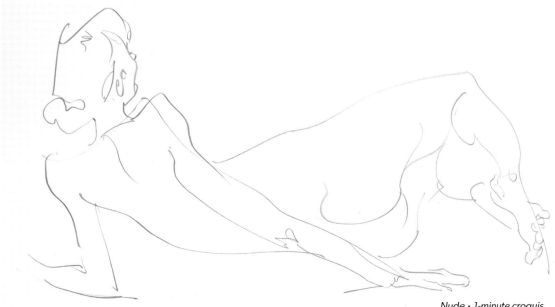

Nude · 1-minute croquis

The orientation of the head is indicated by establishing the position of the tip of the nose and the top of the head.

121

Kozo Ueda's 1-Minute Croquis `Example 1`

Quickly capture the movements of the whole figure, and depict the shapes it makes with lines in the shortest amount of time.

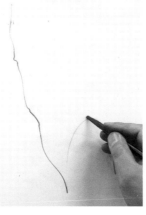

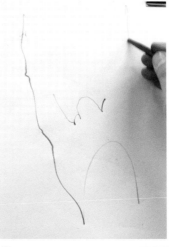

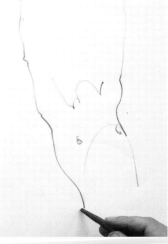

1 This is the line of the ribs that is revealed in this pose. This line is used as the anatomical line between the upper and lower planes of the torso **A** .

2 Capture the position of both arms **B** .

3 The arch of the lumbar area is a characteristic feature of the lower back **C** .

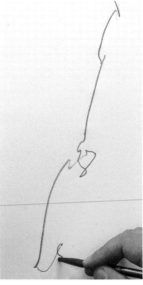

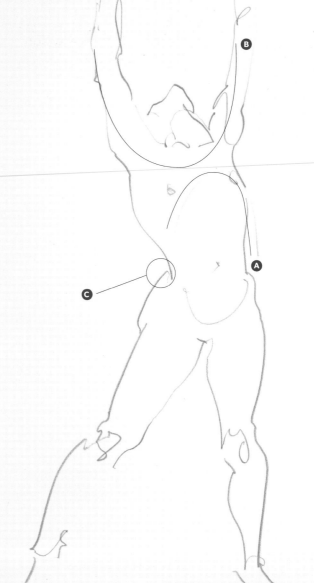

4 Make sure the outline of the foot is clearly defined.

5 The line of the inner thigh does not extend to the feet, but rather terminates at the knee joint.

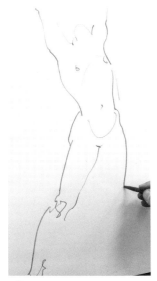

6 Draw the outline of the leg, which drops straight down from the hip bone.

7 The form of the neck and collarbones are captured with a single line.

8 Complete. This simple, dynamic pose has been captured with powerful, free-flowing lines.

122

Kozo Ueda's 1-Minute Croquis `Example 2`

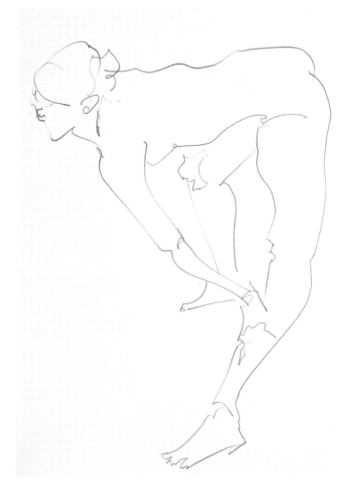

1 This is an attractive pose with a triangular silhouette, created by bending forward.

⑪ The shape of the hand supporting the upper body is captured by the linear row of knuckles.

2 Complete. Capture the outer bend of the legs, and the tension of the left arm supporting the weight of the upper body. The outward bend of the elbow is characteristic of the female body.

Kozo Ueda's 1-Minute Croquis `Example 3`

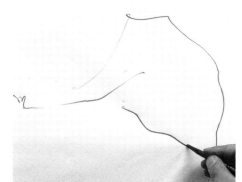

1 The bone structure of the upper body is depicted with a variable line that is in turns angular and rounded.

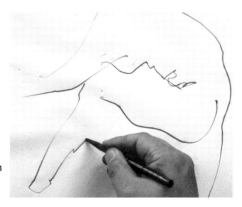

2 The lower body is expressed with free and easy lines.

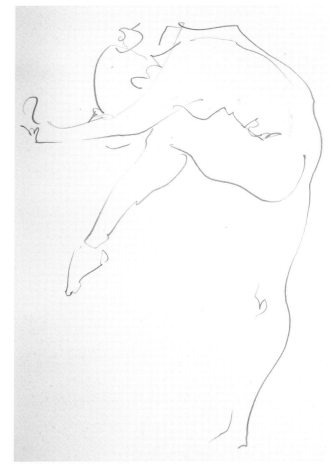

3 Complete. The back side of the right leg is the only part that's fully drawn. For the front part of the leg, just the knee and the top of the foot are depicted. By not drawing the whole leg, the background position of the leg is communicated.

Takahiro Okada's Croquis Techniques (1)

Human beings see things with their brains. The visual information received by the eyes is composited and automatically adjusted into a three-dimensional shape in the viewer's mind. In drawing, that visual information is transferred to two dimensions through the perception and output of the artist. What is called for here is a shape that feels beautiful and balanced—not the precision of an exact copy. When multiple artists refer to the same model, it's okay to have different ways of capturing the subject, depending on the way it's interpreted by the observers.

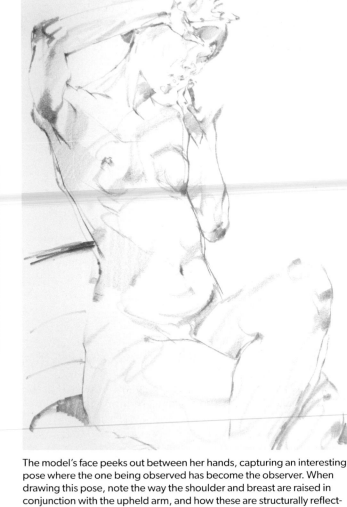

Nude · 10-minute pose

What is a 10-minute croquis? —according to Takahiro Okada

If there are no imposed time limits, it's possible to repeat the four steps illustrated on page 4 (1. Observe; 2. Draw; 3. Compare; 4. Correct) over and over to complete a drawing. But with a 10-minute croquis drawing, you need to do these steps with the minimum of repetition.

** Refer to page 18 for the tip about pleasing abstract lines.*

Camisole Dress · 10-minute croquis

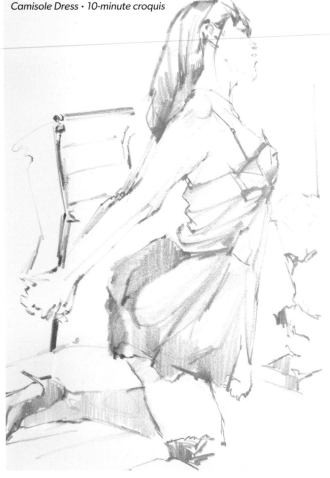

The model's face peeks out between her hands, capturing an interesting pose where the one being observed has become the observer. When drawing this pose, note the way the shoulder and breast are raised in conjunction with the upheld arm, and how these are structurally reflecting the position of the crossed left leg. "Compare" (the third step in the circle of drawing), is the process of comparing the subject to what is put down on the paper, in the effort to weed out problems. If you can't spot the errors, you cannot achieve a "beautiful and balanced" composition.

Camisole Dress · 10-minute croquis

Takahiro Okada's 10-Minute Croquis

Detail of the completed drawing

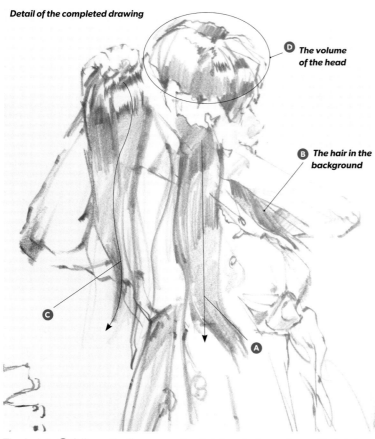

D *The volume of the head*

B *The hair in the background*

C

A

The hair in **A** falls vertically, as gravity dictates. A dynamic quality is introduced as **C** subtly mirrors the curves of the model's body.

Pay attention to the 4 parts of the hair marked **A** to **D** as you define the texture and volume!

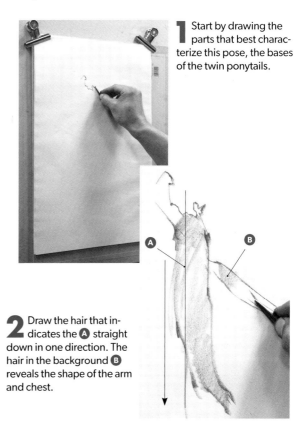

1 Start by drawing the parts that best characterize this pose, the bases of the twin ponytails.

A **B**

2 Draw the hair that indicates the **A** straight down in one direction. The hair in the background **B** reveals the shape of the arm and chest.

● 1 minute in

● 2 minutes in

● 3 minutes in

6 Draw the fingers of the right hand that are grasping the hair.

7 By drawing the hair, the lightness of the fingers that are touching the hair is expressed.

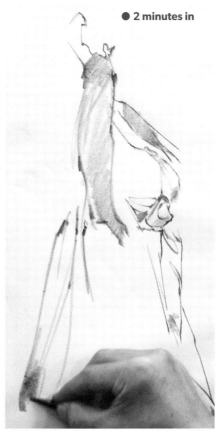

3 Draw the ribbon under the bust.

4 Emphasize the sense of volume of the bust.

5 Continue from the flow of the ribbon to the abdomen and the outline of the skirt.

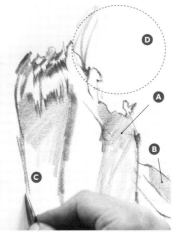

D

A

B

C

8 Draw the line that depicts the fold of the finger joints. Darken the line to express the shine of the hair. Continue to draw the shape of the gathered hair with strong strokes.

● 4 minutes in

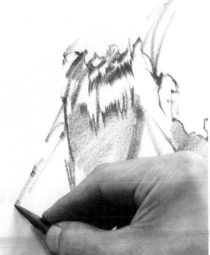

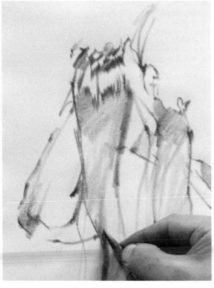

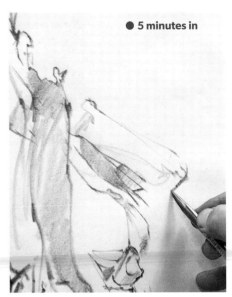

● 5 minutes in

9 Don't just concentrate on the outline. Put in the anatomical line of the left arm at the same time.

10 Emphasize the anatomical line of the elbow in this twisted pose.

11 Draw the left elbow with a fairly weak line, to show its relative position.

Draw the Head

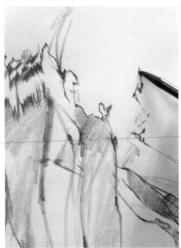

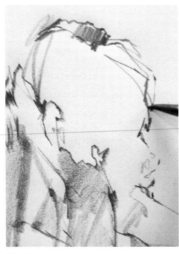

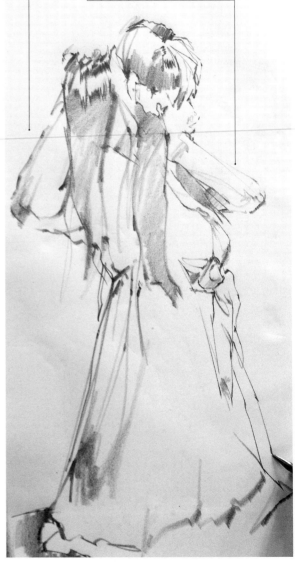

12 Establish the shape of the front part of the pose, in relation to the back of the head.

13 Draw the line from the part of the hair to the midline of the head.

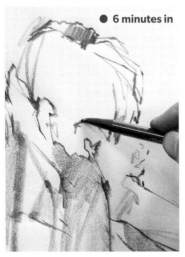

● 6 minutes in

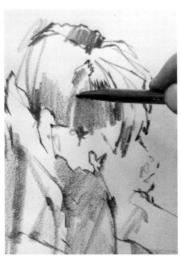

14 Decide on the position of the little finger of the left hand.

15 Emphasize the lightness of the hand by darkening the bangs.

16 The whole composition is becoming clearer now.

7 minutes in

17 Add in the dark shadow on the seat of the chair, and from there go on to the shape of the chair back.

18 Move on from the bone structure to the pattern on the front of the dress. Add the characteristic folds of the dress.

19 Vary the line from thick and thin to add rhythm to the drawing.

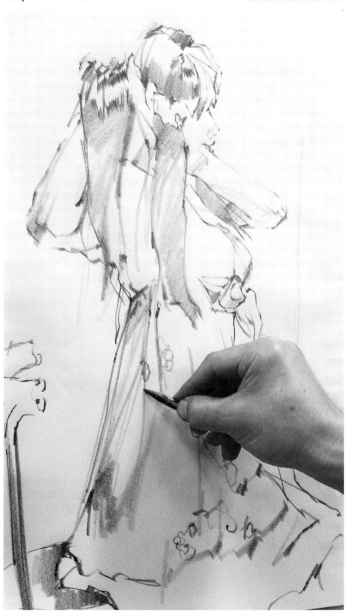

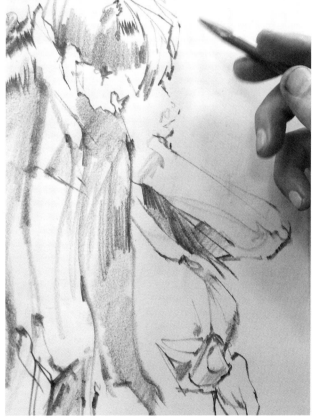

21 The entire figure is now described visually, so we now return to the initial focus point (the hair).

20 Draw in the pattern on the dress, to emphasize the anatomical lines of the dress.

● 8 minutes in

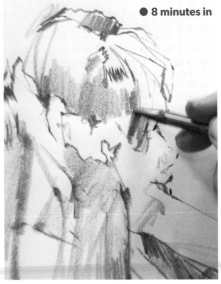

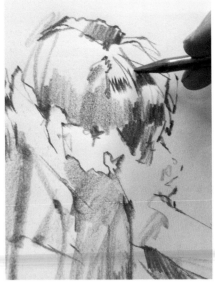

22 To make the lightness of the fingers stand out, add in the darkest shadows of the head.

23 Emphasize the arched form of the bangs with a strong line.

24 Express the shininess of the hair with strong contrasts.

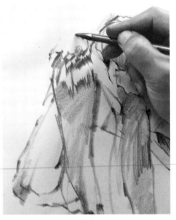

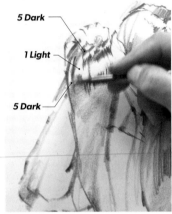

5 Dark

1 Light

5 Dark

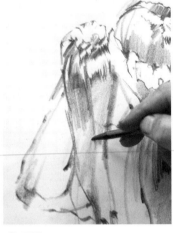

1. Light

2. Moderately light

3. Medium

4. Moderately dark

5. Dark

Beautiful hair is expressed with light, medium and dark tonal values.

25 Just add detail to the most expressive little finger, and treat the rest of the fingers as a silhouette.

26 Strengthen the shadows in the hair, to emphasize the shiny highlights of the hair.

27 Add lines to express the flow of the hair.

● 9 minutes in

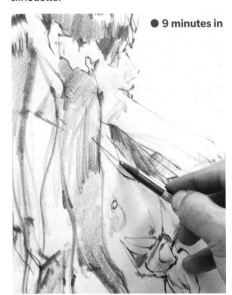

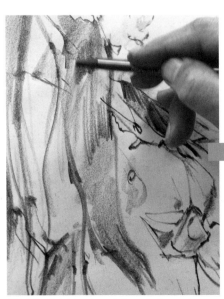

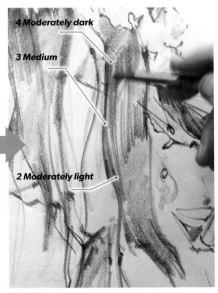

4 Moderately dark

3 Medium

2 Moderately light

28 Add the straight lines of the chain of the pendant, to hint at the midline of the body.

29 Finish up by adding clarity to the image, by emphasizing the hair in the foreground.

30 Hold the Grafwood pencil on its side to add variation to the tones.

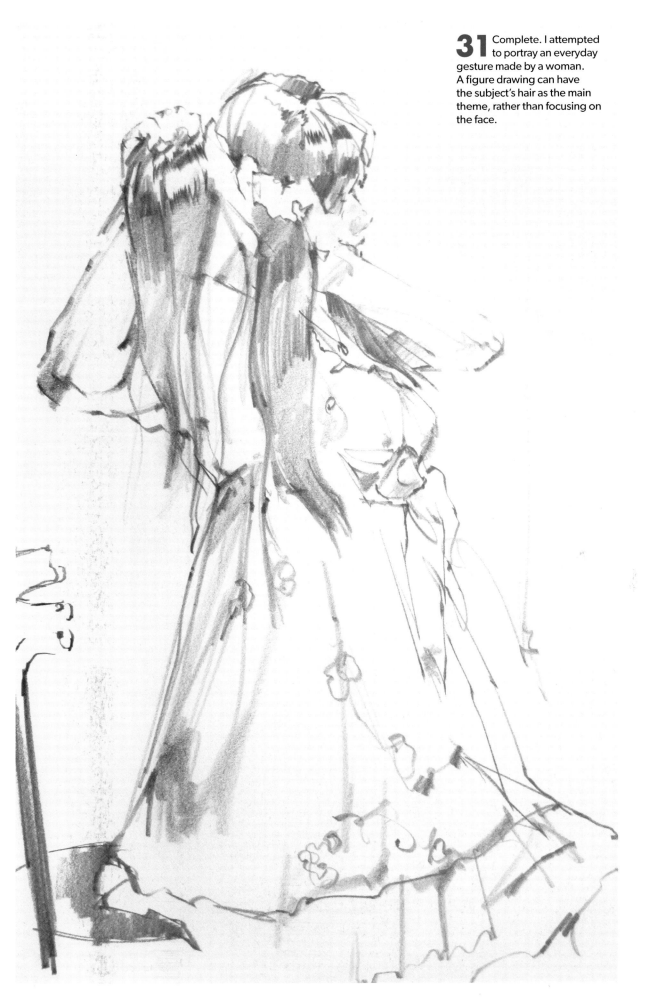

31 Complete. I attempted to portray an everyday gesture made by a woman. A figure drawing can have the subject's hair as the main theme, rather than focusing on the face.

Takahiro Okada's Croquis Techniques (2)

What is a 5-minute croquis? —according to Takahiro Okada

Although it's important to observe everything about the subject you are drawing, in a 5-minute croquis you avoid describing everything you see in the drawing. Omitting some detail has the effect of emphasizing the parts that you really want to feature.

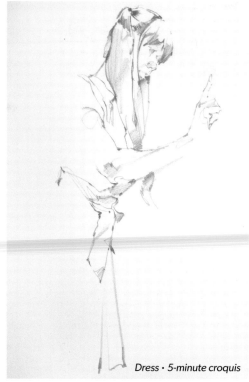

Dress · 5-minute croquis

A pose that shows a fleeting, innocent gesture. By omitting the outline of the back of the figure, the front of the figure with the midline and the arm, which are in the center of the picture, are emphasized.

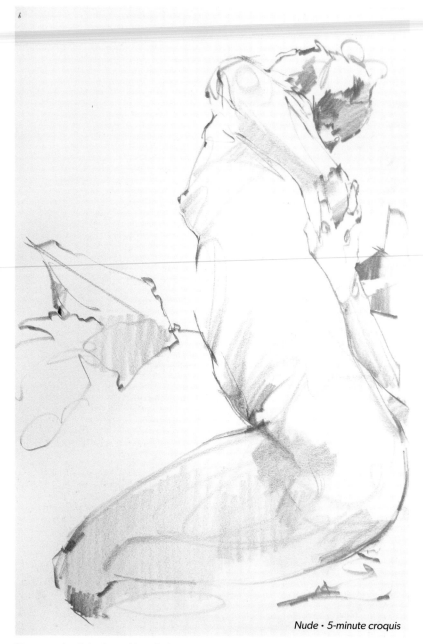

Nude · 5-minute croquis

The upper body is viewed from below, to depict the sense of volume of the human figure. I have added expressiveness to the right hand that is grasping the opposite elbow, to make it the focus of this piece.

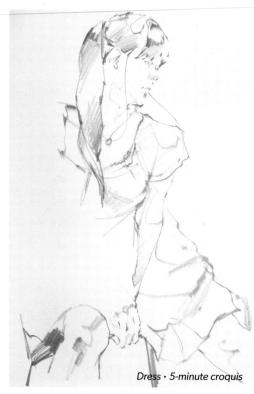

Dress · 5-minute croquis

By emphasizing the ponytail on the right side of the head and making it reflect the left arm, which is supporting the weight of the upper body, I could leave out the right arm.

Takahiro Okada's 5-Minute Croquis

Takahiro Okada · Dress · 5-minute croquis

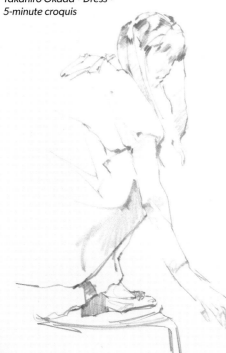

5-minute croquis drawings of the same pose as the one on the left, viewed from different angles.

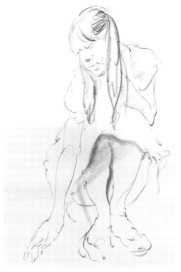

Minoru Hirota · Dress · 5-minute croquis *Kozo Ueda · Dress · 5-minute croquis*

These sketches show the same pose drawn from different angles.

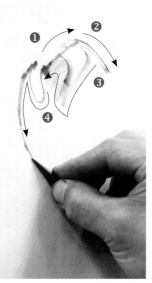

1 The outline of the head starts from bases of the twin ponytails, and flows to the outline of the bound hair.

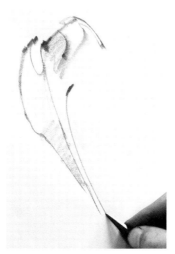

2 The line of the hair merges with the line of the shoulder in the foreground, and becomes a line that depicts the overall structure of the figure.

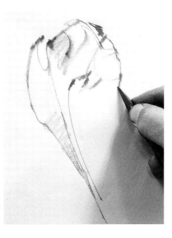

3 Decide on the shape of the bangs.

● **About 1 minute in**

4 Keep the sense of volume of the head in view as you proceed to the facial features.

131

Takahiro Okada's 5-Minute Croquis (continued)

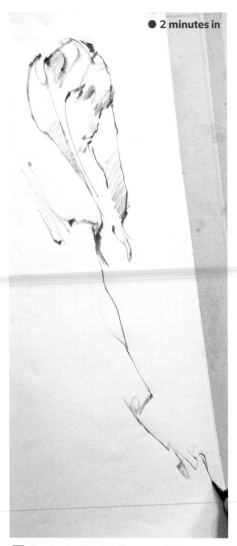

● 2 minutes in

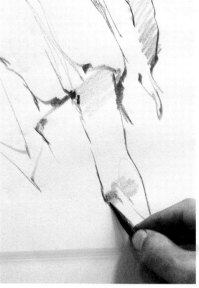

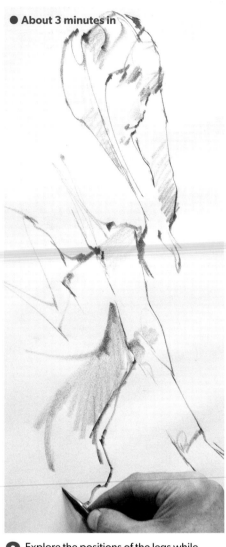

● About 3 minutes in

5 Emphasize the little finger, and then go on to the ring and middle fingers.

6 Draw the elbow, and express its three-dimensionality by adding tones.

7 Express the three-dimensionality of the leg with the anatomical line of the thigh.

8 Explore the positions of the legs while drawing the hem of the skirt.

Finish

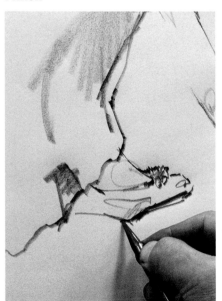

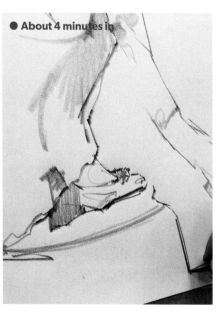

● About 4 minutes in

9 Draw the shoe while being conscious of its contact with the chair surface it stands on.

10 Fill in the shoe to the back of the skirt, and draw the shape of the chair.

11 Add tonal values to the head, while considering how they balance the dark tones of the shoe.

12 Complete. Why wasn't the outline of the back added? I planned to use the lightness of the paper to express the space, and thus omitted the outline for this reason.

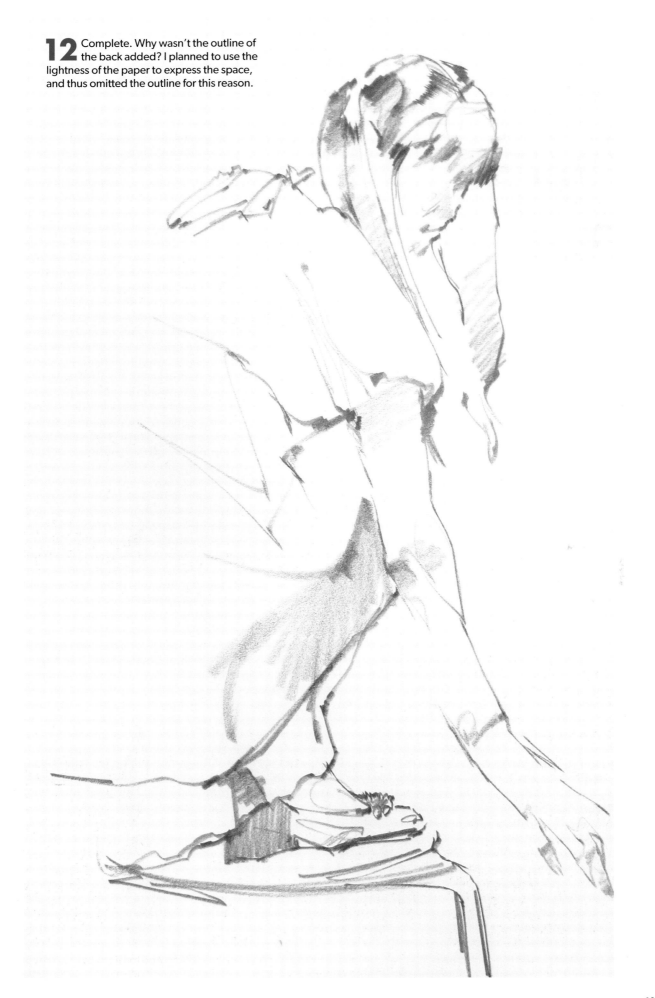

Takahiro Okada's Croquis Techniques (3)

What is a 2-minute croquis? —according to Takahiro Okada

Because the time for comparing and contemplating the subject and what you are drawing has to be cut short, the shape is decided directly on the paper with pencil lines. The outline is not defined with guide lines. The important thing is to have a clear image of the finished drawing. It's necessary to believe in your inspiration and instincts, and to draw in one attempt.

The elongated outlines are drawn with quick lines, and the compressed ones are drawn with bold lines. This pose has a large bent posture. The lines are abbreviated effectively, to emphasize the overall flow.

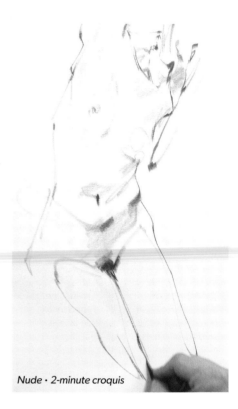

Nude · 2-minute croquis

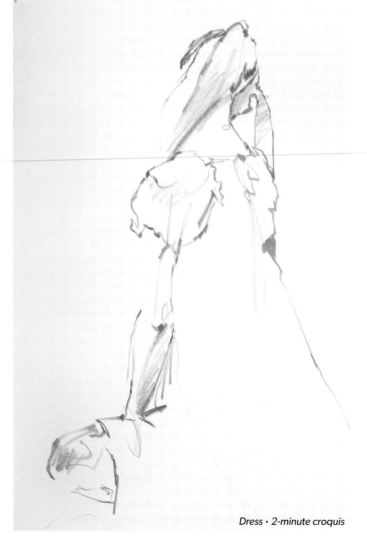

Dress · 2-minute croquis

Compared to a 1-minute croquis, a 2-minute croquis has a bit more time to draw, and there is the feeling of having more time to observe. Because of that it's possible to select your lines thoughtfully.

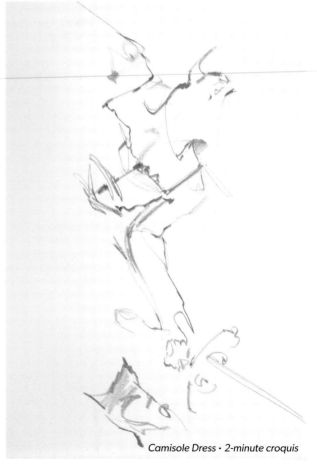

Camisole Dress · 2-minute croquis

In this pose, the left hand holding the sword is thrust forward, and the right arm is raised to maintain balance. Here I have purposefully simplified the face, and emphasized the S-shaped line.

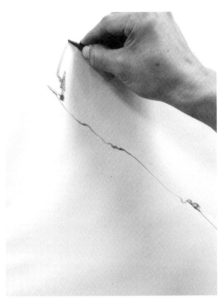

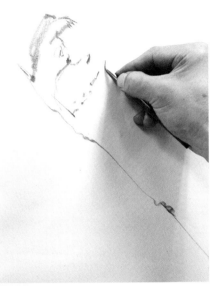

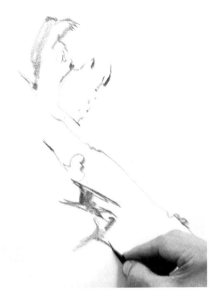

1 Start by drawing the long flowing line from the shoulder that is pushed to the front to the arm, and then decide on the position of the arm.

2 Search out the anatomical line dividing the front and side planes of the head, and then decide on the line of the eyes and nose starting with the eyebrow on the far side.

3 Draw the wrinkles and highlights on the front of the outfit.

● **About 1 minute in**

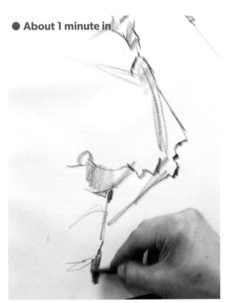

4 Emphasize the strength of the weight-bearing leg by darkening the black of the stocking.

6 Complete. I have indicated the order in which the details of the head are drawn with numbers. This is a pose where the model is swinging down a saber. The mind of the viewer will complete the parts that have been omitted.

Depict the front and back of the outfit by using the side seam as the dividing line.

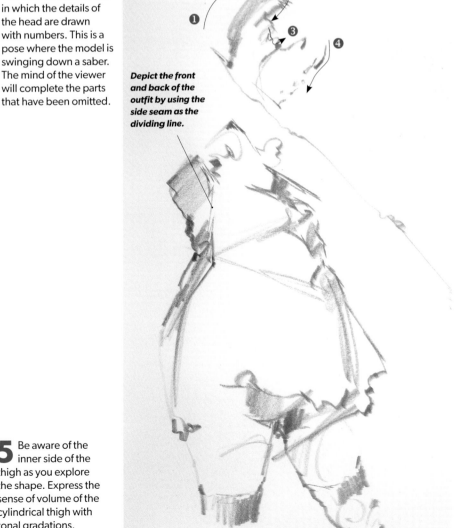

5 Be aware of the inner side of the thigh as you explore the shape. Express the sense of volume of the cylindrical thigh with tonal gradations.

Takahiro Okada's 2-Minute Croquis Example 2

1 Using the line between the face and hair as the starting point, start drawing the lines of the face.

2 Depict the position of the shoulder via the hair resting on that shoulder. Contrast the taut straight line of the shoulder strap with the organic curve of the neck.

3 Express the shape of the breasts as an extension of the shoulder strap.

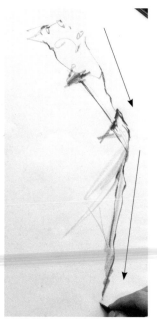

4 Capture the changes in the large planes of the body.

5 Depict the movement the pose possesses with the expression of the wrinkles of the clothing that run from the bust to the back.

● **About 1 minute in**

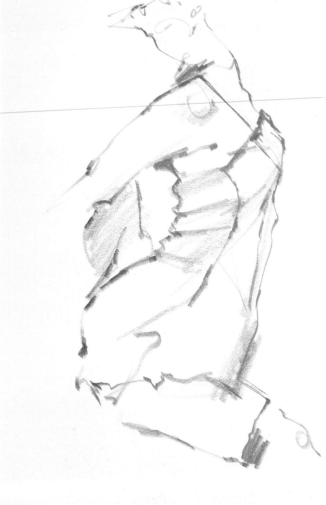

6 It's possible to express the body's movements with the wrinkles on the bodice created by the figure's momentum.

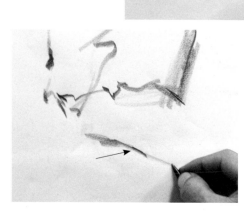

7 By emphasizing where the body comes into contact with its surroundings, you can express its weight. I hinted at the presence of the chair by varying the texture of the line used for the figure.

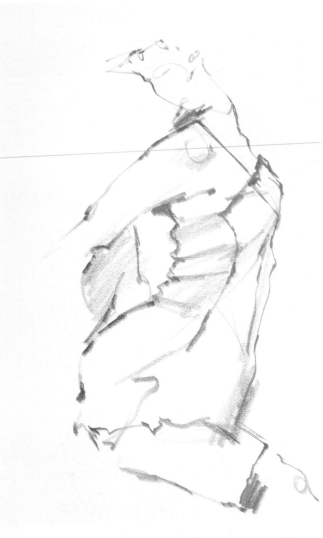

8 Complete. The large Z-shaped movement of the human figure is captured. The chair on which the figure rests is hinted at with the large, blank space around it.

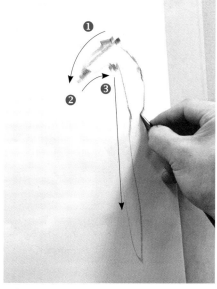

1 Start with the head. Go from the part of the hair on the back of the head to the line of the twin ponytails, which show the pull of gravity.

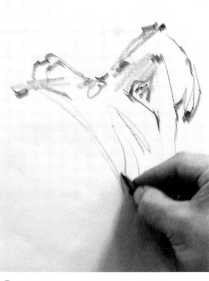

2 Hint at the part of the face that is hidden by the overlap of the ear and shoulder.

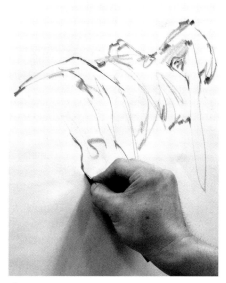

3 Follow the folds of the clothing as you trace the line between the side and back of the body, until you reach the hem of the dress.

4 Draw the thigh in the foreground with strong lines.

5 Draw from the ankle to the toes in one attempt while taking the balance of the composition on the paper into account.

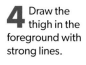 ● **About 1 minute in**

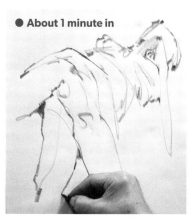

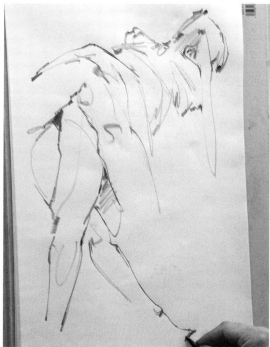

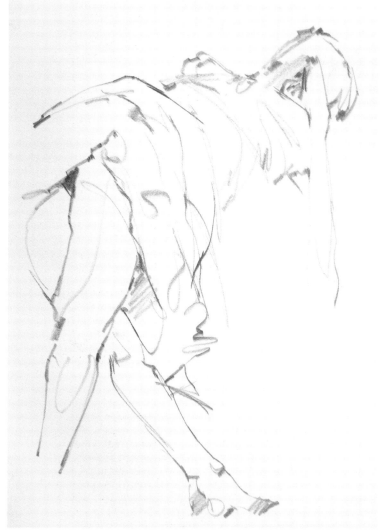

6 Complete. This is a pose where the model is picking something up. The imagination of the viewer is brought into play by purposefully not drawing the toes.

Takahiro Okada's Croquis Techniques (4)

What is a 1-minute croquis?
—according to Takahiro Okada

Because it's crucial to visualize the balance of the composition on the paper and establish the sketch with a minimal amount of details in the shortest amount of time, I feel as though a 1-minute croquis tests all of one's senses. Simplified expressions have the effect of exciting and expanding the imagination of the viewer.

Nude · 1-minute croquis

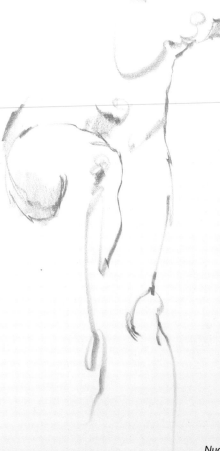

Nude · 1-minute croquis

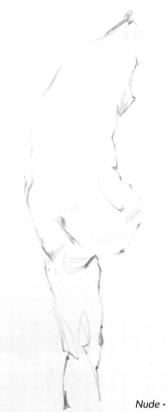

Nude · 1-minute croquis

When doing a 1-minute croquis, be aware of the strength, volume and presence of the subject with your senses, and instead of simply drawing the silhouette, capture those things by varying the strength and speed of the line. Choose the parts you will be leaving out before you start, and keep the final result in mind as you begin your drawing. Here I have captured the raised leg as the key feature and hinted at the basic structure of the figure.

Lines in a 1-minute croquis are drawn by visualizing the overall form first, focusing on the key elements of the sketch, and exploring the shortest route to a satisfactory completion.

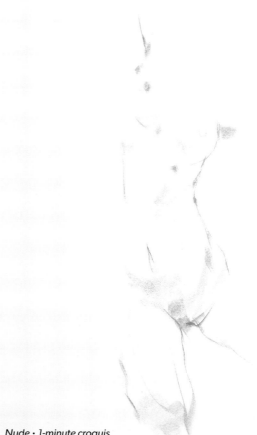

Nude · 1-minute croquis

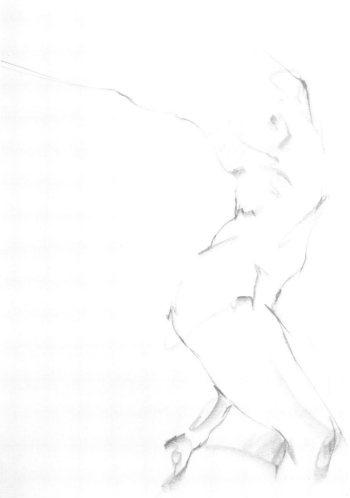

Nude · 1-minute croquis

One of the advantages of doing a croquis drawing in a very short time is that you can avoid depicting the facial features and other details, and instead simply capture the essential features of the human figure, such as the back, torso and legs.

Nude · 1-minute croquis

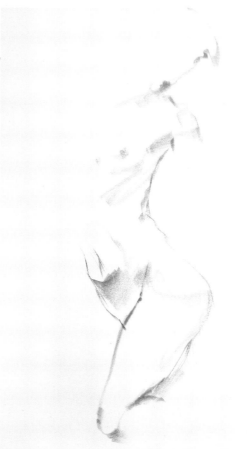

Nude · 1-minute croquis

Takahiro Okada's 1-Minute Croquis Example 1

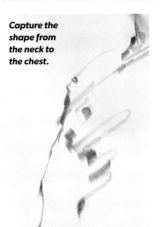

Capture the shape from the neck to the chest.

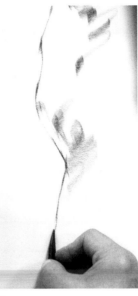

1 Decide on the position of the hip bone, and draw the line of the hip.

2 Look at the anatomical line of the pelvic bone, and decide on the shape of the front of the thigh.

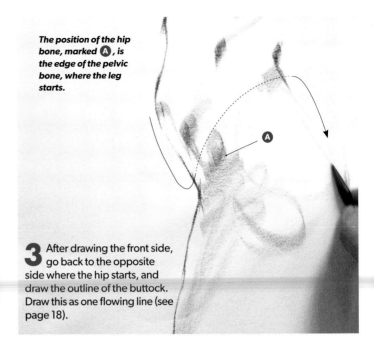

The position of the hip bone, marked Ⓐ, is the edge of the pelvic bone, where the leg starts.

3 After drawing the front side, go back to the opposite side where the hip starts, and draw the outline of the buttock. Draw this as one flowing line (see page 18).

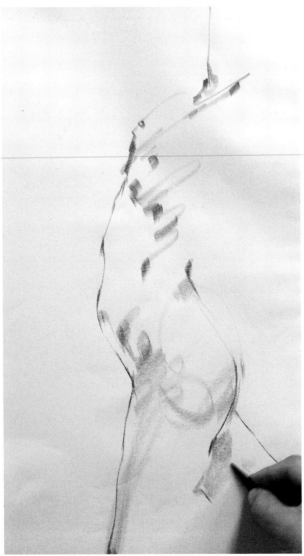

4 By adding the shadow of the back leg, the front leg is brought forward.

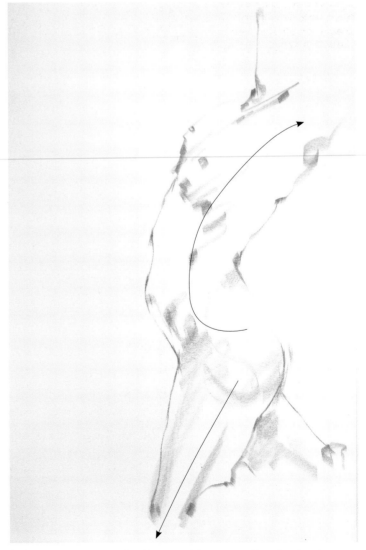

5 Complete. By capturing the twist of the torso and just drawing the beginnings of the limbs, the omitted parts (the ends of the limbs) are suggested. Think of the way the famous Venus de Milo sculpture has no limbs, and you can see what I was after here.

Takahiro Okada's 1-Minute Croquis `Example 2`

The top of the head

1 Decide on the position and size of the head, which will anchor this composition. Go from the chin, clavicle and then to the anatomical line of the breasts, which shows the way the body is facing.

2 From the ribs, capture the volume of the abdomen and the hips.

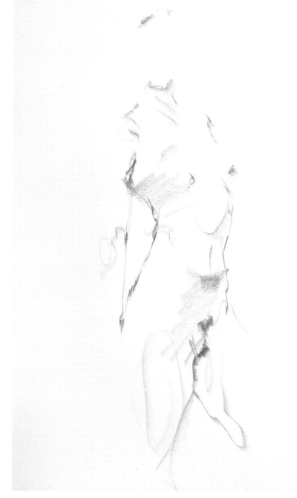

3 Complete. The changes in the lower abdomen below the navel have been captured.

Takahiro Okada's 1-Minute Croquis `Example 3`

1 Start by drawing the line of the back that shows its movement, and from there depict the shape of the back.

2 Draw the elongated line of the left side of the body, as opposed to the contracted, bent line of the right side.

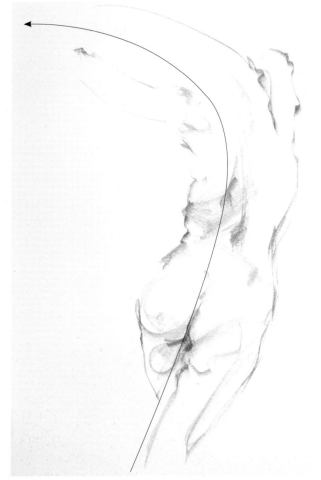

3 Complete. The bow shape (with elongated and contracted sides) is the attractive feature of this pose. The shortened side is drawn with a thick, intermittent line, and the elongated side is drawn with a quick, smooth line for contrast.

Go out in your town to do quick croquis sketches

When I (Minoru Hirota) first started studying art, my teacher told me that, "The model's most beautiful pose is when they are at rest." This means that when someone is relaxed (rather than being conscious of being observed), they are the most natural and beautiful.

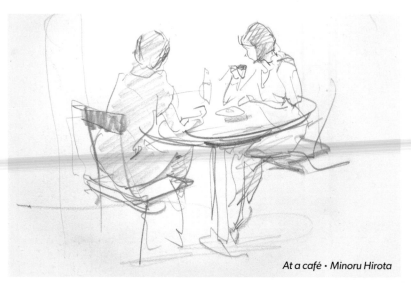

At a café · Minoru Hirota

There are probably at lot of people who would like to draw live models to study drawing, but they can't afford it, or they live in an area where access to facilities with live models is difficult. However, if you shift your focus, and look for people who aren't aware you are observing them and use them as your models, there are many such attractive models all around you. Are any of your family members lounging or watching TV? If you go out on the town, you can see people relaxing in cafés or parks, people waiting on the station platform for a train, people fast asleep on the train…there is an endless supply of models out there.

To do "on the town" drawings, you need to have a small sketchbook or notebook, plus a pencil or a marker pen or any convenient drawing implement that you can draw with. I always have a short pencil stuck behind my ear, like a construction worker does. The subject does not know I'm sketching them, so they may stand up and leave at any time. I don't try to draw them completely, but just try to capture an impression of them. When you get used to it, you'll be able to get down an amazing amount of visual information in just a minute or two, which is a fun challenge! Unlike photographs of people or landscapes, the point of a sketch is not whether you were able to depict the subject skillfully, but how it evokes that time and place when you look at the sketch later, regardless of how short a time you had to execute it. This is because when you're sketching, you aren't just using your vision, but all of your five senses, hearing the sounds around, smelling the scents of the town and so on.

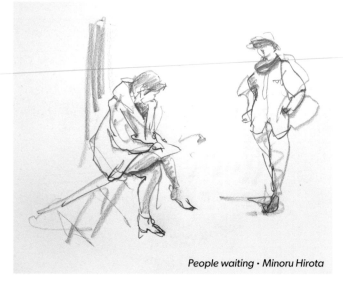

People waiting · Minoru Hirota

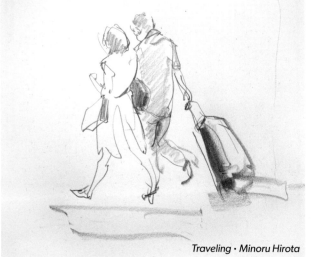

Traveling · Minoru Hirota

What about people who are too shy (or lazy!) to go out on the town to sketch? In that case, try using the images of individuals and groups from the works of great masters like Leonardo da Vinci, Michelangelo, Rafael and Rubens as your models to execute croquis drawings. These masters have already extracted the key points of the subjects for you, so they are very easy to draw, and will be instructive too.

—Minoru Hirota

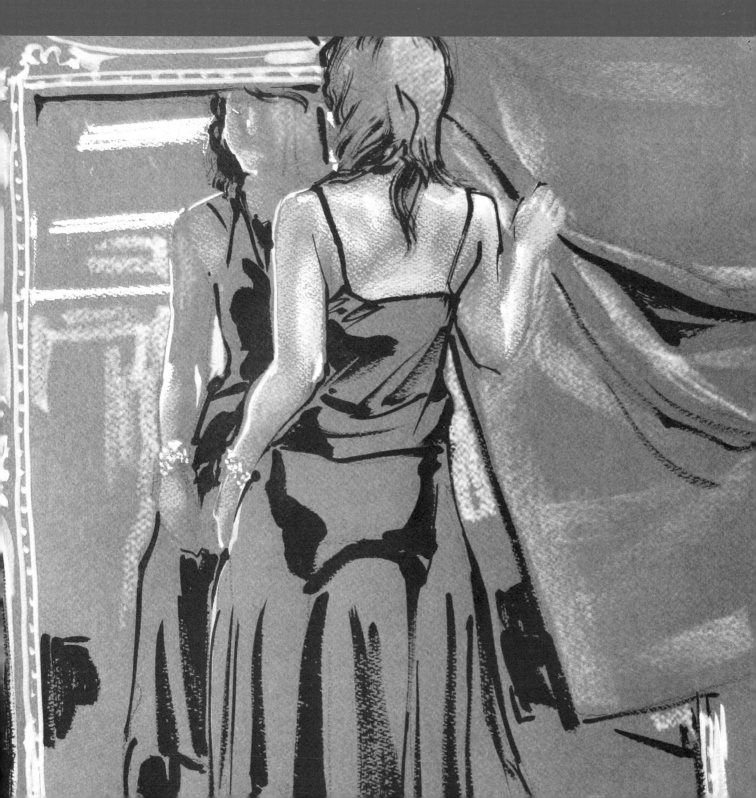

Color Croquis Basics

Light

Use natural colors for the light parts, and whatever color you like for the shadows

Art supplies such as pastels and watercolor paints are particularly suited for quickly capturing a figure using color. Introducing color into your work makes it possible to bring out the attractive features of the subject even more realistically. Using colors, you can instantly impart the appealing tones you see in the model's skin, or the color of the clothing that fills the composition. The human body is often thought of have just being rather monochromatic, but if you search out and depict the anatomical lines of the body accurately, it's possible to give a subtle range of appealing colors of the skin.

The sketch to the left has diagonal lines denoting its shaded area, with the anatomical lines serving as the border between light and dark areas. The light area to the left of the shaded section can be colored with the model's intrinsic* skin color, with the white of the paper showing through as highlights. The shading to the right can be whatever color the artist prefers. Even if the areas of dark shading are filled with a bold color, this face will still look natural.

** **Intrinsic color:** The unique color each person or object reflects.*

Light

The division between dark and light planes

The shaded side

A

B

C

The bright side where the light hits

The sketch above depicts a white egg. The intrinsic color of this egg is white of course, but even if you don't use white and gray you could still depict this egg.

A The light side is the intrinsic color, white.

B The line between planes (the "anatomical line") is the border between light and dark areas. Add whatever color you prefer for this line. However, its tonal value should fall in between the A and C values.

C The part to the right of the anatomical line between planes (including the reflected light) can be the color the artist feels is right or imagines being there.

However, if you choose to get creative and use a color in the A area other than the object's intrinsic color, the color of A will appear to the viewer as that object's color. For instance, if you use a sky blue color here, it will look like a blue egg, and if you use yellow, it will look like a yellow egg, and so on.

Fabric with a Shiny Texture

The transition from light to dark tones is abrupt.

A

C

B

Fabric with a Dull Texture

The transition from light to dark tones is gradual.

B

A

C

Outfits worn by models are usually made of woven fabric. The texture of fabric can be depicted with changes in tonal values. The rules used for monochrome tonal value transitions can also be applied to situations where color is used.

144

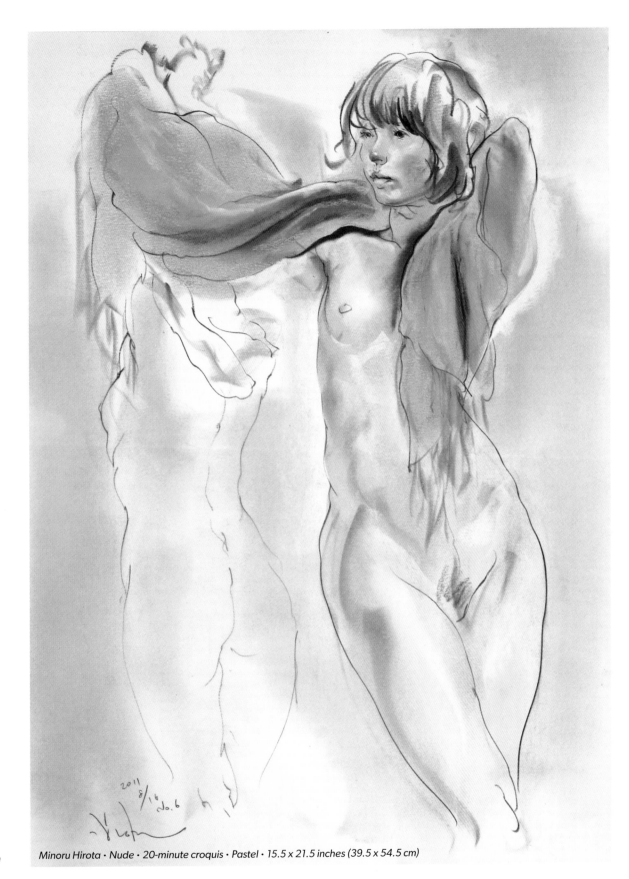

Minoru Hirota · Nude · 20-minute croquis · Pastel · 15.5 x 21.5 inches (39.5 x 54.5 cm)

**Orange
(a reddish
orange)**

Complementary
colors

**Green
(a blue-green)**

The Color Wheel

A circle in which colors are arranged in order of their appearance on the spectrum is called the color wheel. The colors on opposing sides of the wheel are called complementary colors.

Brightness is the relative lightness or darkness of a color. For example, if you mix black into red its brightness will be lowered, and if you mix in white it will be raised.

In this drawing, green, which is the complementary color to orange, the color of the shawl, has been use in the shaded areas of the skin. The anatomical lines have been drawn in dark brown, which has a lower brightness than the orange or green.

Color Croquis Drawn by Minoru Hirota

1 The anatomical lines of the body are drawn in dark brown, and the shaded and the reflected light parts in green and blue. The light parts are a blend of white and the model's skin color.

2 Focus on the line between planes of the tank top (around the model's flank). The relationship between the line in between planes or the anatomical line and the intrinsic color of the subject applies to the expression of fabric too.

3 The explanation of the relationship between the intrinsic color and the optional shade color separated by the anatomical line of the face, as described on page 144, can be adapted for the whole body too. This is a pose where the contrast between the parts of the body where the bone structure is evident, such as the shoulder and scapula, and the voluminous line of the hip and buttocks is beautiful.

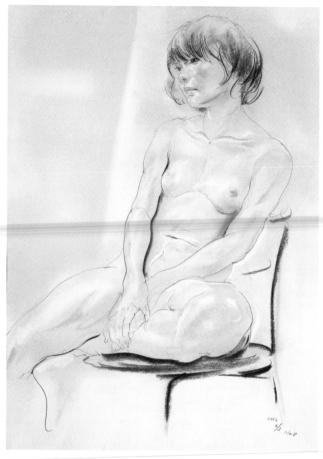

1 *Nude · 20-minute pose*
15.5 x 21.5 inches
(39.5 x 54.5 cm)
Pastel and charcoal

2 *Clothed · 20-minute pose*
21.5 x 15.5 inches (54.5 x 39.5 cm)
Pastel and charcoal

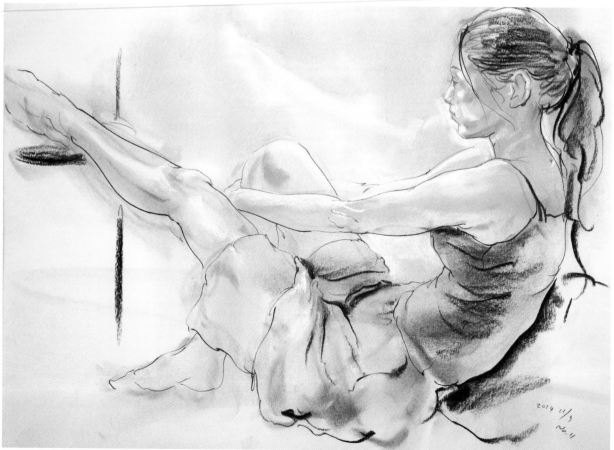

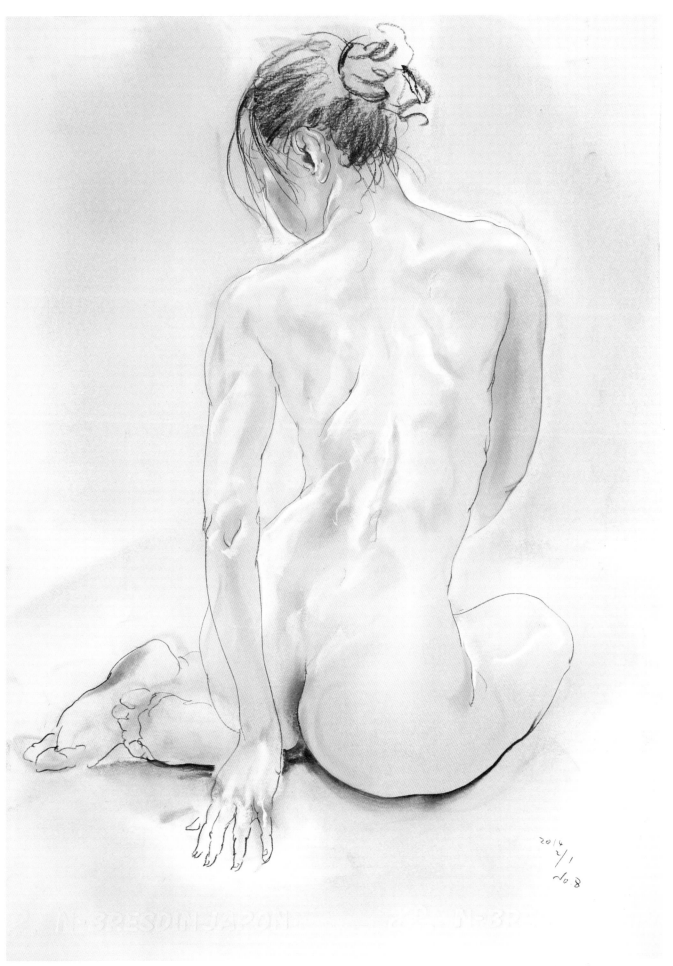

3 *Nude · 20-minute pose · 15.5 x 21.5 inches (39.5 x 54.5 cm) · Pastel and charcoal*

Color Croquis Drawn by Kozo Ueda

1 Black is often thought of as a being "colorless," but it actually has a very deep color that is brought out by varying the tone. Here I have grouped the shadows by using a light wash of sumi ink, to make the three-dimensional parts easy to see. Mashing the brush tip to add fine brush lines lends variation, and using a thick, unrefined line expresses a sense of volume and scale. I always try to go for a striking visual effect by simplifying the lights and darks and working with high contrast colors, while always keeping in mind the balance and flow. By simplifying the outlines, a sense of space is created in the blank parts of the composition.

2 3 I have rubbed pastel into the paper boldly, to express the movement of the figure. Rather than trying to recreate what the eye sees, I have exaggerated the changing shapes of the body, to emphasize the implied motion in a stylistic way.

4 5 In these drawings, I have used pastels on a gray Canson paper to express the volume of the figure. Because the sumi ink tends to drag the unprotected pastel particles across the paper, I applied a fixative spray to the pastel to protect it before adding the sumi ink lines. Because the shapes are already evident from the pastel base, the ink lines can be drawn freely and without hesitation. Add tonal values with the sumi ink brush, and then add highlights to finish. It's important to match the tonal values of the pastel colors used to the gray of the paper.

4 *Clothed · 20-minute pose*
Pastel and sumi ink

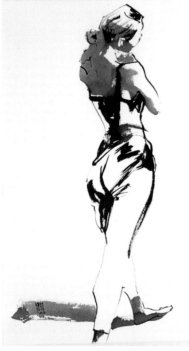

1 *Clothed · 5-minute illustration · Sumi ink*

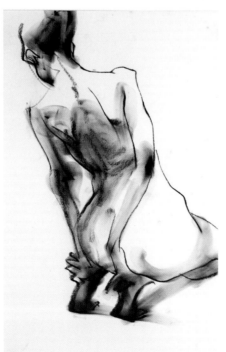

2 *Clothed · 5-minute illustration · Pastel*

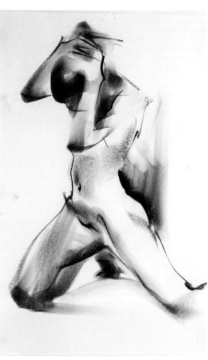

3 *Clothed · 5-minute illustration · Pastel*

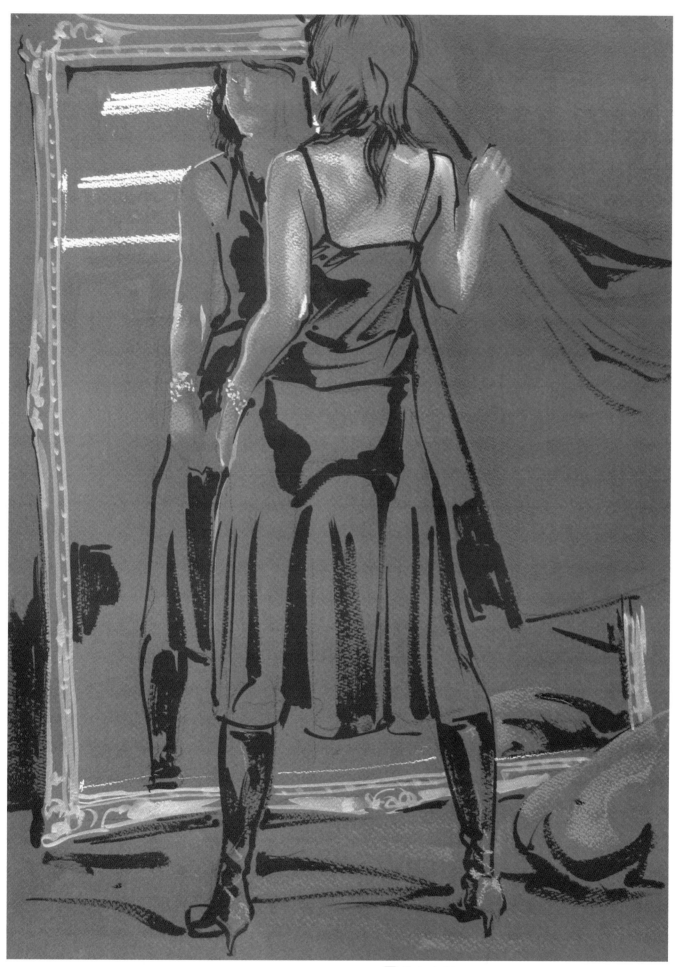

5 *Clothed · 20-minute pose · Pastel, sumi ink, gold paint (kindei)*

Color Croquis Drawn by Takahiro Okada

1 2 These sketches were made on rough-surfaced charcoal paper that I underpainted with yellow-gray for a toned base. When using an underpainted paper, think of using colors in your drawing that will enhance the underpaint color as much as possible. The underpainted color makes it possible to depict the human body with a minimum of effort. Rather than rubbing in an opaque pastel as the intrinsic color of the skin, I chose a base color that would harmonize with the intrinsic color of the skin. When pastels are rubbed into the paper, they become transparent, and so you can make use of the underlying base color. I also added the reflected light on the shaded side of the anatomical lines.

3 4 I have underpainted these drawing with acrylic gouache (an opaque watercolor paint). I mix the acrylic gouache color I'm using with 10% of its volume of clear gouache (a semi-transparent underpainting medium). Clear gouache doesn't have any color of its own, but it adds a rough texture ("tooth") to the paper, which makes the pastel particles adhere to it more effectively. In these pieces I've used a violet-gray base color. The anatomical lines are drawn with a darker tone than the underpainting, and the light and dark sides are separated by that line. I used the model's intrinsic skin color on the light side, and cool colors on the shaded side, thereby adding contrast between warm* and cool* colors to express light and dark.

*__Cool colors:__ Colors that have a cold feeling.
In general it refers to colors in the blue and green range.*

*__Warm colors:__ Colors that have a warm feeling.
In general it refers to colors in the yellow and red ranges.*

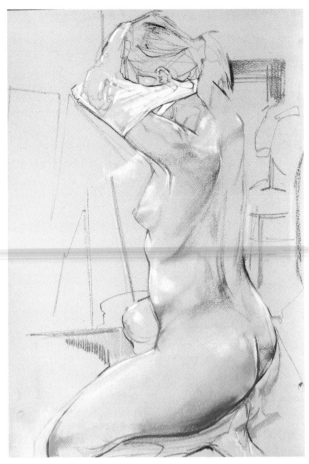

1 *Nude · 20-minute pose · 21 x 26.75 inches (53.5 x 68 cm) · Pastel*

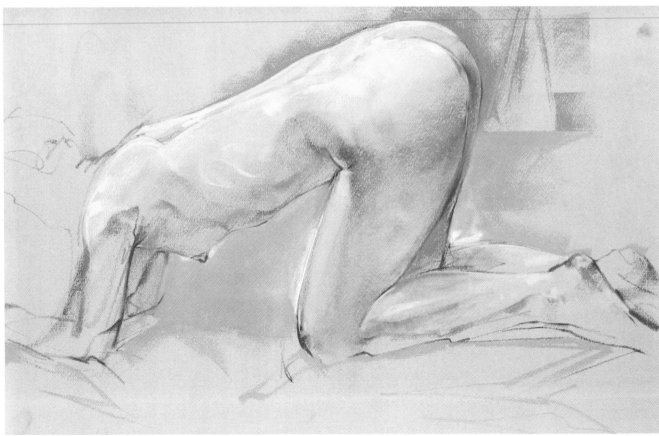

2 *Nude · 20-minute pose · 26.75 x 21 inches (68 x 53.5 cm) · Pastel*

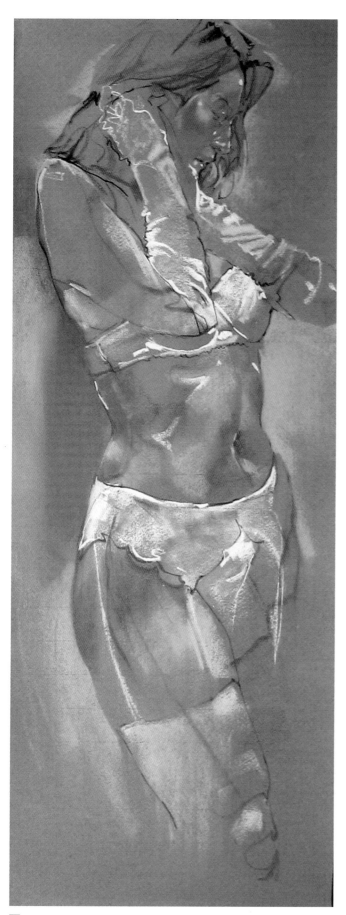

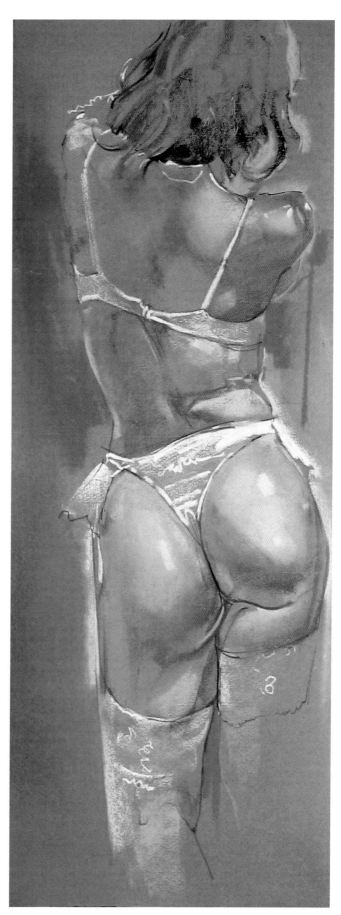

3 *Nude · 20-minute pose · 10.5 x 26.75 inches (26.7 x 68 cm) · Pastel*

4 *Nude · 20-minute pose · 10.5 x 26.75 inches (26.7 x 68 cm) · Pastel*

Art Materials for Color Croquis—Pastels

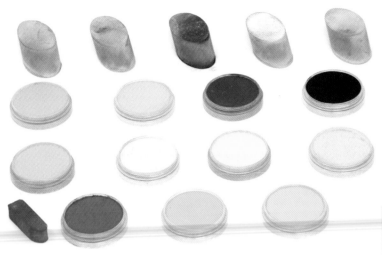

Pastels are well-suited to croquis drawing, because you don't need to wait for it to dry as you do with watercolor paints. Stick type pastels are common, but pan pastels applied with a sponge are useful too.

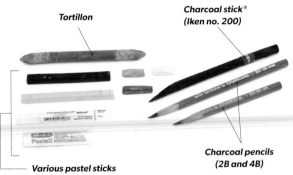

Tortillon

Charcoal stick (Iken no. 200)*

Various pastel sticks

Charcoal pencils (2B and 4B)

Pan Pastels and Sponges

These are Minoru Hirota's color croquis materials. Pan pastels look like cosmetics; you put the powder on a sponge and rub it onto the paper. It is possible to use these to cover a large expanse, as well as to blend multiple colors right on the paper.

***Charcoal sticks** are soft drawing tools made by steam-burning twigs of willow and other types of wood. Charcoal pencils are made by mixing charcoal powder with clay to harden it, making them ideal for creating strong black lines.

How to Use These Art Materials

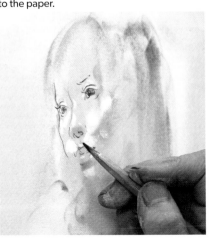

Dab a sponge in the pan pastel and apply it to the paper.

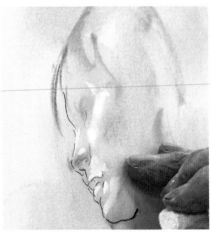

Rub the pastel with your fingers. The powder sits on the surface of the paper, so you can spread it around.

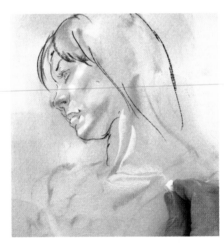

Add highlights with a white pastel stick.

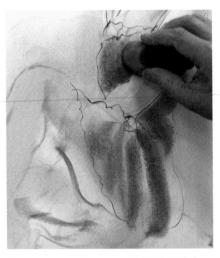

Draw the lines with a charcoal pencil. Use a light and fine black line to draw small details.

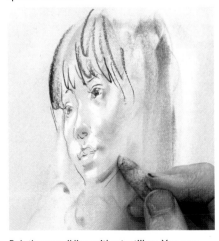

Rub the pencil line with a tortillon. You can also add tones by varying the pencil pressure.

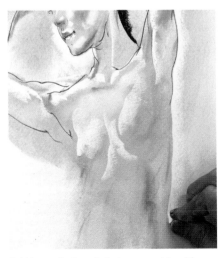

Add tones that are faded on one side with a white pastel stick.

Pastels Are Perfect for Depicting the Skin of a Human Body!

A *The bright part where the light hits (the white of the paper)*

If you just rub the pastel onto the raised parts of the paper surface, it will have a rough texture like the dark part along the line between the planes on the egg. If you rub and spread the powder, you can depict a soft shade as in the reflected light part of the egg.

Because the powder of pastel is just sitting on the surface of the paper due to friction, if you rub it you can achieve complex color blends. You could say that it's the perfect medium for expressing the delicate tones and roundness of human skin.

B *For dark parts such as the part along the line between the planes, leave the texture rough by not rubbing it into the pores of the paper.*

C *For lighter parts like the part with reflected light, rub the pastel powder into the pores of the paper.*

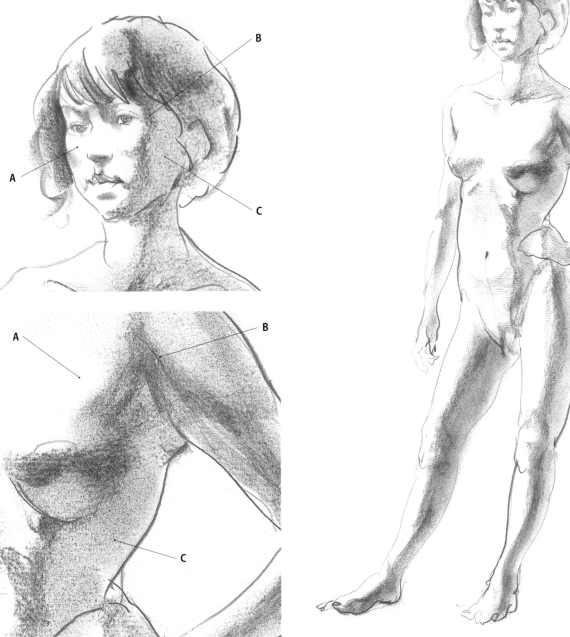

A *The bright part where the light hits*

Minoru Hirota · Nude · 5-minute croquis · 11.75 x 17 inches (30 x 43.5 cm)

153

Take the Moving Croquis Challenge

In a regular croquis session, you make a drawing of a pose taken by the model for a fixed amount of time. The model is required to move as little as possible, and the artist captures a "snapshot" of human movement. In contrast, in a moving croquis session the model is asked to move freely, and the artist observes that movement to draw it.

▌ Minoru Hirota's Take on Moving Croquis

"When you draw a moving subject, the element of movement over time is added as a fourth dimension, and you can depict that fourth dimension on the two-dimensional paper. The direction in which the model is moving is outside of your control, but by layering in traces of the subject's movement on the work surface, an intriguing portrayal can be achieved."

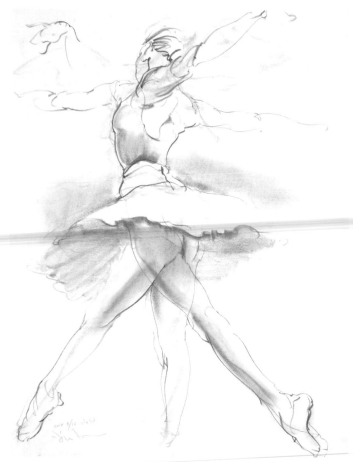

1 January 31, 2014, no. 56 · Moving 6-minute croquis
19.75 x 25.5 inches (50 x 65 cm) · Charcoal

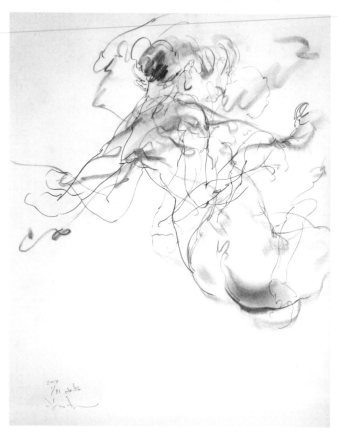

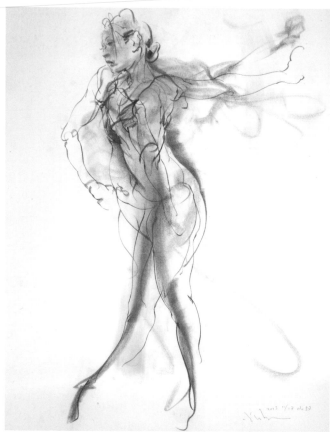

2 August 14, 2014, no. 57 · Moving 6-minute croquis
19.75 x 25.5 inches (50 x 65 cm) · Charcoal

3 November 17, 2014, no. 57 · Moving 6-minute croquis
19.75 x 25.5 inches (50 x 65 cm) · Charcoal

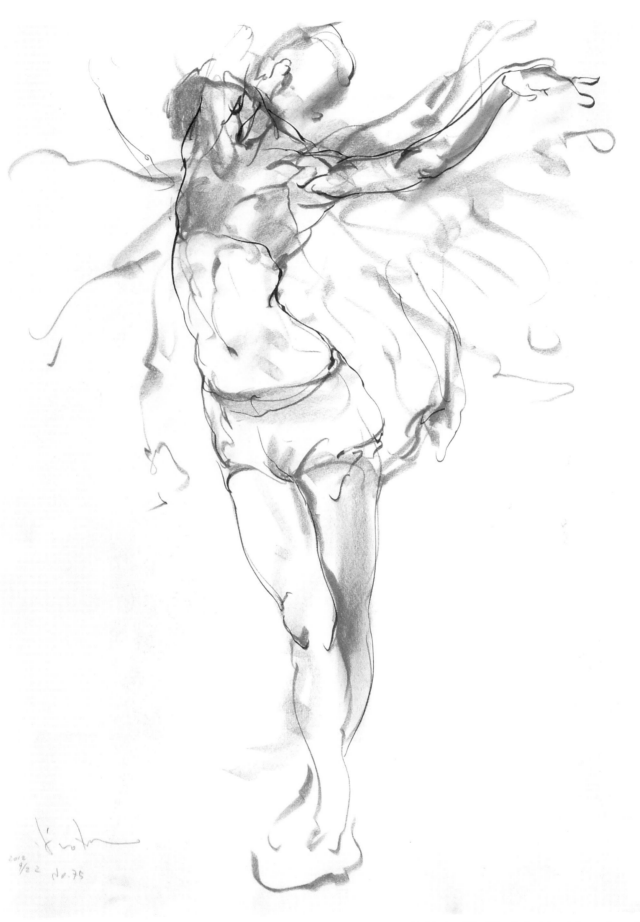

September 22, 2012, no. 75 · Moving 6-minute croquis · 19.75 x 25.5 inches (50 x 65 cm) · Pastel and charcoal pencil

Kozo Ueda's Take on Moving Croquis

"Unlike photographs that capture a split second image, the world as seen through the human eye is stitched together in the back of the brain like reconstructed time lapse images. You could say that the world captured with the naked eye consists of glimpsed memories that we live within. Drawing is the process of determining how you regard the human body. I feel that the moving croquis method is indeed the authentic croquis method."

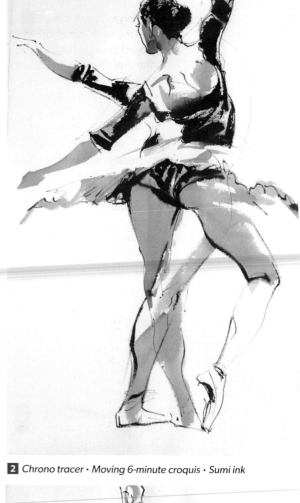

2 *Chrono tracer · Moving 6-minute croquis · Sumi ink*

1 *Time · Moving 6-minute croquis · Pencil*

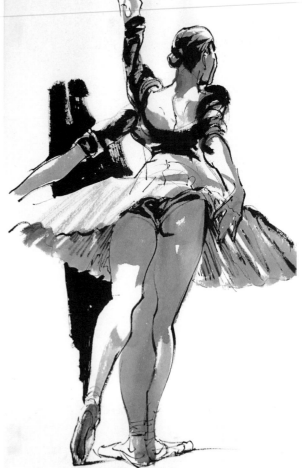

3 *Chrono tracer · Moving 6-minute croquis · Sumi ink*

Takahiro Okada's Take on Moving Croquis

"To someone who is still developing as an artist like me, moving croquis is a theme that always leaves me with homework to do. Because you are drawing the moving subject (the model), the things you need to depict naturally differ from those of a still-pose croquis. One thing you can say is that the point of a moving croquis sketch is to explain "how the subject moved." If you simply keep drawing the weak after-images in your memory, it just becomes an inferior composite, like a sequence of superimposed photographs. "Drawing the shapes that moved" and "drawing movement" are fundamentally different things.

I believe that what has to be expressed in a moving croquis is the "movement of time." In order to extract the quintessential shapes (not just the shapes you can see, but the ones you can't see such as the shapes and lines that make the viewer sense movement) from a huge amount of information, you need a sharp memory on top of a developed ability to observe and keen artistic sensibilities. How do you express the subject? You need to work this out for yourself at your own pace. That's the interesting part of moving croquis."

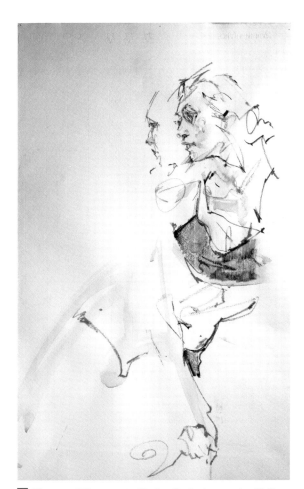

2 *Memory of Movement · Moving 6-minute croquis · 12.8 x 19.7 inches (32.5 x 50 cm) · Pencil, transparent watercolors*

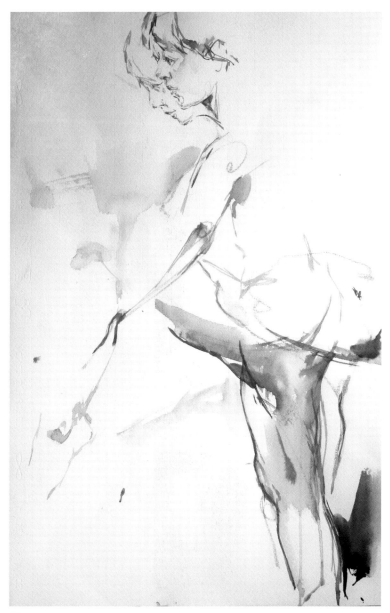

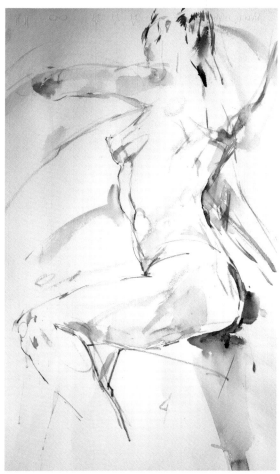

1 *Memory of Movement · Moving 6-minute croquis · 12.8 x 19.7 inches (32.5 x 50 cm) · Pencil, transparent watercolors*

3 *Memory of Movement · Moving 6-minute croquis · 12.8 x 19.7 inches (32.5 x 50 cm) · Pencil, transparent watercolors*

157

About the Artists' Working Environment

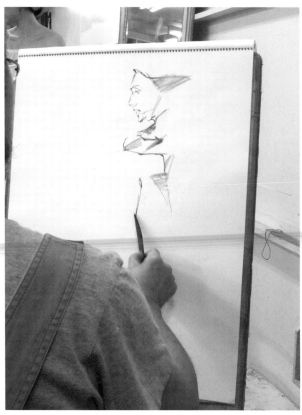

The croquis drawings in this book were all executed with a model posing for the artists. With the exception of the color and moving croquis examples, all the sketches were executed within 10-, 5-, 2- or 1-minute time limits. Because we were doing a lot of drawings in a short amount of time, we all used thick croquis pads with thin paper.

● **Approximate Size of Croquis Paper**

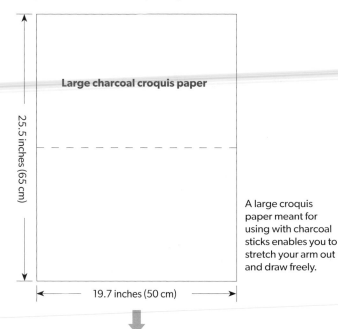

Large charcoal croquis paper

25.5 inches (65 cm)

19.7 inches (50 cm)

A large croquis paper meant for using with charcoal sticks enables you to stretch your arm out and draw freely.

Working on a large (19.7 x 25.5 inches / 50 x 65 cm) charcoal croquis pad. Although it's well-suited for croquis drawings of the human figure, it can be a bit on the large side for everyday drawing. It has the same dimensions as a French P15-size canvas.

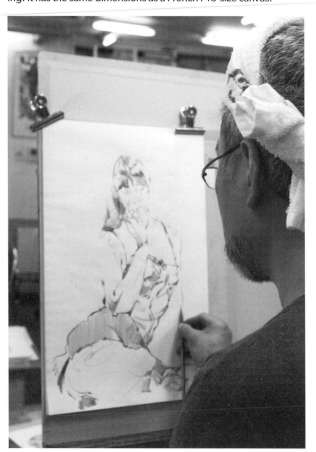

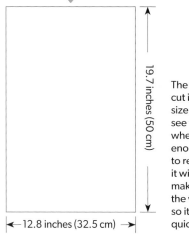

19.7 inches (50 cm)

12.8 inches (32.5 cm)

The above large sheet cut in half is a handy size, because you can see the whole surface when you're close enough to the paper to reach every part of it with your arm. This makes it easier to grasp the whole composition, so it's a great size for quick croquis drawings.

Unless otherwise indicated, all the croquis drawings in this book have been executed on the half-size croquis paper shown directly above, which is 12.8 x 19.7 inches (32.5 x 50 cm). It's best to have a large sheet to work on for croquis because it helps to increase your awareness, but then you will need an easel to work on. If you are holding a croquis pad in your hand while working, we recommend a pad that's 17.9 x 20.9 inches (45.5 x 53 cm—F10 size in Japan), or 20.3 x 14 inches (51.5 x 36.4 cm—B3 size in Japan) in size.

Most of the examples in this book have been done on the half-size paper described on this page, which is easier for croquis beginners to deal with.

● **How to Position Yourself in Relation to the Model**

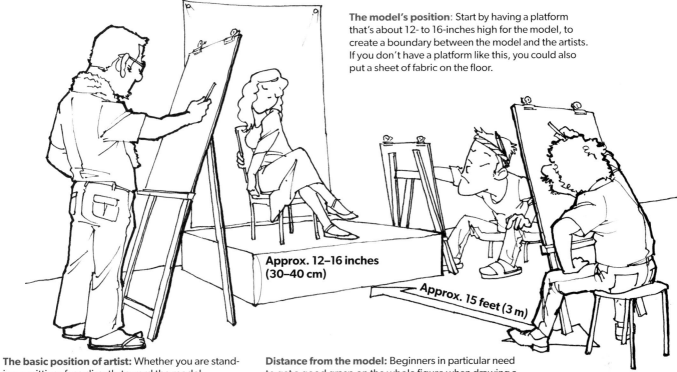

The model's position: Start by having a platform that's about 12- to 16-inches high for the model, to create a boundary between the model and the artists. If you don't have a platform like this, you could also put a sheet of fabric on the floor.

Approx. 12–16 inches
(30–40 cm)

Approx. 15 feet (3 m)

The basic position of artist: Whether you are standing or sitting, face directly toward the model.

Left-handed people should have the working surface to the right of the model, and right-handers should have it to the left side, so that you can compare the model to the drawing without moving your head. Be sure to maintain proper posture, otherwise your point of view will be unstable and it becomes difficult the draw the outlines or the angle of the figure with consistency.

Distance from the model: Beginners in particular need to get a good grasp on the whole figure when drawing a croquis, so it's usually good to position yourself about 15 feet (5 meters) from the model.

The advantages of standing up if you choose to position yourself at a close distance: If you place yourself close to the platform, so that you are looking up at the model, it's easy to capture the details and general shape of the figure, to create a dynamic drawing with a sense of scale. In addition, if you stand up you can view the model from above, which makes it easier to grasp the spatial relationship between the model and the surface of the platform. Another advantage of standing when you're at a close distance is that you can grasp the whole composition as you move around freely, making it easier to find mistakes.

● **Drawings on One Sheet of Large Charcoal Croquis Paper**

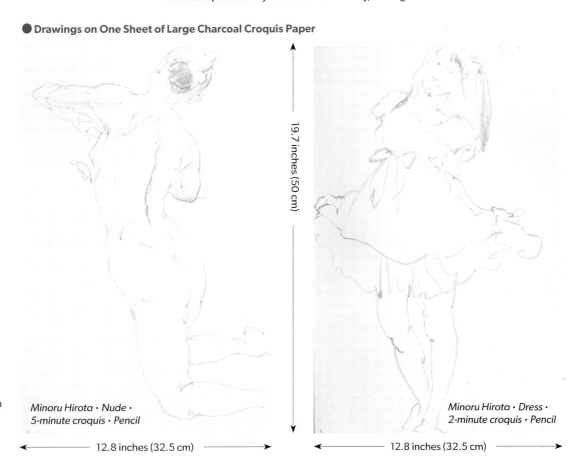

Most of the croquis in this book are drawn on this paper.

Minoru Hirota · Nude · 5-minute croquis · Pencil

Minoru Hirota · Dress · 2-minute croquis · Pencil

19.7 inches (50 cm)

← 12.8 inches (32.5 cm) →

← 12.8 inches (32.5 cm) →

Drawbacks of the Camera Lens and Points to Be Aware of When Using Reference Photos

When you don't have access to professional models, the "models" closest to you are your friends and family. But for regular people, holding a pose for even 10 minutes without moving is a tall order. So what we recommend is...aim for when they are sleeping! Only a short amount of time is available for drawing them until they turn in their sleep, but you can capture a very natural pose. If even that is difficult to do, you can use photographs as reference material for your croquis drawings. See the photos below and the drawings done based on those photos. The model is Kozo Ueda, who fell asleep at his hotel when he was traveling.

Most people think that the camera accurately depicts its subject, but it actually changes the form and proportions of its subjects in many ways.

Use the Depth of Field of a Wide-angle Lens

Example 1 If you take advantage of the characteristics of a wide-angle lens, you can show the distance between the face and the fingertips in a very dynamic way. Although it is a bit unnatural, it's just about on the borderline of being an acceptable way of depicting this pose.

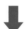 Photo 1: Taken with a wide-angle lens

Play with the Strong Distortion of a Wide-angle Lens.

Example 2 A pose this exaggerated is cartoonish, but the resulting croquis is very interesting. Whether you like either example 1 or example 2 depends on your taste.

Photo 2: Taken with a wide-angle lens as close to the subject as possible.

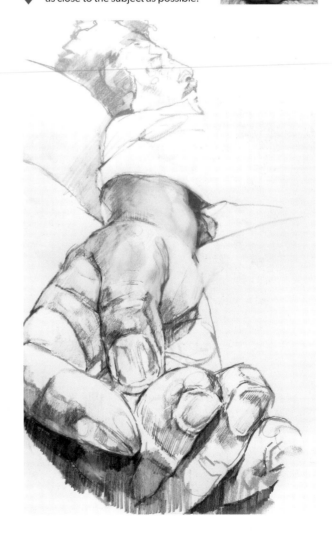

Which is the most true-to-life image? It's confusing, isn't it? Unless you know the features of each type of camera lens, there's the danger of taking really absurd versions of the human form in photos as being "realistic." See your subject with your own eyes, and draw it—this may be obvious, but it's very important. However, as long as you are thoroughly aware of the characteristics of the camera lenses you use, it's possible to use photo reference materials to express yourself artistically.

When you look at a subject with your naked eye, your awareness of it is formed by correcting the image in your mind, emphasizing some impressions and leaving out others. You could even say that you are not even looking at parts that you don't like. A camera lens is just a piece of equipment, so it doesn't make any gut-level adjustments. In particular, it doesn't have the ability to leave things out. So, if you use a photo as a reference, a whole lot of unnecessary information in it gets in your way. If you pick up on too much of that information, your drawing is liable to become overly descriptive and less expressive. That's the main drawback of working from photographs. You can't forget that humans look at things with their brains. —Takahiro Okada

Focus on the Face with a Telephoto Lens

Example 3 A telephoto lens has a shallow field of vision, and brings faraway objects closer. Therefore, it reverses the depth of field of the space. By drawing the parts that are actually close to you in a sketchy, abbreviated way, you can give more meaning to the object in the back (the facial expressions).

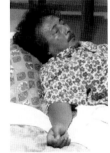

Photo 3: Taken with a telephoto lens some distance away from the subject.

Use a Standard Lens to Normalize the Way the Subject Is Viewed

Example 4 Although this is a normal pose, all of the information is uniform, unlike seeing with the naked eye. So, the resulting drawing is liable to become photographic rather than expressive.

Photo 4: Taken with a standard lens. (In general, it's said that a 70mm or so lens is closest to what's seen with the naked eye.)

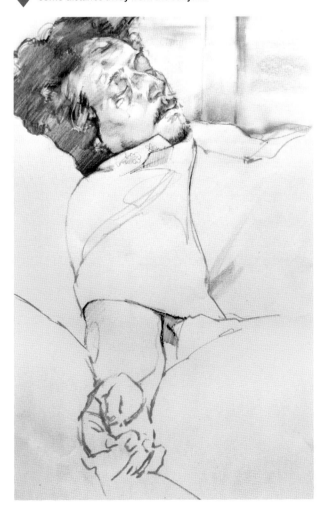

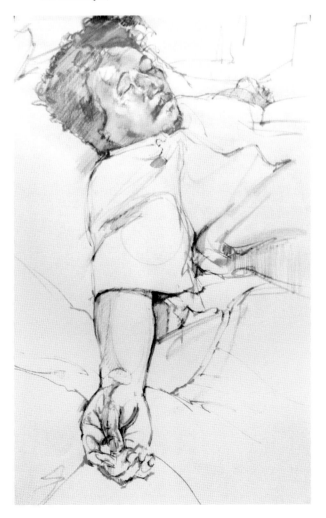

About Minoru Hirota

My Croquis Philosophy

Croquis drawings are generally regarded as basic art studies or training, but in my case, the final result I am aiming for is an image that has croquis-like features. The ultimate image I am aiming for in my work is created by ruthlessly eliminating as many of the unnecessary elements contained in the seemingly endless amount of information received from the subject, leaving just the essential elements.

It's not important to capture the subject in a short amount of time; rather, there is meaning in extracting just the necessary essence because the time is limited. The shorter the time allotted, the less time there is to add tone, so the role of the lines becomes important. It's necessary to express a sense of volume, texture and space with the pressure and speed variances of the drawing implement. I hope that the viewer can feel the sensuality of the line itself, rather than becoming fixated on basics like the shape.

Because it becomes possible to assume more dynamic and supple poses in shorter sessions, the quality of the positions the model takes change too. I am repeatedly reminded (in these short sessions) of how beautiful the human body is.

When I draw shorter(1-, 2-, and 5-minute) poses all day, I easily go through over 100 drawing sheets, but I can only consider a handful of them satisfactory, so the success rate is relatively low. But I think that's what croquis drawing is all about. After all, they reveal the way the artist sees and thinks about the subject in a straightforward manner.

Lastly, a word about moving croquis, which I am still mulling over. Previously my main focus was to capture a split second of the moving human figure, but now I think that I would like to be able to capture movement itself on the paper, so this is a direction I will continue to explore.

About Croquis Drawing

For an artist, an empty blank canvas or paper is an intimidating thing. At that stage it's not a picture or space, it's just a flat board. But as soon as a brush stroke, a line or a tone is added to it, limitless depth and space are born on that previously blank surface. It's a thrilling moment, when two dimensions are transformed into three dimensions.

Whether or not that first mark on the surface has any meaning depends on the second mark. The following marks made are the same. Unless you understand the relationships between those marks, the expression is not convincing. A process that's similar reading an opponent's next moves in chess takes place on the surface, and shapes and spaces are born.

I think that a croquis is the culmination of a brief period of high-tension, where you grasp the subject in an instant, make decisions on the necessary and unnecessary elements, and then add lines and tones. It's the most purely fulfilling time for an artist, because his heart is totally occupied by the model and the work on the paper, and there's no room for anything else to force its way in between.

Artistic expression is difficult—if you add too much to a drawing, the scope of what you can communicate to the viewer is paradoxically narrowed. There are nuances that can be sensed from the picture by leaving elements out. A picture that has been pared down and consists only of the necessary lines and tones communicates a lot to the viewer. However, I feel I rarely create such a work.

During the past two years, I've been taking on moving croquis too. By adding the element of time to a three-dimensional space with depth, it becomes an expression of four dimensions. I don't know where I'm going with these moving croquis sketches, and I can't find a methodology for them either. However, I do think that continuing to want to capture movement and time on the paper as a drawing does have meaning.

* The essays on pages 162 to 166 are excerpted from the ATELIER 21 BOOKS 1 through 4, published by ATELIER21.

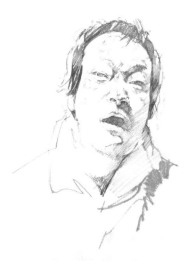

Biography

1959 Born in Hiroshima prefecture

1983 Graduated from the Tokyo University of Arts, Fine Arts Department

1985 Completed the Tokyo University of Arts Masters Program (Hiroshi Kane-sue class)

1991 Selected for the *Hakujitsu Fine Art Association Exhibition* for the first time. Selected every year since. (This prestigious exhibition took place at the Tokyo Metropolitan Art Museum until 2008 and has been held at the National Arts Center, Tokyo ever since.)
Awarded the Minister of Education Honorable Mention award at the exhibition in 1996, and the Prime Minister's Award in 2004

1996 Solo exhibition at the Nihonbashi Mitsukoshi department store, Tokyo; repeated in 2000, 2003, 2007, 2011 and 2015
Solo exhibition at the Shibuya Museum of Arts in Fukuyama, Hiroshima; repeated in 2001, 2006 and 2011
Solo exhibition at the Chiyoharu Gallery in Kyobashi, Tokyo; repeated in 1999, 2002, 2004, 2005, and 2006 to 2012

1997 Exhibition of private collection of Western art at the Fukuyama Art Museum
Solo exhibition at the Umeda Gallery, Osaka; repeated in 2001 and 2007

1998 Solo exhibition at Gallery EMORI in Harajuku, Tokyo; repeated in 2001
Premonition of Beauty exhibition at the Tokyo Takashimaya department store; the exhibit also toured to Yokohama, Osaka and Kyoto
Solo exhibition at the Tenmanya department store in Fukuyama, Hiroshima; repeated in 2001, 2006, 2011 and 2012

1999 ATELIER21 established
Exhibition of newly acquired private collection of Western art at the Saku Municipal Museum of Art in Saku, Nagano; repeated in 2002 and 2012
Heizo Kaneyama Award Commemorative Exhibition at the Hyogo Prefectural Museum of Modern Art (now the Hyogo Prefectural Museum of Art)

2000 Selected for the *Showa Association Exhibition* at the Nichido Gallery in Ginza, Tokyo; repeated in 2001
Solo exhibition at Gallery ARK, Yokohama; repeated annually every year since

2001 Solo exhibition at Zokyudo Gallery, Kyoto; repeated in 2003 and 2005

2002 Solo exhibition at Ginza Yanagi Gallery, Ginza, Tokyo; repeated in 2006, 2008 and 2010
Yakushi Temple Exhibition at the Nihonbashi Mitsukoshi department store, Tokyo

2004 Solo exhibition at the Dentoh Gallery, San Francisco
Kanji Maeda Grand Prix Exhibition at the Tokyo Takashimaya department store and the Kurayoshi Museum, Tottori
Solo exhibition at the Kintetsu department store, Abeno branch; repeated in 2010 and 2013

2005 Solo exhibition at Tokyo Takashimaya department store; tours to Yokohama, Osaka, Kyoto and Nagoya; repeated in 1009 and 2012

2006 Awarded the Michiaki Kawakita prize at the *Western Eye Exhibition*; repeated in 2007, 2008 and 2009
Sonpo Japan Art Foundation Selective Promotional Exhibition at the Seiji Togo Memorial Sompo Japan Nipponkoa Museum of Art

2007 Solo exhibition at the Shanghai Art Fair, China

2009 *Minoru Hirota Collected Works—He Draws a Line To The Sea*, published by Kyuryudo

2011 Solo exhibition at Gallery Wada, Ginza, Tokyo; repeated in 2014

2013 *Art Fair Tokyo* at the International Forum in Yurakucho, Tokyo
Solo exhibition at Matsuzakaya department store, Nagoya
Collaborates with Kim Ito and Kuniko Kato on "The D of Honno-ji", shown at Honno-ji temple in Kyoto, the House of Culture of Japan in Paris, and the Chiryu Cultural Center in Chiryu, Aichi

2014 Solo exhibition *Mr. Tomobe's Color Pencils*—collaboration with folksinger and poet Masato Tomobe, at Gallery ARK, Yokohama

2015 *100 Croquis Exhibition* to commemorate the publication of this book, FEI Art Museum, Yokohama

Presently a member of the board of the Hakujitsu Fine Art Association
Web site: minoruhirota.com

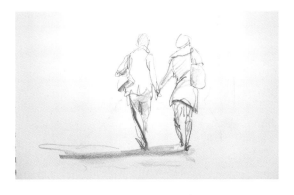

About Kozo Ueda

My Croquis Philosophy

Drawing is essentially the process of recreating the world captured by your eyes with your hands. The echo of what you have seen that is committed to the paper is called the image, and by correcting it again and again you come closer to the actual subject. The image that is in your head is actually an illusion that evaporates with time, and what you leave on the paper is none other than your alter ego, and there is great significance in that.

Now, while croquis is a type of drawing, it is also the opposite of drawing. The nature of croquis is to complete many quick drawings. By increasing the density of the time spent on the croquis by limiting its length, and coordinating the movements of the eyes and the hands to extract that intuited form onto the paper, I think that a croquis is the expression of the desire of the artist to depict the fundamental form of the human figure. It stops just short of idealizing the human figure.

Although working on one's art is a solitary endeavor, when you enjoy the company of friends in a croquis drawing session, try not to be overwhelmed by their enthusiasm as you work to bring out ever more refined and disciplined images—this work is between you, the model and the paper alone.

Whenever I complete a multi-day croquis camp and review the artwork I have previously completed that I considered to be some of my best work, I face the reality that they now look dull and faded to me, and I feel a the thrill of joy and surprise at my progress.

Croquis drawing is so much fun!

About Croquis Drawing

Once again, what is croquis anyway?

When I am normally working on a picture, every part of my brain comes alive in the effort. Serendipity is always at work. The defining feature of croquis is that number of "happy accidents" that occur is enormous. Speaking form myself, the intoxicating pleasure that I feel when working on croquis drawings may be ascribed to mere hyperventilation, but I maintain that it's a different kind of excitement from the kind that one feels when working on other types of drawings. It holds the same kind of driven fun feeling as one receives from navigating an obstacle course.

When I'm working on croquis drawings, I become aware of another version of myself, who nods and thinks, "this is it!" That guy shows up after I've made many attempts and have only been able to achieve the same old results, and I'm just about to give up thinking that I can't do it. It feels like the first time I could ride a bicycle—a fleeting moment in time when I feel as though I am watching myself make a triumphant breakthrough. It's not a moment I can't forget, but rather a moment I would rather not forget—a fleeting moment to cherish.

However, while you can ride a bicycle without difficulty following that seminal breakthrough day, croquis drawing doesn't quite work that way. That's because every time you begin to draw, you're presented with a new "bicycle" that has a different shape.

I'm always chasing that heady feeling of new discovery, as I pursue the next uniquely rendered form. Each new figure is a fresh challenge, but when I draw it expressively, I intuitively recognize when I'm on the right track.

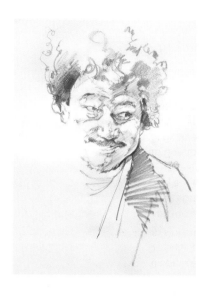

Biography

1959	Born in Fukuoka prefecture
1981	Recipient of the Ataku Scholarship Award at the Tokyo University of Arts
1983	Recipient of the Ohashi Scholarship Award at the Tokyo University of Arts
	Graduated from the Tokyo University of Arts, Fine Arts Department
1985	Completed the Tokyo University of Arts Masters Program (Hiroshi Kanesue class)
1986	*L'Espoir Solo Exhibition* at the Ginza Surugadai Gallery, Ginza, Tokyo
1988	Completed the Tokyo University of Arts Ph.D Program (Yasuo Taguchi class)
	Solo exhibition, *Tokyo University of Arts Ph.D Program Research Exhibition*, at the University of Arts Exhibition Gallery
1992	Mural painting in the Katsushika Symphony Hills Annex in Katsushika, Tokyo
1993	Selected for the *JR Beautiful East Japan Exhibition* at the Tokyo Station Gallery
	Solo exhibition at the Chuzenji Kanaya Hotel in Nikko, Tochigi
1995	Solo exhibition at Gallery Kadose, Kanda, Tokyo
1996	Solo exhibition at the Isetan department store, Matsudo branch, Matsudo, Chiba (to 1998)
	Ceiling painting in the World Glassware Hall in Iwashiro, Fukushima
1997	Solo exhibition at the Kumamoto Prefectural Museum of Art Chibajo Branch Gallery
1999	ATELIER21 established
	Mural painting in the Tomimura General Welfare Center, Okayama
	Exhibited with the Ou Ou Association at Gallery Saiko and other venues, until 2009
2000	Solo exhibition at the Nakadori Gallery, Yokohama; repeated annually until 2008, and then again in 2010, 2011, 2012, 2013, 2014 and 2015
2001	Solo exhibition at Keio department store in Shinjuku Tokyo; repeated annually until 2003
	Solo exhibition at Kobe Hankyu department store
2002	ATELIER21 *60 Sketches* exhibition, at Gallery Dobin, Yokohama
	The Shape of Time exhibition at the Yokohama Citizen's Gallery; repeated annually until 2015
	Solo exhibition at Gallery ARK in Yokohama, repeated annually until 2009, and then again in 2011, 2012, 2013 and 2014
2004	ATELIER21 three-artist exhibition at the Yokohama Takashimaya department store; repeated in 2006, 2008, 2010, 2012 and 2014
	Solo exhibition at the flagship Matsuzakaya department store, Nagoya
2005	Solo exhibition at the flagship Tokyu department store, Shibuya, Tokyo; repeated annually until 2009, and then again in 2010 and 2011
	Solo exhibition at Gallery Miro, Yokohama; repeated in 2008, 2010, 2012 and 2014
	Exhibited with the Ou Ou Association at Gallery Saiko, Gallery Horizon (both in Yokohama) and other venues; until 2008
2006	Hidemi Exhibition at the Kintetsu Abeno Art Museum, Abeno, Osaka
	Solo exhibition at the flagship Hankyu department store, Umeda, Osaka; repeated in 2008 and 2011
	Solo exhibition at the Fukuoka Mitsukoshi department store; repeated in 2008, 2010 and 2012
2007	*The Heart of a Flower, The Brilliance of Art Exhibition* at the Shibuya Museum of Arts in Fukuyama, Hiroshima
2008	*The Feast of Flowers Exhibition* at Gallery ARK, Yokohama; repeated annually until 2014
2009	Solo exhibition at the Sendai Mitsukoshi department store, Sendai, Miyagi
	The Easy Watercolor Textbook, published by Sensei Publishing
2010	Solo exhibition at the Takamatsu Mitsukoshi department store, Takamatsu, Kagawa
2012	Solo exhibition at the FEI Art Gallery, Yokohama
	100 Croquis Exhibition to commemorate the publication of this book, FEI Art Museum, Yokohama
2013	*The Easy Oil Painting Textbook*, published by Sensei Publishing

Current status: Unaffiliated with any art association; member of the Tokyo University of Arts Anatomy Association

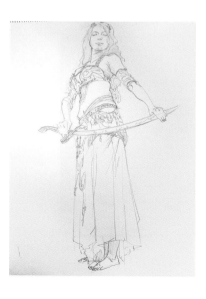

About Takahiro Okada

My Croquis Philosophy

I first encountered croquis drawing when I was in the latter half of my teens.

I remember that I started to work on them seriously after I graduated university, and started teaching at a prep school for students studying for art school entrance exams. At the time, I firmly believed that doing croquis drawings over and over was the way to sharpen the sensibilities of the students, as well as essential training for speeding up their working process. My way of instructing the students was just to sit next to them facing the model and to immerse myself in croquis. Now that I think about it, the one who was most into croquis drawing was me, rather than my students! Before I realized it, I had made "How much can I draw in 20 minutes?" my goal.

And, that attitude was my downfall when it came to prepping the students for their entrance exams. I may be laughed at for just now realizing this after 20 years of working professionally as an artist. What I really should have made my goal for croquis drawings is to express the essential form with the minimum required lines. Your artistic instincts and resolve are tested by knowing when to stop drawing.

Croquis and drawing are fundamentally different. Croquis is the basic thinking process of the artist, revealed on the paper. The sketches are the record that shows what the artist was seeking, what they were thinking, and how they saw.

I feel as though I am on a never-ending journey. The thought that I may have come halfway to my destination may be in itself an illusion.

About Croquis Drawing

To me, croquis is a way of training the self to control one's mind. The reasons are listed below.

The real goal of croquis is not to "reproduce" the subject, but to "express" it. You must pay attention, because whether your aim is to "reproduce" or to "express" will drastically change how you interpret and capture a croquis drawing. In order to "express" the subject, the first thing you need to do is to visualize the finished image in your head. In other word, you need to imagine it. And as you go through the drawing process, you need to always prioritize the visual information, and pick and choose from that information. "Expression" starts from the construction of the image. Choose the elements that are necessary for constructing the image, and discard the elements that are unnecessary or get in the way. This process tests the instincts and resolve of the artist. Emphasis and abbreviation are born from this negotiation. If you face the work surface in a state where you are controlled by your emotions, you won't be able to see what the surface is "asking" for. If you can't overcome this, it's difficult to balance the composition.

One elements of croquis expression that is essential is "rhythm." The "rhythm" of the working surface can be grasped through observation coupled with the brain's sensitivity. The power of observation doesn't just mean the acuity of vision. It's the ability of the brain to analyze. And analysis means to search out the innate nature and purpose of an object. To analyze it further and to connect visual information to "expressions" is the ability to express oneself with language. Scrutinizing the subject is not the important thing; what to observe and how to observe it is the critical factor. At the same time, if you are not able to verbalize how you felt and how you saw, you cannot "express" the subject. ("Expression" as I am using it here is strictly the expression in representational art.)

Your brain is what is moving your eyeballs, as well as the muscles of your fingers holding the pencil. And what you depict on the paper can never surpass what you confirm with your eyes. How to you see the subject? What lines do you draw? These are controlled by the artist's desires and sensibilities. And once you understand your desires, you will be able to understand how you should see the subject, and what kinds of lines to draw.

I think that the brain's processing ability is necessary to draw a "picture." I believe that to work on time-limited croquis is the most effective way to challenge and improve the brain's processing ability.

Biography

1959	Born in Tokyo
1983	Graduated from the Tokyo University of Arts, Fine Arts Department
1985	Completed the Tokyo University of Arts Masters Program (Teruo Onuma class)
1993	Selected for the *Hakujitsu Fine Art Association Exhibition* for the first time; at the Tokyo Metropolitan Art Museum, Ueno, Tokyo
1994	70th Exhibition Friend of the Association Encouragement Award
1995	71st Exhibition Tomita Award
1997	73rd Exhibition U Award
1998	74th Exhibition Sanyo Art Encouragement Award
2002	78th Exhibition Yasuda Fire Insurance Art Foundation Encouragement Award
2005	81st Exhibition Minister of Education, Culture, Sports, Science and Technology Encouragement Award
2008	84th Exhibition Sanyo Art Award
1994	Solo exhibition at the Nakadori Gallery, Yokohama; repeated in 2006 Tomorrow's Hakujitsu Association Exhibition, at the Central Gallery, Ginza, Tokyo *New Oil Painting Artists* exhibition at the Nagoya Mitsukoshi department store
1997	*Tomorrow's Hakujitsu Association Exhibition*, Matsuya department store, Ginza, Tokyo; repeated annually until 2009
1998	*Kanji Maeda Grand Prix Exhibition* at the Tokyo Takashimaya department store and the Kurayoshi Museum, Tottori Solo exhibition at the Nihonbashi Mitsukoshi department store, Tokyo
1999	ATELIER21 established Solo exhibition at Gallery ARK, Yokohama; repeated annually until 2015 *The Shape of Time* exhibition at the Yokohama Citizen's Gallery; repeated annually until 2009
2000	*Oak Tree Road* exhibition at Gallery EMORI, Harajuku, Tokyo
2001	*Irreplaceable Image* exhibition at Nihonbashi Mitsukoshi department store, Tokyo Exhibition of newly acquired private collection of Western art at the Saku Municipal Museum of Art in Saku, Nagano
2002	Hakuto Association exhibition at the Kintetsu department store Art Gallery, Osaka Solo exhibition at Gallery Miro, Yokohama; repeated annually until 2015 ATELIER21 exhibition at the Tokyu Department Store, Fujisawa, Kanagawa
2004	ATELIER21 three-artist exhibition at the Yokohama Takashimaya department store; repeated annually until 2013 Solo exhibition at the flagship Matsuzakaya department store, Nagoya
2005	Exhibited with the Ou Ou Association at Gallery Saiko Yokohama; until 2009
2006	*60 Sketches* exhibition at Nori Gallery Ginza, Tokyo
2007	Solo exhibition at Gallery Wada, Ginza, Tokyo
2009	*ATELIER21 Oil Painting Exhibition* at the flagship Matsuzakaya department store, Nagoya
2010	*Hakusho Association Exhibition* at the flagship Matsuzakaya department store, Nagoya
2012	*Second Takahiro Okada Oil Painting Exhibition* at the flagship Matsuzakaya department store, Nagoya
2013	Two-artist exhibition at the Odakyu department store, Machida, Tokyo
2014	Drawing exhibition at the flagship Matsuzakaya department store, Nagoya *ATELIER21 3-Artist Exhibition Rediscovering Yokohama!* at Yokohama Takashimaya department store *ATELIER21 3-Artist Exhibition* Travel to Nagasaki at Nakadori Gallery, Yokohama Solo exhibition at Ginza Hikari Gallery

Currently a member of the Hakujitsu Association

Books to Span the East and West

Our core mission at Tuttle Publishing is to create books which bring people together one page at a time. Tuttle was founded in 1832 in the small New England town of Rutland, Vermont (USA). Our fundamental values remain as strong today as they were then—to publish best-in-class books informing the English-speaking world about the countries and peoples of Asia. The world is a smaller place today and Asia's economic, cultural and political influence has expanded, yet the need for meaningful dialogue and information about this diverse region has never been greater. Since 1948, Tuttle has been a leader in publishing books on the cultures, arts, cuisines, languages and literatures of Asia. Our authors and photographers have won many awards and Tuttle has published thousands of titles on subjects ranging from martial arts to paper crafts. We welcome you to explore the wealth of information available on Asia at **www.tuttlepublishing.com**.

Published by Tuttle Publishing, an imprint of Periplus Editions (HK) Ltd.

www.tuttlepublishing.com

JINBUTSU CROQUIS NO KIHON HAYAGAKI 10-PUN, 5-FUN, 2-FUN, 1-PUN
Copyright © ATELIER21, Tsubura Kadomaru/HOBBY JAPAN
All rights reserved
English translation rights arranged with Hobby Japan Co., Ltd. through Japan Uni Agency, Inc., Tokyo

English Translation © 2020 by Periplus Editions (HK) Ltd.
Translated from Japanese by Makiko Itoh

ISBN: 978-4-8053-1603-0

Staff (Original Japanese edition)

Authors ATELIER21
Editor Tsubura Kadomaru
Publisher Daisuke Matsushita
Cover design and book layout Masaharu Naka (Ad Arts)
Ayumu Kobayashi (Ad Arts)
Photography Katsuyuki Kihara (Studio EN)
Keiko Shimauchi (Studio EN)
Planning Midori Hisamatsu (Hobby Japan)
Yasuhiro Yamura (Hobby Japan)
Models Natsumi Kuroda (Kitamura Fine Art Model Referral Office)
Sayuri Iimori (Kitamura Fine Art Model Referral Office)
Aya Murata (Kitamura Fine Art Model Referral Office)
Nanami Kitagawa (Pour Vous Model Referral Office)
and others. We are grateful to all the models who cooperated with us in the creation of the works in this book.

Distributed by

North America, Latin America & Europe
Tuttle Publishing
364 Innovation Drive
North Clarendon, VT 05759-9436 U.S.A.
Tel: (802) 773-8930
Fax: (802) 773-6993
info@tuttlepublishing.com
www.tuttlepublishing.com

Japan
Tuttle Publishing
Yaekari Building 3rd Floor
5-4-12 Osaki
Shinagawa-ku
Tokyo 141-0032
Tel: (81) 3 5437-0171
Fax: (81) 3 5437-0755
sales@tuttle.co.jp
www.tuttle.co.jp

Asia Pacific
Berkeley Books Pte. Ltd.
3 Kallang Sector #04-01
Singapore 349278
Tel: (65) 6741 2178
Fax: (65) 6741 2179
inquiries@periplus.com.sg
www.tuttlepublishing.com

25 24 23 22 21 20 10 9 8 7 6 5 4 3 2 1
Printed in Singapore 2009TP